Florentine Renaissance Sculpture

FLORENTINE RENAISSANCE SCULPTURE

Charles Avery

JOHN MURRAY

TO MY PARENTS

Printed and bound in Great Britain
by Butler & Tanner Ltd, Frome and London

0 7195 1932 2

Contents

Foreword

This book is intended to meet the need for a compact handbook to Florentine Renaissance sculpture for the use of students of art history and of those visitors to Florence whose curiosity is not satisfied by the standard guidebooks. It is derived in large part from material prepared for a series of lectures at Cambridge University and for a number of seminars at the Courtauld Institute of Art, London University.

Although every attempt has been made to render the text reliable as well as informative, it cannot pretend to be a substitute for the larger reference books that have preceded it, first and foremost the comprehensive series on Italian sculpture by John Pope-Hennessy, and more recently Charles Seymour's *Sculpture in Italy 1400–1500*. These authorities chose to divide their material on the whole by themes and by major commissions respectively. I have reverted to the time-honoured method of treating the career of each sculptor in an integral fashion wherever possible. This approach emphasizes the total contribution of the individual artist to the general development of style and enhances the narrative flow of a text that is introductory rather than definitive in intention. The main exception occurs in the discussion of the early Renaissance, where I have felt that a division between sculpture in relief and in the round enhances the clarity of the discussion. In order to focus attention on the main developments in style and ideas while keeping the material within the limits of a relatively inexpensive volume it has been necessary to omit entirely some interesting but secondary figures; while of the sculptors who are included, discussions of the better-known, particularly Michelangelo, have been compressed in favour of comprehensive accounts of the less familiar.

The Introduction comprises a consideration of general factors that influenced the course of Florentine sculpture: the relationship between the emergence of humanism and the Renaissance in sculpture; an outline of the conditions of patronage that permitted the rapid development of style during the period; the reasons for the initial pre-eminence of sculpture over painting;

and an account of the complicated technique of bronze cast-ing, which I feel to be fundamental to a proper understanding of the many sculptors who worked in that medium, from Ghiberti and Donatello to Cellini and Giovanni Bologna. The second chapter gives a rapid survey of the state of sculpture in Tuscany and Florence from 1250 to 1400, which is an essential preliminary to the main theme of the book. Thereafter, when the career of a sculptor has led outside the confines of Florence, the narrative, for the sake of logical continuity, has followed. Otherwise, the central position enjoyed by Florentine sculpture for two centuries and the virtual exclusion of reciprocal influ-ences from outside constitute a sufficient justification for its treatment in partial isolation.

LONDON, 1969.

Introduction: The Renaissance and Patronage at Florence

The appeal of Florence lies in the sense of intimacy that it retains despite its intellectual and artistic renown. Other cities of equivalent prestige, Athens, for instance, or Rome, were laid out with a demonstrative grandeur which overwhelms rather than captivates. The architecture and sculpture with which they are adorned strain so powerfully towards the ideal that the character of the cities is grandiose and impersonal. Not so with Florence, where the homely vestiges of the mediaeval town survive side by side with the elegant monuments of the Renaissance; where the old, haphazard layout of streets and squares could still be negotiated with ease by a Florentine of the fifteenth century; and where later ages have chosen to embellish or redecorate rather than to demolish and build anew.

In Florence, sculpture perhaps more than architecture determines the character of the place, so vivid is one's impression of an entire population of statues. Wherever he may turn, the visitor meets men of marble or bronze looking down from their niches on church façades and public buildings, or from their pedestals in squares, courtyards and gardens. These figures, carved in marble, modelled in clay, or cast in bronze, constitute a series of artistic milestones along the road that the Renaissance followed. Some of the most famous names in the history of art are in fact those of Florentine sculptors: Ghiberti, Donatello and Luca della Robbia; Verrocchio and Michelangelo; Cellini, Ammanati and Giovanni Bologna.

The impressive array of sculpture is the result of an unbroken artistic tradition, lasting for over three hundred years and with its origin in the early fourteenth century. For the greater part of this period its driving force was the cultural movement known as the Renaissance. In Florence, the revival of interest in the culture of ancient Greece and Rome was motivated in the first instance by practical considerations. The existing, mediaeval legal system and a debased Tuscan dialect were proving cumbersome obstacles in the rapidly developing fields of politics and commerce. Roman Law and the precise but flexible Latin

language provided obvious models, easy of access, for the necessary reforms. As the knowledge of Latin and, later, Greek literature spread among the educated, their interest naturally expanded beyond legal codes, grammar and rhetoric to the Roman way of life and the moral and philosophical precepts which had guided it. Passing references drew attention to the role that had been played by the visual arts and men began seriously to examine the visible remains of ancient Rome, which were so evocative of its past glory. The prestige which Florence began to enjoy as the intellectual centre of the new movement suggested an attractive analogy with the position of the capital of the ancient world. Hopes even arose of uniting the divided forces of contemporary Italy in a new Roman Empire, with Florence playing the central role. Symbolic of such a role was the outward adornment of the city with magnificent new buildings and impressive sculpture to enhance its prestige and to point the comparison with the Rome of old.

The historical causes of the Renaissance are numerous, and the reasons why it should have occurred at Florence and at this particular period are exceedingly complex. In the background of the classical and artistic revival was the economic recovery from the disaster of the Black Death which had swept over Europe in 1348. The salient features of the Florentine economy at the time were textile manufacture, trade and international banking. Family banks, in particular that of the Medici, were so successful in using new business methods that before long they financed the greater part of European commerce, as well as supporting many of the national régimes. Affluence alone, however, is not enough to explain the lavish patronage which permitted the rapid development of the Renaissance style. A further incentive existed for successful businessmen to devote their wealth to enriching and beautifying the city with fine works of art.

Fundamental to any banking business is the receiving of interest on loans. In the Middle Ages this was considered to be usury, a sin condemned by the Bible. The survival of this prejudice well into the fifteenth century was a serious disability to the banking business. Yet, inconvenient as it may have been to the banker, it was of fundamental importance to art patronage, for the accepted way of expiating the sin of usury was to finance the repair, construction or decoration of some religious foundation. Nearly every public building in Florence had some religious connection and would qualify as the object

of a settlement of this kind of moral debt to the community. The greater the profits that accrued, the greater was the stigma attached to the lender and the greater was the sum needed to clear his conscience and good name. Thus the Medici, the most successful bankers, felt obliged to devote a considerable proportion of their profits to such ends. Of course, this system provided undoubted opportunities for self-advertisement in the lavishness with which men supported public projects, but appearances were carefully maintained by a patron as astute as Cosimo de' Medici. When donating funds to the monasteries of San Marco and San Lorenzo, he insisted on meeting practical needs such as the monks' accommodation, very much in the spirit of pious atonement, before turning to the embellishment of the churches proper, which would contribute more obviously to the prestige of his family. In any case, the interpretation of what constituted a fitting expiation for successful usury tended to be surprisingly generous: for instance, the expense of erecting the huge Medici palace could be counted, inasmuch as it added lustre to the city.

In the early years of the Renaissance, however, the principal patrons of the arts were rarely individuals. Sculpture in particular was normally commissioned by corporate bodies, the guilds and political parties, as an accessory to the public buildings which they were under an obligation to maintain. The guilds had come into prominence with the drift to the towns and the emphasis on urban commerce and manufacture that had resulted from the aftermath of the Black Death. By 1400 Florence was largely run by the seven Greater Guilds, representing the most important trades and professions, each of which had a particular social standing and political outlook. The differences between them led to intense rivalry that found a positive expression in the munificence with which they decorated the civic buildings for which they were responsible. Most fruitful for the development of Florentine sculpture was the rivalry between the Guild of Wool Merchants (*Lana*), which traditionally underwrote the expenses of maintaining the Cathedral, and that of the Cloth Importers (*Calimala*), which patronized the Baptistry, while all the guilds came into open competition in decorating the guild hall, Or San Michele.

Architecture was naturally the art which profited most from the patronage of the guilds, on account of the practical advantages that it offered to members and general public alike. For similar reasons, it also attracted the support of individual

3

patrons like the Medici, when trying to atone for their suspect profits. Sculpture, in the role of an architectural accessory, was almost as popular. It could be displayed in the open air and yet, unlike a fresco painting, would withstand the ravages of time and weather. This simple but important fact must have been particularly apparent to men of the Renaissance from a consideration of what had survived from the ancient world. Virtually all that was then known of Roman figurative art consisted in sculpture, either statues or reliefs, ranging in scale from the minute to the monumental. It should be no surprise, therefore, that the first revival of the classical style appeared in the same medium. The emergence in the last decade of the fourteenth century of patrons who were ready to finance monumental sculpture coincided propitiously with the advent of humanism and the interest in ancient art that was consequent upon it. Both these phenomena contributed to the pioneer role which the art of sculpture was to play in the revival of classical style during the fifteenth century.

At first nearly all major sculptures represented religious subjects, as they had in the Middle Ages, because they were destined for the sacred buildings maintained by the guild system and private patronage. Initially, individual motifs, such as nude figures in poses derived from Roman sarcophagus reliefs, were tentatively introduced into otherwise mediaeval contexts. Then, as confidence increased, a classical prototype might be adapted and reinterpreted to form the basis of a complete subject, pagan imagery being used to enliven a traditional Christian theme. Once the break with Gothic artistic ideals had been achieved, new humanist ideas could be pursued to their logical conclusions in a series of energetic and perceptive experiments. As the discovery of classical manuscripts increased men's knowledge of ancient art and enabled them to understand the full significance of the remnants that had survived, there was a demand for the revival of certain types of sculpture that had not been current in the Middle Ages. The most significant were connected with the role of the individual in ancient society and constituted forms of personal memorial: the portrait-bust and the equestrian monument. Apart from these kinds of major sculpture, the portrait-medal and the small bronze statuette were also revived in emulation of antique examples, such as were to be found in the collections of every avowed humanist. Bronze statuettes seem sometimes to have been produced as deliberate forgeries of antiques, but the greater

4

artists soon realized their potentialities and Renaissance originals began to feature alongside classical examples in the studies of humanists, where they helped to recreate a Roman environment in which life could be lived '*all'antica*'.

The rise of humanism did not generally preclude belief in Christianity, and attention turned no less to memorial tombs. Apart from the inevitable sarcophagi, Roman remains provided no satisfactory model for a tomb inside a church and Gothic schemes had to be adapted. The pointed arch of the typical wall-monument could be exchanged for a round, Roman arch with classical columns or pilasters to support it, while the traditional effigy of the deceased and the Virgin and Child above could be treated in the new Renaissance style, so as to produce a complex that had an air of authentic, Roman gravity, despite its essentially Christian imagery.

From classical writers such as Pliny the humanists also learned of the emphasis that the ancients had placed on bronze as the finest medium for monumental sculpture. Although Graeco-Roman bronzes are now known in some numbers, they have been discovered comparatively recently and were virtually unknown in the Renaissance, apart from literary descriptions. Bronze statues, though essentially more durable than those in marble, which suffer from weathering if exposed, are prone to be melted down for the value of their metal and had largely disappeared during the Middle Ages. However, one notable example had survived above ground at Rome, the gilt bronze equestrian figure of Marcus Aurelius [now on the Capitoline Hill]. Its existence was of vital importance to the Renaissance, both as a magnificent example of the technique to which Pliny referred so frequently and as a prototype for the revival of the equestrian portrait itself.

The costliness and difficulty of bronze founding militated against its popularity after the fall of Rome, at least as a medium for major sculpture. The main examples of its use in Italy during the later Middle Ages consist in sets of bronze doors, the most influential being those designed for Pisa Cathedral by Bonannus (1180) and those for San Marco, Venice, by Bertuccio (1300). Even so, these doors were composed of quite small elements, cast separately and then attached to a frame. It was to these that the authorities turned when commissioning the first set of doors for the Florentine Baptistry (1329): the Pisan ones were carefully studied and a Pisan artist, Andrea Pisano, was selected, while Venetian bronze-founders were

employed. It was only with the second set of Baptistry doors (those that resulted from the famous competition of 1401) that a lasting tradition of bronze-founding was established at Florence. The artist responsible for them, Ghiberti, also has the distinction of being the first sculptor of the Renaissance to cast a life-size bronze statue, his St John the Baptist (1412).

For a proper appreciation of the factors that govern the production of bronze sculpture, a knowledge of the technique is essential. The method usually employed for ambitious statues, complicated statuettes, and intricate reliefs is known as *cire perdue* ('lost wax'), for reasons that will become apparent. Its basis is the making of a fireclay model, coated with wax to the thickness that is desired in the final bronze. The thickness is determined by a compromise between the need for strength and the desirability of economizing in metal, which is costly. The sculptor can easily model on the surface of the wax much of the detail that he wishes to be reproduced in the bronze.

The next part of the process is purely technical and was frequently not undertaken by the sculptor, but was sub-contracted to specialists, such as bell or cannon founders. Wax projections are added at selected points to provide the means for metal to flow in ('runners') and excess gases to escape ('risers'). The model is then coated thickly with a moist compound of plaster, which when solidified forms an outer casing, known technically as the 'investment'. Metal rods or nails are inserted to secure the relationship of the original clay core of the model to the investment during the next stage, when the wax is melted in an oven and run off. Once this has taken place, the fragile object with which one is left consists of a fireclay core, surrounded by an empty space conforming to the original layer of wax and enclosed by the plaster investment, which has on its inside a precise, negative mould of the surface given to the wax by the sculptor.

Molten bronze is then run into this space through the holes left in the investment by the wax runners (now melted away), while the gaseous fumes escape through the risers. If all goes well at this hazardous juncture, the investment is broken away after the bronze has solidified. The runners and risers, now of solid bronze, project at all angles and have to be sawn off. The points where they meet the surface of the bronze need to be chiselled in conformity with the original design, and it is at this point that the sculptor or his assistants usually take over from the foundrymen, whose task is complete. The essence of the

process is of course to reproduce the detailed wax surface of the original model very exactly in bronze. Ideally, therefore, little should need to be done to make the cast finally acceptable, apart from cleaning. Actually, the finer details normally lose some of their precision and require sharpening with a chisel, while roughnesses have to be smoothed away with a file. If a high polish is required, wire brushes and pumice stone are used to buff the surface.

The ultimate character of the work of art is vitally affected by the treatment that it receives in these finishing stages, and normally the sculptor performs the operations himself, or at least supervises them closely if the sculpture is large and the physical work involved is too great for him alone. The finishing of the panels for Ghiberti's Gates of Paradise occupied him and his assistants for ten years while Donatello's reliefs for the pulpits of San Lorenzo were finally worked up, in some cases after his death, by assistants with their own distinctive styles.

Thus the sculptor himself participates in making the original model and in working the surface detail of the final bronze. If the purely technical processes that intervene are performed by assistants or even outside the studio, it makes no essential difference to the aesthetic qualities of the work of art, nor does it diminish the sculptor's title to its authorship.

In this connection, it may be as well to observe that even sculpture in marble was often produced on a collaborative basis during the Renaissance. With assistants or apprentices undertaking the arduous labour of blocking out any large statues to his designs, the master-sculptor was free to concentrate on the vital, creative stages of carving and finishing his figures. A similar system was of course applied by painters of the period, particularly when faced with enormous fresco cycles. Telling details such as faces and hands were all the master would paint, while his assistants were left to cover most of the surface-area that was to be decorated. In this way the master made the best use of his time and talents and the costs of vast artistic undertakings were kept down. This system, economic for both artists and patrons, was generally regarded as satisfactory. Only in the rare instances where no expense was to be spared or the artist's reputation was at stake did exceptions occur. In such cases, if a patron were involved, the contract would stipulate precisely which parts were to be by the master's hand, to ensure the highest quality.

Patrons were careful to protect their interests by elaborate

guarantees extracted from the artist. The cost of a project was roughly estimated in advance, but apart from funds to cover his running expenses for materials and helpers, the artist usually worked at his own risk. The total value was estimated only after completion by reference to disinterested third parties, usually artists themselves, who were asked to pronounce upon the quality of the workmanship and to determine the appropriate financial reward. The censure of fellow-artists, when it could find expression in so painfully direct a way as a reduction in the amount that a defaulter would receive, was a powerful incentive to meticulous craftsmanship. Although the system was fraught with obvious difficulties and was open to occasional abuse on either side, it no doubt helped to maintain the remarkably high standard of work that prevailed in the Renaissance.

A deceptively high proportion of the sculpture that has survived from this period is of outstanding quality: this is simply a reflection of the natural tendency to produce the best work in the most durable materials, bronze, marble or stone. The bulk of everyday production would be carried out in cheaper materials such as wood, terracotta or plaster, and these works have mostly disintegrated with the passage of time. Although the majority of this sculpture was second-rate and of little lasting value, frequently consisting of mediocre moulded copies of well-known compositions, particularly of the Virgin and Child, there are literary references to work in these less permanent materials by almost every major artist. Ease and speed of execution recommended these media to good artists, as well as to hacks who could exploit them for commercial ends, because they permitted rapid experiments, unlike the more durable materials which demanded lengthy attention to purely technical procedures. Models in clay would almost invariably have preceded the carving of marble, and the loss of all but a few of these manifestations of spontaneous creativity is much to be regretted. But quite apart from their use for sketch-models, famous artists frequently had recourse to terracotta or plaster, and a variety of even less durable materials like papier mâché or cloth stiffened with size, for certain highly finished and quite sophisticated sculptures, which have almost universally disappeared. These were the elaborate decorations that they provided for religious festivals, political parades and sporting events. They ranged from full-scale triumphal arches, statues and obelisks in the streets, to elaborate floats and even down to items of fancy dress for the participants. A perusal of contempo-

rary sources shows what a large amount of time and energy was devoted to producing these frivolous and ephemeral works of art, and they must have constituted one of the most lucrative sidelines in the sculptors' shops. They almost certainly played an important role in the formation and divulgation of style which we are no longer in a position to appreciate, for the majority were dismantled or abandoned as soon as they had fulfilled their function. The loss of these highly original works of art is bound to falsify to some extent our picture of the development of style during the Renaissance: to cite one example, it is all too easily forgotten that equestrian monuments were a normal feature of these schemes of decoration and provided signal opportunities for experiment with ambitious compositions which would defy permanent execution in bronze, owing to the inherent problems of weight and balance.

The political division of Italy into separate city states seems initially to have prevented a rapid spread of the new learning from Florence. The humanist attitude to life and the new forms of art, together with all the economic, intellectual and artistic energy of the Florentines, remained concentrated within the city walls. Here, fierce rivalry between patrons as well as artists produced a highly competitive atmosphere conducive to a rapid development in the arts. This was further stimulated by the intellectual background, itself prepared for exciting novelties and constant progress through the ever-widening range of knowledge revealed by the rediscovery of classical literature. The immediate acceptance of a new device like mathematical perspective was typical, and its very invention by empirical means shows how far mediaeval prejudices against scientific thought had dissolved. This artificial aid, unknown to the ancients, not only emphasized the break with the current Gothic tradition by making its art look old-fashioned and unconvincing, but opened the way for a rise in the social status of the artist from the humble position of manual craftsman that he had hitherto occupied. When he was seen to practise a science akin to mathematics and no longer to work merely with his hands he became accepted as more nearly the social equal of his patrons.

In no other city of Italy was there quite the same combination of enlightened patronage, ample funds and creative intelligence. During the opening years of the fifteenth century, Florence gained an artistic pre-eminence which was to be unrivalled for at least fifty years. In sculpture, Siena and Padua were ultimately

converted to the Renaissance style largely through the work of Donatello; Venice followed, through the example of Padua and the visits of Donatello and Verrocchio; and Rome and Naples through visits and imported works of Donatello, Mino da Fiesole, Pollaiuolo and others.

Although, as a result of the ambitious patronage of Pope Julius II, the artistic focus of Italy moved to Rome early in the sixteenth century, and Michelangelo himself lived there permanently from 1534, the preponderance of the latter's sculptures at Florence proved sufficient to maintain its strong sculptural tradition. Paradoxically, the very presence of Michelangelo in Rome may have discouraged the efforts of lesser sculptors, except for those such as Ammanati in whom he took a personal interest. Conversely, sculptors in Florence enjoyed a certain amount of freedom, despite Michelangelo's continued influence through his legacy of sculpture and his position as unofficial adviser to the Medici dukes, who had long since become the principal patrons.

The Florentine tradition received a timely injection of new blood with the arrival, soon after the middle of the century, of a Flemish sculptor, Giovanni Bologna. His creative personality was so strong that he was able to found a new school of sculpture which perpetuated his style well into the seventeenth century: its influence was rooted so deep at Florence that the Baroque style, firmly established in Rome by Bernini and quickly taken up by other courts of Europe, gained no ground there until after 1650.

Florence thus played a seminal role in the development of humanism and in the creation of its visual equivalent, the Renaissance style. Her sculpture was a source of inspiration to the rest of Italy, providing universal themes which could be varied according to particular, regional preconceptions. To tell the history of Italian sculpture for the two hundred years in question exclusively in terms of works produced in Florence, or at least by Florentines, causes only a minimal disruption in the pattern of historical fact; and it has the overwhelming advantage of concentrating attention on an unparalleled succession of masterpieces, representing almost as many epoch-making advances in style.

2

The Background to Renaissance
Sculpture

The symbolic date that is usually taken as the beginning of the
Renaissance is 1401, the year in which the open competition was
held at Florence to select an artist to make a new pair of bronze
doors for the Baptistry. There is some justification in settling
upon this date: before, sculpture was on the whole mediaeval
and Gothic in character, while after it was predominantly in-
fluenced by the revival of interest in the ancient civilizations of
the Greeks and Romans.

Sculpture in Florence and Tuscany did not, of course, begin
with the Renaissance. In fact, the very idea of making monu-
mental bronze doors for the Baptistry goes back to an earlier
commission that had been carried out by Andrea Pisano in the
1330's: the pair of doors which is now at the south entrance to
the Baptistry. Andrea was stylistically indebted to an even
earlier school of sculptors at Pisa founded by Nicola Pisano and
his son Giovanni. To comprehend the background against
which Florentine Renaissance sculpture must be seen, we must
therefore go back in time about 150 years and focus our attention
on the sculptural scene in three cities of Tuscany which were at
the time politically hostile to Florence, their sympathies being
Ghibelline not Guelph: Pisa, Siena and Pistoia.

During the twelfth century and the first half of the thirteenth,
the style current in Italy, as in the rest of Europe, was Roman-
esque. In Tuscany the principal monuments in this style were
the high, arcaded façades of the cathedrals at Lucca and Pisa.
A rather different interpretation, typified by a patterning of
surfaces with green marble elements, appeared at Florence in
buildings such as the Baptistry and San Miniato al Monte.
Unlike their French or German counterparts, these buildings
offered little scope for sculpture, other than occasional oppor-
tunities for grotesque heads as terminal decorations or gar-
goyles. Italian architects never decorated portals with the
wealth of semi-architectural figure sculpture that was such a
salient feature in northern Europe. They preferred to employ

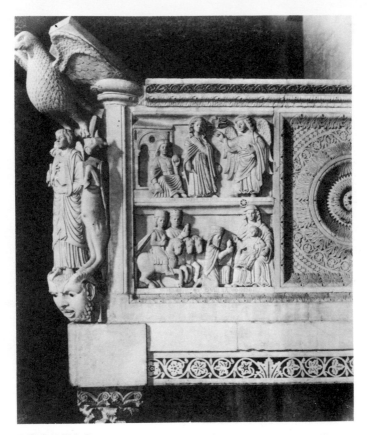

1. Pulpit, Pistoia

sculpture inside churches to decorate screens and pulpits. Fairly typical is a pulpit in San Bartolommeo in Pantano, Pistoia (1250) [1], which makes use of a formula invented at least a century before, consisting of a rectangular balcony raised on columns and abutting a wall, with narrative reliefs ranged along the sides and figures in three-quarter relief at intervals to support lecterns.

The first work known to us by Nicola Pisano, a pulpit in the Baptistry, Pisa [2], signed and dated 1260, marks a new departure in the treatment of this traditional type of composition. Nicola's pulpit is free standing and hexagonal in plan, with a single, large panel of relief forming each side. The platform is now supported

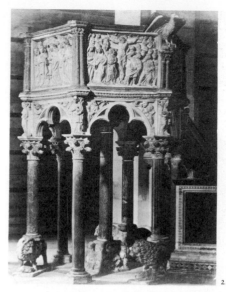

2. Pulpit, Pisa. Nicola Pisano

on round arches which spring from the capitals of the main columns. A small figure at each angle supports a cluster of colonnettes separating the reliefs. The architectural clarity of the composition gives the pulpit a new, monumental quality which is far superior to the decorative effect of its Romanesque predecessors. The change is quite startling in its suddenness, when one remembers that the pulpit at Pistoia had been carved less than ten years before.

No less radical are the differences in conception and style of Nicola's narrative panels. The figures, when upright, occupy more or less the full height of the relief and stand convincingly in front of one another in several planes; a spatial environment is suggested by motifs such as the horses' necks curving into the scene of the Adoration [3] from the left, or the glimpses of landscape behind the Annunciation. The folds of drapery, far from forming mere patterns, demonstrate the positions and movements of the limbs beneath and emphasize the rational proportions of the body. Above all, the facial expressions and gestures are thought out as parts of a coherent, imaginative reconstruction of a real scene. Typical of Nicola's feeling for psychological realism are the concentration and deep emotion shown in the gaze of the kneeling king as he presents his gift, and the attention of the Christ Child as He receives it.

13

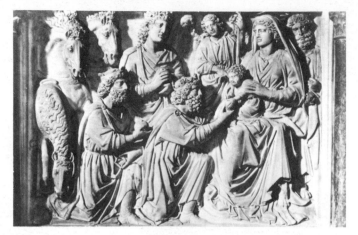

3. Adoration of the Magi. Nicola Pisano

One of the angle figures in the zone below the reliefs, a nude male representing the Christian virtue of Fortitude [5], provides a clue to Nicola's source of inspiration: ancient Roman sculpture. Happily, there has survived in the Camposanto at Pisa a sarcophagus [4] depicting the legend of the Greek heroine Phaedra, which Nicola must have known. The particular stance of his Fortitude reflects in reverse that of the man standing near the left end of the sarcophagus. The weight is borne on one leg and the hip projects to one side, while the relaxed leg is bent forward at the knee and the shoulders are set

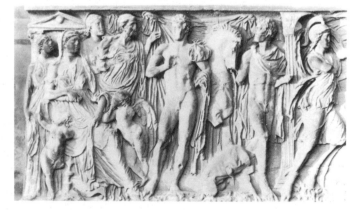

4. Phaedra Sarcophagus (detail: left end)

5. Fortitude. Nicola Pisano

on a plane at an angle to that of the pelvis. This pose had been evolved by Greek sculptors of the fifth century B.C. and had survived with infinite variations throughout the history of classical art. Subsequently taken up by artists of the Renaissance, it became known as *contrapposto*, owing to the tensions that it set up within a human frame, the asymmetry of the separate limbs being reconciled in an overall balance and harmony.

Nicola borrowed other motifs from the Phaedra sarcophagus, for instance the seated female whom he transformed into the Virgin for his Adoration panel, once again in reverse. It is noticeable, however, that the slightly squat proportions of his figures, their broad, impassive faces and heavy folds of drapery resemble Roman sculpture of a later period, when these very features characterized a decadence from the earlier classical ideal, as found on the Phaedra sarcophagus. Nicola's taste was no doubt conditioned by the Romanesque style to which he was accustomed, as well as by observation of Early-Christian reliefs, embodying a debased canon of proportion, which were not as yet distinguished from work in the true classical style of Graeco-Roman art.

Presumably in recognition of the success of the Pisa pulpit, Nicola was commissioned some five years later (1265) to carve one for Siena cathedral [6]. Though similar in design, the second pulpit was far more ambitious, its octagonal shape providing two more panels for relief and the quantity of sculpture being increased by the substitution of figures at the angles of the relief zone instead of clusters of columns. The number of participants in the narrative panels was also drastically increased and this necessitated a reduction in their scale. Though the drama of the scenes is enhanced, the narrative is less lucidly conveyed. Traces of paint have, however, been discovered on the background and drapery and the use of colour no doubt improved the legibility of the crowded scenes. Serried rows of figures set above one another to suggest spatial recession, yet with all the heads projecting forwards to the original surface of the slab of marble from which the relief had been carved, herald a new method of composition, again probably learned from Roman sarcophagi. The increased consciousness of a surface plane lends to the panels a new unity, which replaces the stately linking of the figures in a frieze-like, linear pattern that had held together the compositions of the Pisan series.

There is a significant change not only in the method of carving but also in the style of individual figures. The squat

6. Crucifixion. Nicola Pisano

shapes and comparatively bland expressions of the Pisa pulpit have given way to far more lithe and graceful proportions, to increased confidence in depicting the human body from any angle and in violent movement and to a careful rendering of facial expression. This permits us to interpret the reactions of each individual to the events in which he is participating. Nicola shows himself to be a master not only of lively characterization but of sustained dramatic tension in the grouping and visual counterpointing of the figures in his crowd scenes, witness the Massacre of the Innocents or the Crucifixion [6].

The change in the type of figure is emphasized by a completely altered style of drapery, which now falls in naturalistic and graceful loops instead of in the heavy, angular folds of Pisa. These innovations probably reflect the influence of northern Gothic sculpture from the great cathedrals not only of France but also of Germany. Quite how this influence came about is uncertain, though it may be due to Giovanni, Nicola's son, who was assisting him in carving the pulpit, as we know from payments made to him in 1267–8. Another important assistant was a Florentine, Arnolfo di Cambio, who was later to introduce his own variation of Nicola's style into his native city about 1300.

Nicola's next major project was a large public fountain for Perugia, a town in Umbria, well to the south-east of Tuscany. It was completed in 1278, some ten years after the Siena pulpit,

again with the assistance of Giovanni. Though it is difficult to distinguish the respective contributions of father and son, one pair of reliefs is signed by Giovanni, and several of the angle figures closely resemble his later independent work.

In his last years, Nicola returned to Pisa and worked on a series of massive half-length figures designed for the outside of the Baptistry, the scene of his early activity. It appears that he had died by 1298.

Nicola's early attention to Roman prototypes perhaps reflected an ambitious and perceptive extension of Romanesque practice rather than a conscious desire to revive the style of classical sculpture. Possibly for lack of an intellectual stimulus, such as motivated the Renaissance when it ultimately occurred a century and a half later, Nicola's classicism was gradually supplanted by a Gothic style in his later sculpture. Nevertheless, his art constituted a break with the symbolism of the Romanesque style. His attention to realism in the appearance and characterization of his figures, whether it was achieved by using classical models or Gothic ones, suggested a radically new attitude to sculpture which was to culminate eventually in the High Renaissance.

Giovanni Pisano's first independent work seems to have been a splendid series of over life-size marble statues of Prophets and Sibyls for the façade of Siena Cathedral. He may even have designed the façade, judging from the prominence which the sculpture on it enjoys, in contrast to normal Tuscan practice. The statues are not connected with the portals, as they would have been in a French scheme, but are set in shallow niches high above the ground, at the level where the portal arches spring. To ensure proper visibility, the designs had to be simple and the drapery and facial features boldly modelled. Giovanni responded well to both these requirements and a head such as that of Haggai [7] shows how effectively he used deep undercutting of the marble by means of a drill to produce troughs of shadow which set off the highlights. Here he is applying Nicola's understanding of psychology and his control of movement and drama on a monumental scale. Seen at eye-level, the necks look unnaturally long and the heads jut forward awkwardly, but these distortions must have been calculated to counteract the effects of the foreshortening that was implicit in the intended position of the series, high on the Cathedral façade.

By a bold stroke of imagination Giovanni put this device of deliberate distortion to use in the relief scenes of his next

7. Haggai. Giovanni Pisano

commission, not for optical reasons, but in order to emphasize rapid or strenuous movement and intense depths of emotion. This commission was yet another pulpit, destined for Sant'Andrea, Pistoia, though actually carved at Pisa. Giovanni returned to the hexagonal plan of Nicola's first pulpit, but carved the reliefs in a style closely related to that of the Siena pulpit, on which he had worked as an assistant. The figures were distributed over the surface area to suggest recession in space, but were all excavated to a uniform depth of relief. The figure style was closely related to that of the statues on the façade of Siena Cathedral and the bold distortion of anatomical forms give a most exciting feeling of drama. In the scene of the Nativity [8], this can be felt in the head of the angel, jutting swiftly and eagerly forward in the Annunciation group at the left, or in the effortful bending of the Virgin towards the Christ Child in the manger. The figures which separate the relief panels at the corners occupy a position analogous to that of the statues at Siena, and, like them, are interesting from several different angles because of the sharp twists in their postures.

The pulpit for Pistoia seems to have been executed about

8. Nativity. Giovanni Pisano

9. Virtues. Giovanni Pisano

1297, and in 1302 the authorities of Pisa commissioned Giovanni Pisano to carve one more for the Cathedral. This fourth variation on the theme of the pulpit may have been something of an embarrassment to the sculptor, at least as far as the reliefs were concerned, since those for Pistoia were so fresh in his mind. For the most part, they represent simplifications of the earlier compositions, and sacrifice much of their flow and energy, perhaps in an attempt to compromise with the style of his father's early pulpit which was so close at hand in the Baptistry. The second Pisa pulpit is, however, the most ambitious of the whole series in its figure sculpture. A return to the larger size of Nicola's Siena pulpit, with eight sides, and the greater use of caryatid figures instead of plain columns as supports, permitted a far wider range of subject and treatment. These figures are larger in scale than any previously employed on the pulpits and are almost free-standing. They are arranged in two tiers, Prudence and Fortitude [9] forming the lower part of one support. The nude figure representing Prudence demonstrates Giovanni's interest in the classical nude, being given a pose close to that of the 'Venus Pudica' of antique sculpture.

There are later sculptures by Giovanni Pisano, a series of the Virgin and Child and a series of Crucifixes, but they do not add substantially to our knowledge of his style and its sources. He died between 1314 and 1319.

II. FOURTEENTH-CENTURY SCULPTURE AT FLORENCE:
ARNOLFO DI CAMBIO; TINO DI CAMAINO; ANDREA
PISANO; ANDREA ORCAGNA

The careers of Nicola and Giovanni Pisano scarcely impinged upon Florence at all and it was through Nicola's principal assistant on the Siena pulpit, Arnolfo di Cambio, that a variant of their style was brought to Florence in the closing years of the thirteenth century. Arnolfo's connection with the Siena workshop dated from 1265, but the first evidence of his independent style is to be found on the Shrine of St Dominic at Bologna. The design, with a rectangular sarcophagus supported on caryatid figures [10] and decorated with reliefs, may have been planned by Nicola, but the individual compositions do not reflect his sculptural thinking. The scenes that are probably by Arnolfo show a more static, frieze-like method of composition applied to figures of marked solidity and rotundity, with an almost complete absence of any suggestion of movement or drama.

10. Archangel (detail). Arnolfo di Cambio

During the 1270's Arnolfo was occupied at Rome and Perugia and his style seems to have crystallized. Soon after the death of Cardinal de Braye (1282), he was commissioned to execute a tomb for him at Orvieto. The original arrangement has been destroyed, but an attempt at reconstruction shows how all the figures on the tomb were related to each other by narrative action as well as by framing elements that have been lost. An effigy of the Cardinal rests on a draped bier and flanking figures are shown in the act of drawing the curtains in from each side, as though to conceal the corpse from us [11]. Above, two saints are seen presenting the kneeling Cardinal to the Virgin and Child, who crown the design. The sense of purposeful activity that motivates the figures is convincing but their movements lack the urgency of Giovanni Pisano's compositions.

11. Acolyte. Arnolfo di Cambio

12. Virgin of the Nativity. Arnolfo di Cambio

After a period of activity at Rome, where he erected two large *ciboria* (architectural canopies), Arnolfo was awarded a commission for the design of the façade of Florence Cathedral (1296): this design, in so far as it was actually executed, is known from a sixteenth-century drawing. Lunettes over the side doors contained figures of the Virgin of the Nativity [12] and the Dormition both featuring large, recumbent statues of great grandeur and remarkable simplicity, while over the central door was a seated Virgin and Child, flanked by saints. The bold blocking out of forms and clear definition of the folds of drapery were necessitated by the destination of these figures well above eye-level on the façade, while the austere monumentality and restraint of their poses is totally unlike the gracefulness and movement of contemporary figures by Giovanni Pisano.

Thus Arnolfo, who died in 1302, introduced into Florence a very personal interpretation of the early style of Nicola Pisano, which did not take into account the subsequent development by Giovanni of means to express movement, drama or deep emotion. This should not imply that the obvious seriousness and emotional sincerity of Arnolfo's boldly simplified figures are in any sense retrogressive: in some respects they are closer to the native sculptural traditions of Italy than are the highly individual, carefully characterized figures of Giovanni, which rely so heavily on northern Gothic ideas for their expressiveness.

A feeling for solidity and generalized sculptural forms marked the work of another sculptor who had been trained in the Pisan school, Tino di Camaino. Born about 1285 at Siena, Tino spent the early part of his career there and at Pisa, apparently specializing in sepulchral monuments, before coming briefly to Florence in about 1321. The most original and significant part of the monument which he carved in that year for Bishop Antonio Orso is the seated statue of the deceased [13] which is still in the Cathedral. The massive forms of hands and face catch one's attention as they protrude from the shadowy cavities of the embroidered sleeves and collar of the Bishop's garment. The chin, cheekbones and brows and the hard lines of the closed eyes and mouth form a deeply moving image of a human face reduced to its bare essentials and, as it were, divested of all significance as an individual by the process of death. After being employed on two other tombs, Tino was summoned to Naples in 1323. He played no further part in the story of sculpture at Florence, but the monuments that he carved during his brief sojourn are among the most powerful images of the fourteenth century.

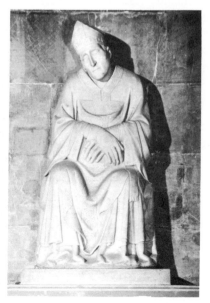

13. Monument to Bishop Orso
(detail). Tino di Camaino

Not long after Tino's departure, about 1329, a project to sponsor the pair of bronze doors for the Baptistry, possibly in emulation of the Romanesque ones by Bonannus at Pisa Cathedral, finally materialized and the Guild of Cloth Importers, which was responsible for works at the Baptistry, selected Andrea da Pontedera to design them [14]. Nothing is known of Andrea's training or background, except that he was named 'Pisano' from his place of origin, although he was not a member of the same family as Nicola and Giovanni. From the technical expertise of the bronze doors it is apparent that he must have been a mature artist by 1330, while the character of the reliefs suggests that he was trained as a goldsmith, presumably at Pisa. Each leaf of the door has fourteen panels set in a frame and each panel has a gilt bronze scene in relief set in a quadrilobe mount [15]. The subject of the series is the life of St John the Baptist, the patron saint of Florence to whom the Baptistry was dedicated. The quadrilobe design of the mounts recalls northern Gothic prototypes and the high degree of finish obtained by chasing the bronze with the chisel is reminiscent of the work of French goldsmiths.

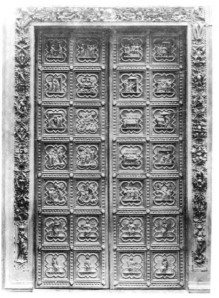

14. South Doors, Baptistry.
Andrea Pisano

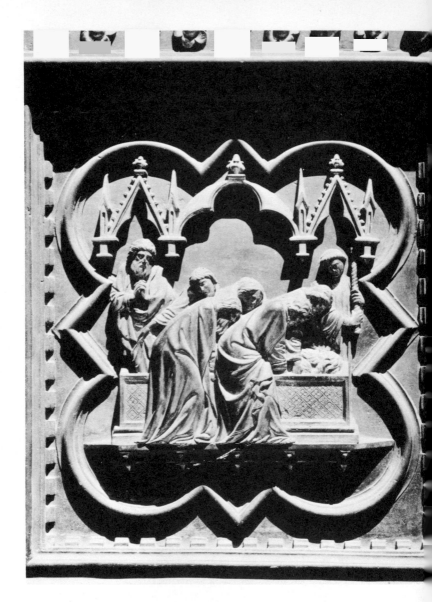

15. Burial of St John the Baptist. Andrea Pisano

The economy of means with which the episodes are narrated, with a limited number of figures and sparse details of setting, is unlike the crowding of reliefs by the Pisani. Possibly it reflects a study of Arnolfo's and Tino's sculpture and, perhaps more important, of the recent frescoes by Giotto in the Peruzzi Chapel in Santa Croce. Another readily available pictorial source was the great cycle of mosaics inside the dome of the Baptistry which had only recently been finished.

The use of the decorative quadrilobes disposed of the need to construct a convincing pictorial space for each scene, such as Giotto's frescoes have. Instead, Andrea introduced only an occasional stage-property: a curtain without any visible support; a doorway without a building; a Gothic canopy without columns. The graceful fall of drapery in looping folds gives the figures greater elegance than those in Giotto's frescoes and points to Andrea's French sources of inspiration. The compositions are, however, far from being purely decorative in effect and the tiny figures have a dignity and grandeur in their slow and purposeful movements that are reminiscent of Roman funerary art and have the same sense of monumentality.

The connection with Giotto that had been implicit in the reliefs for the Baptistry doors, which were completed by 1336, became explicit in Andrea's next commission. This was a series of carved reliefs to decorate the lower storeys of Giotto's Campanile. There has always been some dispute over which artist was responsible for the designs of the first few reliefs, as two early sources ascribe them to Giotto. In view of the collaborative nature of most mediaeval, and indeed Renaissance, architectural and sculptural undertakings, it seems reasonable to admit the probable influence of Giotto on the earliest compositions. Andrea, however, took control of the whole project on Giotto's death in 1337 and probably designed the remainder.

The series is devoted first to selected episodes from Genesis and then to famous practitioners of the arts and sciences. Among the latter are some fascinating and amusing genre scenes, such as that showing Phidias at work, in the guise of a medieval sculptor with the perennial tools of the trade: hammer, chisel and drill [16]. Other panels show crafts such as weaving and sciences such as astronomy and navigation, while Icarus with his wax wings optimistically personifies the art of flight. Andrea also carved some large, marble figures for niches on the Campanile and they reflect the same sincerity of mood and elegance of style as the figures in his reliefs. He left Florence in

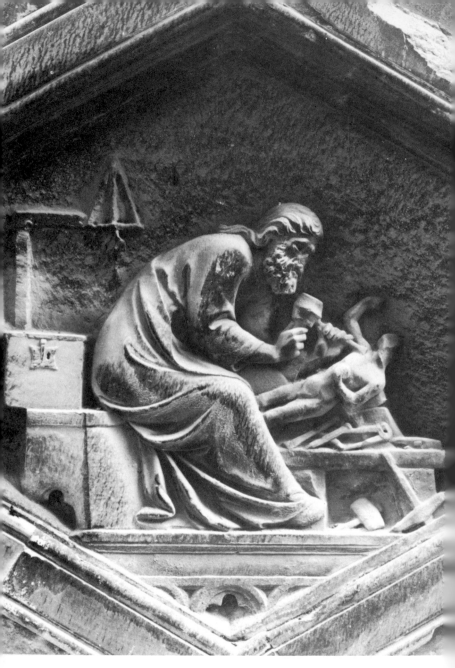

16. The sculptor. Andrea Pisano

1343, going to Pisa and then to Orvieto, where he was appointed overseer of works at the Cathedral. He died in 1349, probably a victim of the Black Death.

Andrea's departure from Florence may have been precipitated by the economic crisis of the 1340's, which was exemplified by the failure of the Peruzzi bank in 1343, while the plague of 1348 decimated the population and undermined the stability of an economy that had been based on agriculture. Money for financing expensive artistic undertakings involving sculpture became scarce and the only remaining project of importance in the middle of the century seems to have been commissioned as a thank-offering for the passing of the Black Death.

This was a tabernacle in the Guild Hall of Florence, Or San Michele. It was the only important complex of sculpture by Andrea Orcagna, who had matriculated in the Guild of Stonemasons in 1352 and had been appointed as overseer of Or San Michele in 1355. The elaborate and unorthodox architecture of the tabernacle was designed to frame an earlier painting of the Virgin by Daddi, which was considered to have miraculous powers and was accordingly the centre of an important cult in Florence. The tabernacle is covered with sculptural details of high quality and decorative marble inlay and mosaic. Simple reliefs in a Gothic style which depict the life of the Virgin are set round the front and sides of the altar, while on the back, facing the street through an open arch, is an enormous relief of the Burial and Assumption of the Virgin [17]. The dual nature of the subject is reflected, rather unfortunately, in the separation of the relief into two distinct registers by a horizontal band of strangely stylized rocks. Below, an attempt is made to suggest a three-dimensional space, with a group of apostles gathered round a sarcophagus, while above is seen the hieratic figure of the Virgin in a symbolic *mandorla*, surrounded by flying angels and set off against a decorated background. The design as a whole seems strangely unco-ordinated and lacks the logic of a clear and unified narrative. In the group of apostles, one of whom embraces the Virgin's hand in a motif plainly derived from the analogous scene by Arnolfo on the cathedral façade, the dramatic tension that a Giovanni Pisano or a Giotto would have achieved is distressingly absent. Orcagna's figures are not clearly characterized or convincingly animated in their grief.

Orcagna was involved in architectural projects for the rest of his career and died in 1368. Large-scale sculpture was, perhaps for the economic reasons outlined above, almost entirely

abandoned at Florence until a revival of interest that took place in the last decade of the fourteenth century. This found expression principally in the sculptural decoration of the Porta della Mandorla on the north side of Florence Cathedral, where the tentative introduction of motifs derived from classical art into an otherwise Gothic scheme heralded the coming of the Renaissance.

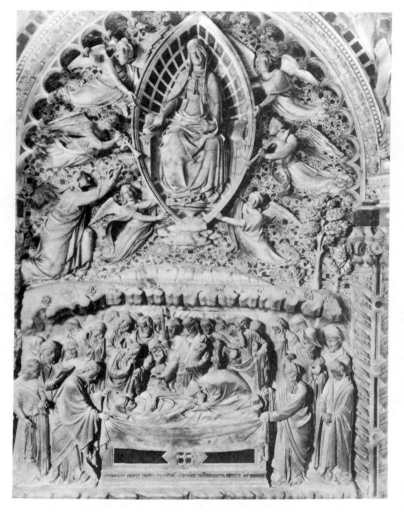

17. Burial and Assumption of the Virgin. Andrea Orcagna

3

From Gothic to Renaissance

I. RELIEF STYLE: GHIBERTI; BRUNELLESCHI; JACOPO DELLA
 QUERCIA; DONATELLO

The competition held at Florence by the Guild of Cloth Im-
porters, with the aim of selecting an artist capable of making a
second pair of bronze doors for the Baptistry to match those of
Andrea Pisano, was announced in the winter of 1400–1. This
was a period of intense patriotism in Florence, owing to the fact
that the city was under siege from the Milanese. Its inhabitants
had reason, however, to be thankful for the passing of a plague
which had broken out in 1400, while the very survival of man-
kind past the turn of the century was regarded by some as mira-
culous. The Cloth Importers may have been prompted to
sponsor a further pair of bronze doors at this juncture by these
political, social and religious pressures, but sheer rivalry with
the Wool Merchants, who were financing the decoration of the
Porta della Mandorla of the Cathedral, no doubt played some
part in their decision.

 The idea of holding an open competition in which artists were
invited to submit test pieces, all depicting an identical subject
(in this case the Old Testament story of the Sacrifice of Isaac),
was unusual. It is best interpreted as a sign of a new, business-
like approach to art patronage on the part of the guild, as though
tenders were being invited for some commercial contract. The
prominent position of the Baptistry and the high standard that
had been set by the Pisano doors, as well as the great expense
that the project was likely to entail, suggested the need for
caution in selecting its executant. Bronze founding was a
difficult and risky technique, and the sculptural workshops that
existed in Florence specialized in marble carving. In the event,
seven contestants were short-listed, of whom the two best were
goldsmiths, not sculptors proper, and thus specialists in a tech-
nique which was closely related to bronze founding. There
seems to have been a lengthy dispute over the artistic merits of
the trial reliefs submitted by these two goldsmiths, but finally
the young and virtually unknown Ghiberti triumphed by a
narrow majority over Brunelleschi, who was far more ex-
perienced and already renowned. The final, surprising decision,

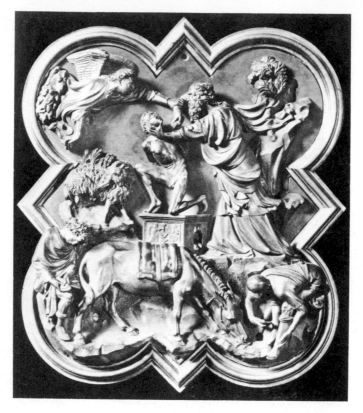

18. Sacrifice of Isaac. Brunelleschi

which represented a victory for the progressive over the re-
actionary forces in Florentine taste, was reached only in 1403,
possibly owing to the protracted siege, which was not raised
until after the death of the Duke of Milan in September, 1402.

The contrast between the trial reliefs of Ghiberti and
Brunelleschi [19, 18], which have been preserved in Florence
to this day, is striking and yet the difference in their artistic
intentions is hard to define. There is no question of a simple
opposition between an outmoded Gothic style and a radically
new Renaissance one. It is rather that two distinct variations
from the Gothic are involved, both new in their way, but
Brunelleschi's stressing a dramatic and realistic interpretation
and Ghiberti's a more suave and graceful development. Classical
motifs appear in both reliefs and do not therefore provide con-

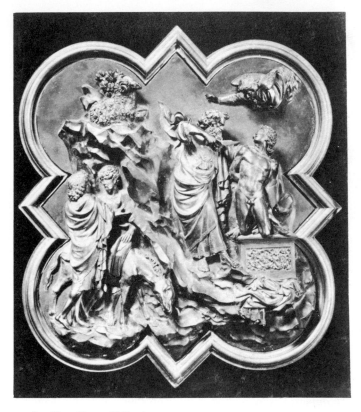

19. Sacrifice of Isaac. Ghiberti

clusive grounds for distinguishing between the two styles. The
use made of them by each artist is, however, rather different:
Brunelleschi introduced the classical pose of the *Spinario* (a
seated boy picking a thorn from his foot) in one of his attend-
ants, but was forced for narrative reasons to show him clothed,
instead of nude as in the original. Ghiberti used a nude torso for
his Isaac, and if anything improved on the beauty of his model,
catching something of the spirit of idealism that had been so
fundamental to classical art, and not merely copying an
attractive pose. The piecemeal adaptation of such single motifs
had been characteristic of the art of the last decade of the four-
teenth century, as exemplified in the carvings on the Porta della
Mandorla, the most notable being a fine, muscular figure of
Hercules [34].

35

Brunelleschi's panel is the less unified and less plastic of the two, partly owing to his use of an old-fashioned technique, which dated back past Andrea Pisano to the Middle Ages, and involved casting the figures and other elements separately and pinning them to a solid back plate. This technique and the disjointed figure style are similar to Brunelleschi's work on a silver altar for San Jacopo, Pistoia, on which he had been employed in 1400 immediately before the competition. His relief is in fact the more dramatic, with the angel actually intervening to prevent the act of sacrifice: an atmosphere of violence is suggested by the diametrically opposed movements of the protagonists and the sharp profiles of their faces and bodies. Where the panel is most deficient by comparison with Ghiberti's is in the lack of unity in the overall composition. The stipulated number of figures is distributed painstakingly all over the surface area, but there is little sense of depth or of a real narrative scene.

Ghiberti's panel was cast in one piece, except for the little figure of Isaac, which was made separately, finished perfectly and then keyed on to the relief. This represented a considerable economy in metal, apart from permitting a more fluid and unified sculptural approach. Both the technical superiority and the greater clarity of Ghiberti's panel must have helped to sway the jury in his favour, despite his youth and lack of professional experience, and against the proven ability of the older artist, who had probably been regarded as the favourite among the competitors.

Ghiberti's composition is built up round a strong diagonal formed by a rocky landscape. This he used to separate the main episode of the sacrifice from the subsidiary scene of attendants and donkey, which is given such undue and tiresome prominence in Brunelleschi's more prosaic and symmetrical design. The graceful, echoing curves of the turning bodies of Abraham and Isaac are less suggestive of violence but far better integrated as a composition than Brunelleschi's equivalent figures, while the pair of servants conversing quietly across the back of the donkey form a second unified group that echoes and balances the other visually. Ghiberti's vision of the miracle is, in short, far more poetic than Brunelleschi's mundane narrative.

In his later writings, Ghiberti was careful to emphasize the origins of his style in the work of a certain Master Gusmin, a goldsmith from Cologne, who worked for Louis of Anjou. In particular, he claimed to owe to Gusmin the precision of his workmanship, the conviction of his heads and nude bodies, and

the general air of sweetness and poetry. Although nothing has survived by Gusmin's hand, there is a strong connection between the style of the trial relief and that of French goldsmiths of the late fourteenth century, whereas Brunelleschi's style is based on the tradition of native Florentine work.

Before Ghiberti began work on the doors, the programme was changed to a cycle of New Testament subjects, such that the competition panel itself remained unused. In the two lowest rows of panels the Evangelists and Fathers of the Church were shown, corresponding in position to the Virtues of Pisano's doors. In the absence of documents, the individual reliefs can be dated only on the evidence of narrative order and style. A new contract of 1407 suggests that Ghiberti had fallen behind with the work, but most of the compositions had been designed by 1416. The last few, however, together with the series of heads of prophets in the frame, seem to be parallel in style to Ghiberti's statue of St Matthew, which dates from 1419. The idea of partially gilding the reliefs was decided upon in 1423 and the doors were finally hung in the following year.

Typical of the earliest reliefs is the Baptism of Christ [20], where the opposing curves of St John the Baptist and the group of angels, clad in flowing robes, form an oval frame about the sinuous, half-naked figure of Christ, who stands in the River Jordan in the act of benediction, the sway of His body subtly counterpointing the poses of the other figures.

Soon after, about 1410–12, the highly decorative, linear elements of Ghiberti's style became even more markedly em-

20. Baptism of Christ. Ghiberti

phatic, as in the panel of St John the Evangelist [21]: there, the superb realism of the pose of deep concentration is rendered poetic by the rhythmic lines of drapery looping from limb to limb in a fashion that is typical of the International Gothic style current in contemporary painting. In the narrative panels of this period Ghiberti achieved complete compositional fluency and even succeeded in turning to his advantage the awkward shape of the quadrilobe mounts that frame each design. The panels that were probably designed last tend towards static and symmetrical compositions that are no longer based on the same system of dynamic curves as the earlier designs. Of these, the Resurrection [22] is a good example, with its trees and groups of sleeping guards arranged symmetrically about the Risen Christ, who is at the apex of a compositional triangle.

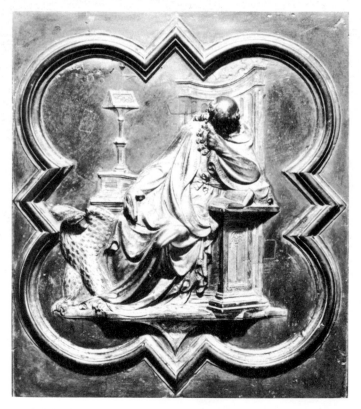

21. St John the Evangelist. Ghiberti

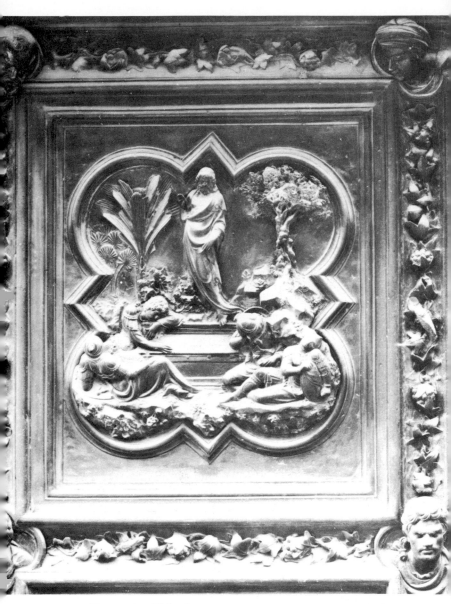

22. Resurrection. Ghiberti

The frames which contain the twenty-eight reliefs are decorated with a running frieze of foliage. This is punctuated at each intersection with a quatrefoil compartment out of which projects the idealized head of a prophet in high relief, each differently characterized. The outer jambs of the doorway are decorated with a similar, though more elaborate, frieze with flowers, plants and even perching birds, every detail showing Ghiberti's powers of observation, his love of nature and the deep artistic response that it evoked.

The execution of the North doors of the Baptistry occupied the first half of Ghiberti's career and their success was so great that in 1425 the Cloth Importers' Guild commissioned a further pair. These, the so-called Gates of Paradise, proved to be his masterpiece, and took him the rest of his active life to produce, reaching completion in 1452, only three years before his death (see p. 49). By the time Ghiberti began to work on that set of doors, however, there had emerged in the field of relief sculpture several considerable artists, who had an undoubted effect on his style. It seems advisable therefore to take stock of the situation in the first decade of the fifteenth century and to follow the careers of Jacopo della Quercia and Donatello up to the point when they came into conflict with Ghiberti on an important commission of the 1420's, the font in the Baptistry at Siena.

Jacopo della Quercia was one of the unsuccessful participants in the competition of 1401, and a Sienese citizen at the time. Little is known of his origins, except that he must have been born about 1374 at Siena and was the son of a mediocre painter and goldsmith. His father moved to Lucca (1394) to work at the court of the rulers of that town, the Guinigi family, and it was for them that Jacopo executed his first generally accepted work, well after the date of the competition. This was a tomb for Ilaria del Carretto, wife of the ruler, who died in 1405 [23]. The original arrangement of the tomb was destroyed soon after, but a beautiful effigy and a fine sarcophagus decorated with a frieze of cherubs holding swags of flowers have survived. These may well have been integrated into an architectural setting with a canopy, as was customary. Although the effigy is Gothic in style, the cherubs are probably based on a Roman sarcophagus still at Pisa, which Jacopo could have known. An admission of classical elements into an otherwise Gothic scheme is typical of the period and may have featured in Jacopo's trial relief for the Florentine competition as it had in those of Ghiberti and Brunelleschi. The carving of the marble is of superb quality and

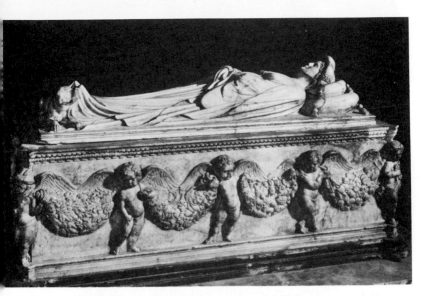

23. Monument to Ilaria del Carretto. Jacopo della Quercia

the delicate, serene features of Ilaria, set off against the elegant folds of her wedding attire, make one of the most charming and memorable sculptures of this transitional period, when the ideal of beauty was so perfectly poised between the conflicting demands of Gothic and classical art.

Jacopo did not move further towards a revival of Roman style for some time, but as in the case of Ghiberti, he was strongly influenced by the current trend in taste towards the ultra-sophistication of International Gothic. His response to this fashion can be felt in an increasing sinuousness and plasticity in the heavy folds of drapery that envelop his figures, from a Virgin and Child of 1408 at Ferrara and the sculptures that decorated the *Fonte Gaia* (or public fountain) in the Campo at Siena to the figures in deep relief on an altar of the Trenta family at Lucca [24]. The sculptural effect of these figures is highly individual: in the nudes of the *Fonte Gaia* there is a distinct consciousness of volume in the full, plump forms and an expressive control of anatomy in movement, which seem to be derived from Roman sources. In the figures of the Trenta altar, the proportions of the body are conspicuously elongated, in conformity with the tall, narrow niches in which the sculptures are set, and the drapery convention is carried to an extreme of

41

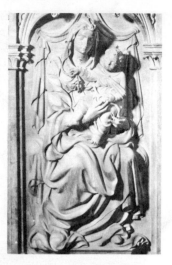

24. Virgin and Child.
Jacopo della Quercia

stylization reminiscent of Ghiberti's without having quite the
same effect. In a statue such as the St John the Baptist [39],
Ghiberti stressed an incisive feeling of linearity and a certain
logic in the fall of drapery, both of which are lacking in the
plastic confusion of Jacopo's tumbling masses of folds. Even
more important, Jacopo's faces are bland and inexpressive by
comparison with the overt, emotional appeal that lies in the
hypnotically intense stare of Ghiberti's St John.

In the small, narrative reliefs of the predella of the Trenta
altar, for instance in the scene of the Martyrdom of St Lawrence,
Jacopo again emphasized the muscularity and plasticity of the
nearly nude figures and showed them performing deliberately
brutish and highly realistic movements quite out of keeping
with International Gothic sentiment, and in a manner not un-
like that of a young marble sculptor of Florence whom we have
not yet mentioned, Donatello. Jacopo's interest in Donatello
can best be appreciated by comparing the bronze reliefs which
they both executed in the 1420's for the marble font in the
Siena Baptistry. Ghiberti, who had been called in to advise the
authorities in 1416, was presumably responsible for the novel
idea of using bronze reliefs to decorate the sides of the hexagonal
basin, as he was a specialist in this medium. He executed two
of the reliefs himself, though not until 1425–27; two were com-
missioned from a local family of goldsmiths, the Turini; and
two were allocated to Jacopo, the most famous native sculptor.

However the latter was so dilatory that in 1423 one of his reliefs was offered instead to Donatello, who delivered it in 1427, some years before Jacopo's remaining panel. Thus on the font we have an opportunity of observing all three major sculptors of the early fifteenth century at close quarters.

Ghiberti's Baptism of Christ [25] is a variation on his earlier treatment of the theme on the Florentine doors [20]. On the larger scale of the Siena relief, Christ is made to stand out more dramatically against a plain, undefined background and the Baptist stands back, performing the ceremony with an unnaturally elongated arm that arches swiftly over Christ's head. Ghiberti's most striking innovation here is his use of increasingly subtle gradations of relief to suggest the recession into depths of the angels in the heavenly host. The main figures project forward in three dimensions, enacting the scene in real space, and not in the imaginary depth of the relief. Ghiberti again resorted to this device of bringing the action well into the foreground and using figures that are modelled almost in the round for his second panel, St John Preaching before Herod. An architectural vista forms a backdrop to this scene rather than giving an illusion of the depth within which the action is taking place.

Donatello's panel, the Feast of Herod (1423–7) [26], is by comparison astoundingly successful in creating an illusion of considerable spatial depth. The technique he invented of compressing the foreground figures into the thickness of the relief, instead of allowing them to project forward from it, as Ghiberti did, helps to render the transition between the real space of the foreground and the imaginary space of the architecture less abrupt. By a virtually correct use of the newly discovered device of linear perspective, Donatello constructed a convincing, stage-like space: the nearer section encloses the foreground scene of the banquet which has been interrupted by the horrific presentation of St John's head on a salver; and the further parts allude to earlier episodes in the story. The space and indeed the time of the main action are separated from the earlier scenes by a low wall, the cornice of which emphasizes the level of the heads in the foreground. The drama and horror of the story are brought out in centrifugal movements that leave the centre of the scene, normally the focus of attention, in a vacuum. The contorted faces and the gestures of the boldly foreshortened hands form the means with which Donatello attacked the elegant artificialities of the International Gothic style.

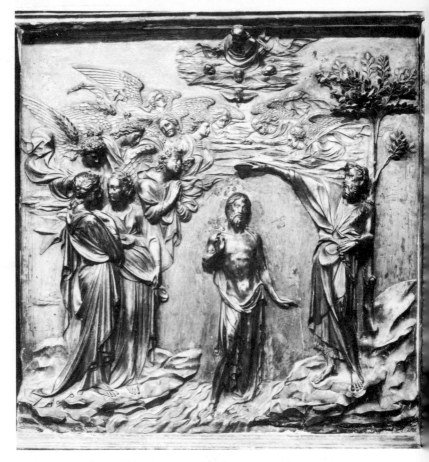

25. Baptism of Christ. Ghiberti

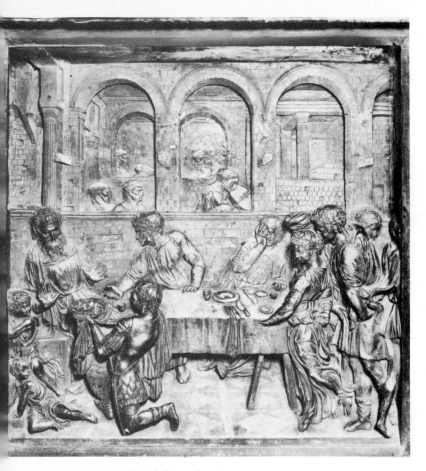

26. Feast of Herod. Donatello

27. Annunciation to Zacharias. Jacopo della Quercia

Owing to Jacopo's dilatoriness, his relief for the Font, the Annunciation to Zacharias [27], was designed after Donatello's. A debt to the Feast of Herod is apparent in the attempt to achieve an effect of space. Instead of penetrating the depths of the relief, however, Jacopo's architecture tends to push forward into the physical space occupied by the foreground group. It is not rationally constructed as in the Donatello, with the result that the surface of the altar does not appear to be flat and the relationship of Zacharias and the Angel to their setting is very insecure. The bulky masses of drapery give some impression of latent power in the forms beneath without allowing the articulation of the bodies to be clearly apprehended.

The same feeling of vigour characterizes the later work of Della Quercia outside Tuscany, at the Cathedral of San Petronio, Bologna. Between the 1420's and his death in 1438, he carved a splendid series of marble reliefs which flank the West door and depict scenes from Genesis, the Creation and the Fall of Man. Jacopo is at his most successful in the confined fields of these panels. The figures nearly fill the surface area with

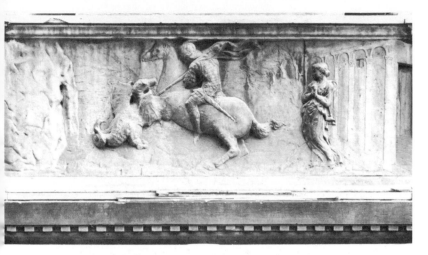

28. St George and the Dragon. Donatello

their strong, muscular bodies and heavy folds of drapery, but the emphasis is on their outlines and no attempt is made to suggest an extension of space behind them.

The Feast of Herod was Donatello's first relief in bronze, but not his first attempt at exploring the problems of spatial suggestion, for as early as 1415 he had carved a shallow marble panel to place under his statue of St George at Or San Michele. He managed to depict the story of St George and the Dragon [28] in a convincing space, while scarcely using the physical depths of the block. The third dimension is suggested by the converging lines of a colonnade at the right, which he constructed roughly in accordance with the newly discovered laws of linear perspective. Rows of trees diminishing in size continue the suggestion of space towards the background: they are barely scratched on the marble and become less distinct, as though seen through a haze. The crystalline surface refracts light strongly enough to suggest an internal illumination and an effect of atmosphere in the pictorial space in a subtle and highly evocative way.

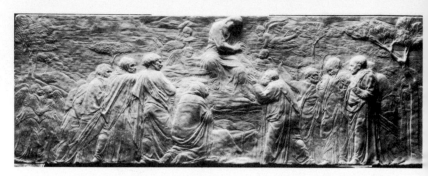

29. Christ Giving the Keys to St Peter. Donatello

 In another version of the Feast of Herod (Lille), which
Donatello carved in marble, he extended the use of linear per-
spective to build up a comprehensive and completely rational
setting for the scene, almost as Alberti was to recommend in his
treatise *On Painting*, published in 1436. Perhaps more striking
is a relief of Christ Giving the Keys to St Peter [29: Victoria
and Albert Museum]: there, serried ranks of figures which
diminish rapidly in scale are seen in foreshortening, as though
from below. The sculptor is now playing on the spectator's
acceptance of the conditions of linear perspective, without
needing to resort to an architectural setting to provide a frame-
work of lines. The diminution in size of the rows of hillocks and
trees in the background, combined with a near miraculous sug-
gestion of atmospheric perspective, completes the effect of
recession into space. The low viewpoint thrusts the nearest
figures dramatically forward, as though they were on the edge
of a stage, rather as in Masaccio's fresco of the Trinity with
Donors in Santa Maria Novella, which is a fundamental docu-
ment of the application of linear perspective in Renaissance
painting. That this connection with Masaccio is not accidental
is proved by the close relationship of the relief with the fresco
of the Tribute Money in the Brancacci Chapel, where the mass-
ing of the figures in solemn rows and the feeling for their
individual volumes build up a similar effect of monumentality.
 Two other marble reliefs, which date from just before and
just after 1430 respectively, correspond in style to Christ
Giving the Keys: these are the Assumption of the Virgin, which
is probably the only part of the Brancacci monument at Naples
that is by Donatello's hand (p. 71); and the Entombment of

48

Christ, which forms part of the tabernacle of the Holy Sacrament at St Peter's, Rome [54]. All three reliefs are characterized by squat, almost aggressive figures with ugly faces and clumsy hands; realistic poses, violent movements and wild gesticulations. These exciting innovations in the field of dramatic expression continued to haunt Donatello and became almost obsessive towards the end of his life. Although they have an immediate appeal to the modern spectator, they form only one aspect of his artistic character, which was so varied as to permit him to make an equally important contribution in the field of highly idealized, overtly beautiful and emotionally attractive subjects.

As we have seen, a contract with Ghiberti was drawn up by the Guild of Cloth Importers on 2nd January, 1425, for a third pair of doors for the Baptistry [30], to match the pair which had been completed and hung in 1424. A prominent humanist, Leonardo Bruni, suggested a cycle of Old Testament events to

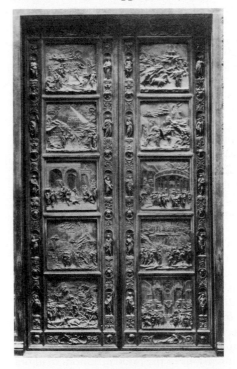

30. Gates of Paradise. Ghiberti

fill the twenty-eight panels which would be necessary to match the design of Andrea Pisano's and Ghiberti's earlier doors. For some years Ghiberti was busy with other projects, including the reliefs for the Siena font, and nothing seems to have been done until 1429. Then he began by casting the backs of the doors, and incorporated only twenty-four panels in the design. By the time that he turned his attention to the front, the number of panels was further reduced to ten, and work proceeded on that basis. All ten panels were cast and ready for chasing by 1436, which represents a fantastic achievement of organization in Ghiberti's workshop. Finishing the reliefs took ten years and the doors and frames were finally completed in 1452.

The reduction in the number of panels seems from his later autobiography to have been Ghiberti's own idea. On the other hand, by the use of a rather old-fashioned device known as continuous narration, whereby episodes of a story that are disparate in time and place are shown as though occurring simultaneously, he managed to include even more incidents than had been proposed in Bruni's scheme. Whereas Donatello's narrative reliefs were wide with low horizons, emphasizing the foreground action, Ghiberti's panels were square in proportions, and the ground appears to slope up towards the horizon as in a bird's-eye view. This gave him the opportunity to use the middle and backgrounds to the full and enabled him to distribute the episodes of his stories with such artistry that the chronological inconsistencies are never obtrusive. Perhaps the faint archaism of this system was in fact suited to the idealized vision of a biblical Golden Age that inspired the artist.

The ten panels of the Gates of Paradise repay intense examination for, apart from the sheer beauty of these celestial visions, there are many touches of closely observed detail that lend a feeling of authenticity to the scenes, besides reflecting possible interest in Donatello's contemporary activity. In the Creation panel [31], for instance, a little wooden fence separates the reclining Adam from the scene of the Expulsion in the right corner, while in the figure of Adam heaving himself laboriously from the ground as he is created there is a sense of monumentality and physical vigour, and his right hand is spread out in a claw-like position that is reminiscent of Donatello. In an episode on the next panel, Cain is shown in the act of cudgelling Abel to death, and the mechanics of the action are convincingly suggested by the muscular tensions of the body in a modern idiom that is quite unlike the artificial symbolism of the International

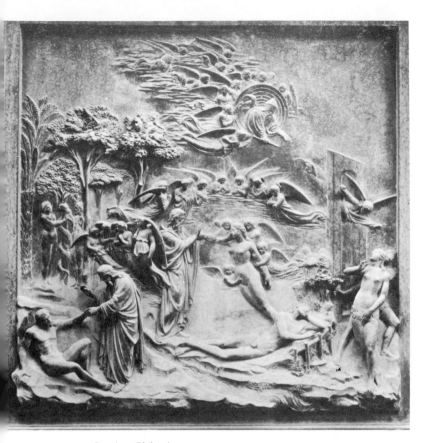

31. Creation. Ghiberti

Gothic style. In the Story of Noah, the ark, represented in accordance with medieval practice as a pyramidal shape, is drawn correctly in perspective, and a group of animals shows how nearly Ghiberti understood the principles of shallow relief, as invented by Donatello. The most convincing architectural perspective is that of the arched loggia which forms the setting for the Story of Jacob and Esau [32], while the most ambitious, though not entirely successful, one is the strange,

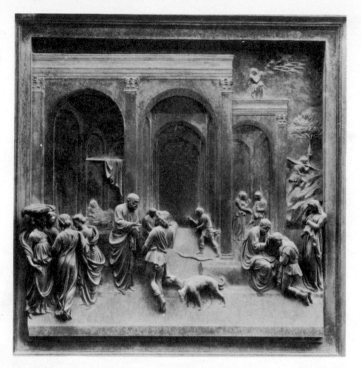

32. Jacob and Esau. Ghiberti

circular structure that is no doubt meant to convey some idea
of the fantastic opulence of the Egyptian court in which the
Story of Joseph is depicted. In both these panels, though more
markedly in the Story of Jacob and Esau, the main figures
scarcely penetrate the spacious architectural vistas and the
episodes take place all round, but not inside, the buildings.
Ghiberti was, however, a master of the small group in which the
psychological relationships of the figures one to another are
ably conveyed: to take only two examples, the concentration
and care with which God creates and raises Adam to his feet are
perfectly conveyed by the bowed head and earnest gaze of the
Creator; and the conflicting emotions are vividly suggested in
the scene where Jacob is receiving his father's blessing by
deception and the boy's mother stands nearby, a picture of
anxiety and guilt. The same keen intuition is shown in the self-
portrait head [33] which Ghiberti included in one of the roun-
dels that punctuate the frame of the doors: despite the tiny scale

33. Self Portrait. Ghiberti

of this portrait, one can almost feel the presence of the artist in the extremely shrewd and confident look, which also seems to betray a sense of humour.

The reliefs and figures in the frame became one of the standard texts to be consulted by aspiring artists throughout the Renaissance; Michelangelo himself dubbed the doors 'the Gates of Paradise' and later in the sixteenth century Cellini continued to derive inspiration from them.

After the year 1440, there is no trace of any further creative activity on Ghiberti's part, and he devoted himself to writing his *Commentarii*, which included a history of art, his own biography and theoretical treatises. He died in 1455, having been the acknowledged master of official sculpture in bronze for about half a century. Yet he was never so radical an innovator of ideas as Donatello.

II. FIGURE SCULPTURE: GHIBERTI; DONATELLO; NANNI DI BANCO

The long-established habit of taking the competition of 1401 as the starting point of the Renaissance has frequently given rise to a misleading impression that it took place in, as it were, a sculptural vacuum. This was far from the case, for the Guild of Wool Merchants had been adding to the sculptural decoration of the Cathedral since about 1391, the focus of attention being the Porta della Mandorla on the north side. The carving was contracted out by a master-sculptor to an extensive workshop in the normal way, and it is difficult to distinguish the respective

34. Fortitude. Porta della Mandorla

contributions of individuals. These tended to lie between opposite poles, on one hand of a revival of classical motifs, probably stimulated by the awakening of humanism among the patrons, and on the other of a fascination for the decorative excesses of the International Gothic style which was beginning to percolate into Florence from the north. A classical Hercules [34] and a nude female seen from behind are prominent among the motifs on the door-jamb, while the leafy scrollwork around them has begun to take on the form of the acanthus, as it appeared in Roman art.

After the excitement of the competition, a feeling of disenchantment seems to have spread through the art world at Florence. Presumably, it was occasioned by the novelty of the style of the trial reliefs and the disturbing fact that the winner was a young artist with little or no sculptural training. He had shown the style of the established sculptors who had entered the competition for the unimaginative repetition of stock motifs that it was. Soon after, the authorities of the Wool Guild deposed two successive master-sculptors from control of the Cathedral workshop on the grounds of their alleged incompetence, but the real cause for complaint lay no doubt in their old-fashioned styles. At about this time we first hear of the young Donatello, working as an assistant in Ghiberti's shop on the earlier set of doors. By 1406, however, he was carving a small marble Prophet for the Porta della Mandorla, and two years later he was commissioned for a figure of David as a crowning piece for a buttress near the Porta. A pendant figure of Isaiah was commissioned from Nanni di Banco, a young sculptor whose father had long been a member of the team working on

the Porta della Mandorla. These figures were life-size and free-standing, which was unusual in Tuscany where most statues were conceived within an architectural frame of some sort. Both were still distinctly Gothic in appearance and Nanni's Isaiah had the more classical head.

In 1408, the pair of young sculptors received commissions for two seated Evangelists which were destined to occupy niches flanking the west door of the Cathedral. In the design of his St John [35], Donatello seems to have taken into account the foreshortening that this setting, slightly above eye-level, would entail, for the upper part of the torso is disproportionately tall when the statue is seen on a level, but the forward projection of the knees disguises the exaggeration when the figure is seen from below. The sophistication of planning a statue for a particular viewpoint and deliberately distorting it to compensate for the eventual effects of foreshortening is typical of Donatello's rational attitude towards his art, and may reflect an appreciation of Giovanni Pisano's elementary use of the technique on his Prophets for the façade of Siena Cathedral (p. 18). Similarly, the neck demanded elongation for the head to be clearly visible from below, and this constituted a weakness in the composition of Nanni's St Luke [36]. Donatello overcame

35. St John the Evangelist. Donatello 36. St Luke. Nanni di Banco

this problem with the cunning device of a flowing beard, again as on some of the Siena Prophets, which disguised the awkward transition between shoulders and head. Nanni's Evangelist, with his arms akimbo and the rather imperious downward glance, which would have met the spectator's upward gaze when the statue was in its niche, suggests an active, extrovert personality. St John seems quiet and thoughtful, but there is nobility in his abstracted gaze and latent power in his relaxed hands. These, characteristically of Donatello, are enlarged in scale.

By comparison with these two extremely radical solutions to the problem of the seated figure, a companion piece by Niccolo di Pietro Lamberti, who had recently lost his position as master-sculptor at the Cathedral, seems very staid and unenterprising, its multitudinous folds of drapery looping repetitiously from limb to limb without creating movement. This did not go un-noticed, and he was paid less than the others when the statues were valued in 1415. His discomfiture had begun a few years earlier, when the Guild of Linen Drapers transferred to Donatello a commission for a standing St Mark which originally had been allotted to him. Not to be outdone, Lamberti left forthwith (1415) to make his career in Venice. This, then, was the point at which the novel style of the Renaissance gained general acceptance. Gothic was abandoned, except for its partial survival in the interpretation of Ghiberti, which allowed it a limited lease of life alongside a judicious admission of real-istic and classical elements.

The transfer of the commission for St Mark [37] to Donatello drew him into the other sculptural arena of Florence, the guild hall of Or San Michele. Here, a struggle for supremacy between styles and personalities was to be fought over the first quarter of the century. The idea of decorating the outside of the build-ing with statues in niches dated back to 1339, but only the Wool Merchants had actually commissioned a figure (a St Stephen, later replaced with one by Ghiberti). After the Black Death, attention had been focused on the tabernacle by Orcagna inside, but in 1406 an edict was passed by the governing body which threatened to confiscate any of the external niches that should remain unfilled after ten years had elapsed. This finally spurred the guilds into action and produced a spate of com-missions. The proximity of the niches one to another led to a feeling of competition between the guilds and the artists whom they employed, with the result that the sculpture of Or San

Michele provides a uniquely informative conspectus of the evolution of Renaissance style.

The earliest figures were still in the Gothic idiom of Lamberti, and his St Luke [38] is typical, with its swaying axis, looping drapery and entirely frontal, static composition. Donatello seized the opportunity that he was given in 1411 by the Linen Drapers to revise the conception of a standing figure as thoroughly as he had just revolutionized the seated one; in his St Mark he rethought the logic and the mechanics of the standing pose on the basis of his knowledge of classical models. The weight-bearing leg is differentiated by the vertical folds which hang in front of it, rather like the flutes of a column, and the free leg is covered with broad areas of cloth between the wrinkles of the mantle, one of which emphasizes the point at

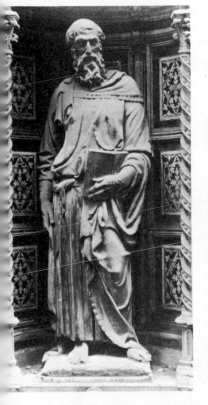

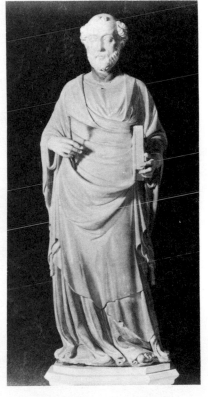

. St Mark. Donatello

38. St Luke. Niccolo di Pietro Lamberti

which the knee bends. Under the drapery of the torso the swelling shape of the chest is clearly visible. As with the St John, Donatello allowed for the height at which the figure was destined to stand by elongating the torso at the expense of the legs. The sixteenth-century art historian, Vasari, relates a tale which emphasizes that this was deliberate. The rather peculiar device of making the Saint stand on a cushion may have been introduced in order to suggest the weight of the figure by the visible pressure of the feet on the yielding surface. Had he stood on a solid surface, the weight could not, of course, have been demonstrated so tangibly.

Ghiberti entered the arena in 1412 with a figure of St John the Baptist [39], commissioned by the Cloth Importers, who were already employing his services for the Baptistry doors. The great novelty of this statue lay in its use of bronze, instead of the customary marble. A clause permitting the use of this medium had been inserted in the edict of 1406, perhaps on the instigation of the Cloth Importers, who may have anticipated the great advantage of being able to exploit the talents of Ghiberti, who was no marble sculptor. Stylistically the St John provides a complete contrast to the contemporary statues by Donatello and Nanni di Banco, in that it represents the epitome

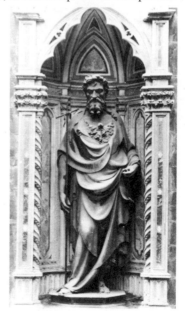

39. St John the Baptist. Ghiberti

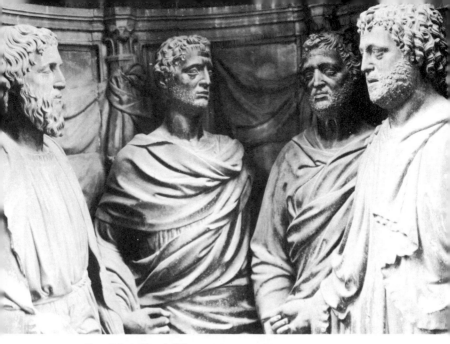

40. Four Saints. Nanni di Banco

of International Gothic sculpture. Highly fashionable though
it was, this style proved to be too linear for successful applica-
tion on a monumental scale, particularly when it was juxtaposed
to figures based on classical canons of style. Its elegant, swing-
ing drapery, which is almost completely independent of the
forms of the anatomy beneath, lacks the conviction of the severe
Roman togas of Nanni's Four Saints [40], who stand like a
semicircle of senators in their large niche nearby. Ghiberti's
stylization of the hair, beard and goat-skin, masterly and ener-
getic though it is, looks exaggerated and mannered by com-
parison with the neat and well-ordered appearance of the Four
Saints, who had all the moral weight of archaeological accuracy
to reinforce their claim on the attention of a spectator reared in
the traditions of the new humanism. Even though the St John
may soon have begun to seem dated in style, for long it re-
mained remarkable as a triumph of technique. No figure on its
scale had been cast in Florence before, and for some twenty
years this achievement was not equalled outside Ghiberti's
workshop.

If the Four Saints and his other figures at Or San Michele
showed Nanni di Banco in a thoroughly classicizing mood and

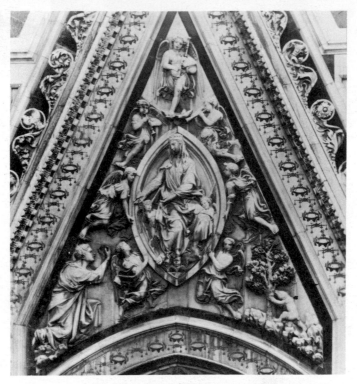

41. Assumption of the Virgin. Nanni di Banco

stylistically at loggerheads with Ghiberti, his most important later sculpture, a relief of the Assumption of the Virgin [41] on the gable of the Porta della Mandorla, shows him retreating from this severely archaeological style towards a distinctly Gothic manner, not unlike that of Jacopo della Quercia. He received the commission in 1414 and by his death in 1421 most of the figures had been carved. The pointed oval 'glory' (*mandorla* or almond, from which the door gets its name) is plainly inspired by Orcagna's Assumption of sixty years before [17]. Perhaps it was the influence of this model and of previous sculpture on the doorway that led Nanni to adopt a style which compromised with the Gothic, at least in the windswept folds of drapery that billow round the legs in calligraphic patterns [42]. Some of the heads however are classical in type and there is a reminiscence of the weight and plasticity of drapery that characterized his statues at Or San Michele.

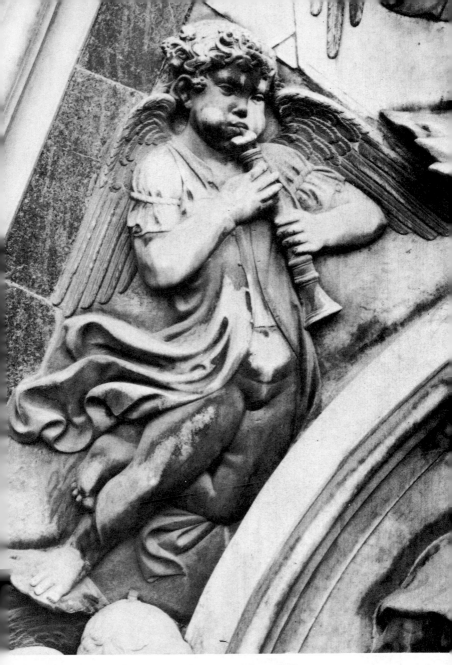

42. Angel (detail from the Assumption). Nanni di Banco

Donatello's answer to Ghiberti's decorative and costly bronze of St John the Baptist was another marble figure, a St George [43] for the Guild of Armourers, which possibly dates from 1415. Small holes suggest that he may once have been crowned with a metal wreath and held a sword or spear in his right hand, projecting rather sharply. The statue stands well forward in its niche, which for structural reasons is the shallowest of all, and so it has subsidiary views from each side. The stance, with the legs wide apart and the weight evenly distributed over the balls of the feet, is as vital to Donatello's character sketch as the slight frown of concentration which clouds the idealized features of the young knight. There is a greater quota of sheer realism and psychological understanding than in the earlier, more strictly classical, figures. Under the niche in which St George stands, Donatello carved his relief of St George and the Dragon discussed above [28]: the revolutionary suggestions of linear and atmospheric perspective in this relief and the high emotional charge of the statue above combined to make the niche of the Armourers the focus of all that was progressive in Florentine art when the complex was unveiled about 1420.

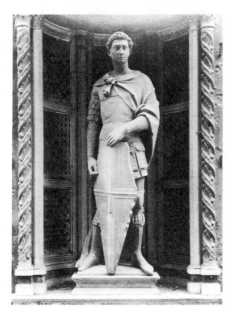

43. St George. Donatello

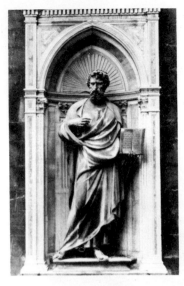

44. St Matthew. Ghiberti

Ghiberti evidently felt obliged to concede a point when he was commissioned by the Banker's Guild to produce a statue of their patron, St Matthew (1419) [44]: the twin challenge offered by Nanni's Four Saints, with their classical weight and solemnity, and by the astounding realism of St George, combined with the effects of a visit to Rome, seem to have persuaded him to explore the possibilities that ancient Roman art could offer him. The axis of the figure is a vertical from the head to the left foot and is aligned exactly with the centre of the niche, while vertical folds of drapery hang in front of the weight-bearing leg, in a manner reminiscent of Donatello's St Mark. St Matthew is less flat and frontal than St John, for the right arm curves round in front of the chest in a rhetorical gesture while the left shoulder and arm are retracted into the depths of the niche. The fall of his drapery is simpler too, and more satisfactorily related to the movements of the parts of the body. Perhaps most striking is the change in the facial type of St Matthew: the face is no longer dominated by the enormous, slit eyes of the St John, and features such as eyebrows and cheek-bones are no longer exaggerated. The head shows how Ghiberti could adapt his decorative style to the requirements of a classical model by slightly modifying the tousled hair and curly beard so that they conform to the greater restraint of Roman portrait heads.

63

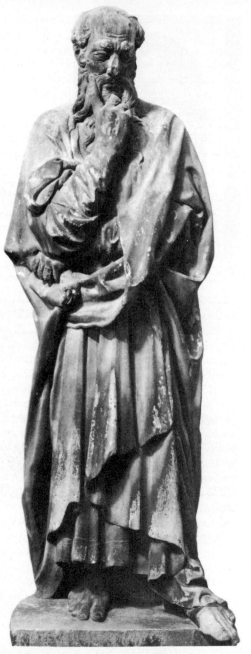

45. Bearded Prophet.
Donatello

64

Some years earlier, Donatello had received a contract for two marble figures of Prophets to fill niches high on the exterior of the Campanile of Florence Cathedral. He was probably involved in work on the St George, and the Prophets were not finished until 1418 and 1420 respectively. The siting of the figures presented problems of steep foreshortening and visibility, but Donatello had no difficulty in overcoming them. The Bearded Prophet [45] rests his chin on one hand and appears to be sunk in thought, his gaze directed at the spectator below: the static posture is emphasized by vertical folds of drapery as in the earlier St Mark, but the foot projects well over the corner of the block, in an attempt to link the space of the niche with that of the real world below. The Prophet with a Scroll has the beginnings of a new, more plastic system of drapery, but Donatello uses the direction of the glance and the finger pointing to a scroll to set up a psychological link with the spectator. The hands and features are boldly cut in order to show from a distance, and there is a portrait-like realism in the heads. This may be portraiture at second hand, imitated from Roman ancestor-busts, which provided convenient prototypes for naturalistic faces, often heavily lined and with sunken cheeks. At the time, the reality of pose and appearance were without precedent, and they must have seemed even more effective than they do today. By this stage, Donatello had left Nanni di Banco almost as far behind as Ghiberti, in terms of sheer realism as opposed to the mere imitation of classical sculpture. He had evolved his own canon of somewhat idealized naturalism and direct references to antique sculpture became rare.

While Donatello and his associates continued to work on the Prophets for the Campanile, a political body, the *Parte Guelfa*, commissioned a St Louis [46] for their niche at Or San Michele. In an effort to outdo all the earlier statues, the medium of gilt bronze was specified, but the technique of fire-gilding meant that the figure had to be cast in a number of sections, instead of in one piece like Ghiberti's figures. Consequently, the standing saint had to be constructed piecemeal out of sections of bronze secured to a metal armature: the attention to drapery that this necessitated and the process of modelling in wax as a preliminary to casting in bronze seem to have directed Donatello's imagination to the creation of a new and expressive style of crinkly, plastic folds which suggest a thick, resistant type of material. The sheer size of St Louis and the bulk of his cope, which completely fills the niche, build up a remarkable impres-

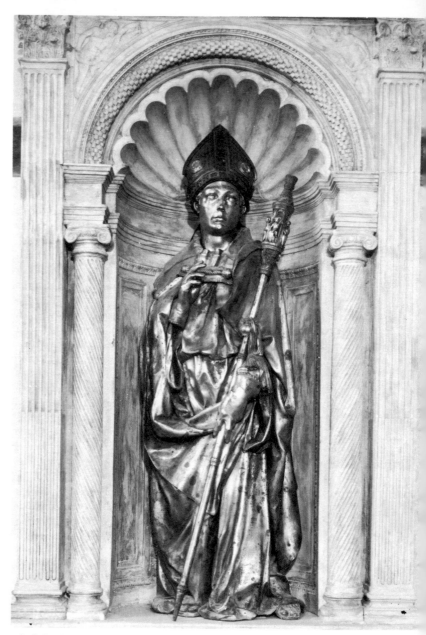

46. St Louis. Donatello

sion of grandeur and this in turn is heightened by the expensive gilding. The novel, classical architecture of the niche itself may owe something to Brunelleschi, with whom Donatello had remained in close contact since their early trip to Rome (*c.* 1402), while the decorative sculpture revived some important classical motifs from sarcophagi and reliefs, such as the flying *putti* supporting a wreath, which were to be much imitated later in the century.

The last of the figures made at this period for Or San Michele was a St Stephen, which Ghiberti cast in bronze about 1426–8 for the Guild of Wool Merchants, to replace an earlier statue dating from the fourteenth century. Its pose and treatment of drapery show little advance over his earlier St Matthew, while the broad, bland face, though acceptably classical in form, seems suspiciously similar to that of St Louis, and only slightly more refined than that of a St Philip by Nanni di Banco. This statue proved to be Ghiberti's last statement in figure sculpture on a large scale, for he concentrated on reliefs for the rest of his career. It can have done nothing to disturb Donatello's supremacy in the field.

Although work at Or San Michele had come to an end with the filling of the last niche, Donatello carved several more Prophets for the Campanile. The Jeremiah, of about 1423 [47], shows the new, plastic drapery style that had been introduced in St Louis being applied to marble: bold ridges and hollows give it a life of its own, irrespective of the anatomy beneath. The pinched and unshaven face is less idealized than those of the first two Prophets, and looks forward to the downright ugliness of the last in the series, Habakkuk [48]. This statue, begun before 1427 and finished in the 1430's, has a deep, emotional conviction which finds expression in the uncompromising, ascetic features and the bold economy of the swathes of drapery.

The conflict between Ghiberti and Donatello cannot be resolved into a simple opposition between the Gothic and the Renaissance styles of sculpture. It is rather their different attitudes to classical art that distinguish them. Ghiberti, deeply rooted in the traditions of Gothic metalwork, used the idealization of the human body which was apparent in classical art to achieve serene, graceful figures of great delicacy and charm. Donatello, on the other hand, abandoned his early Gothic training in favour of a whole-hearted absorption of the classical style, using his new-found knowledge to two ends. The first,

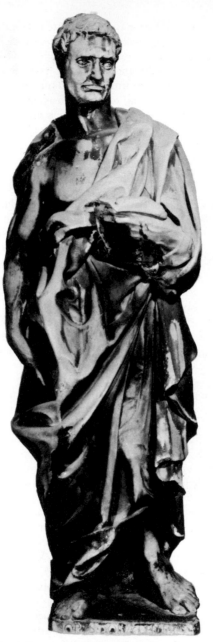

47. Jeremiah. Donatello

not entirely unlike Ghiberti's, was to achieve an ideal of balance and harmony by using classical proportions and poses for his figures; but the second was entirely opposed to this: it was the exploitation of the realistic aspects of Roman art for ever more violent and expressive effects of drama and deep emotion.

Round these two protagonists were grouped the rest of the sculptors of the period, the strength of their allegiance to one or the other varying, their styles sometimes amalgamating the two opposed streams and sometimes continuing the rift between serenity and idealism on the one hand and realism and drama on the other.

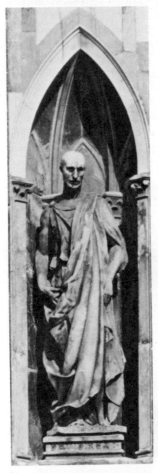

48. Habakkuk. Donatello

4
Donatello: Maturity (c. 1420–1466)

By the time the St George and the first two Prophets for the Campanile had been completed, Donatello's reputation as a marble sculptor was firmly established. With the commission for the St Louis his career as an artist in bronze began in earnest and he went into partnership with Michelozzo, an expert in bronze founding, who had been trained at the mint and had subsequently assisted Ghiberti with the St Matthew. The combination of sculpture and architecture, of bronze and marble, that had been involved in the St Louis and its niche was called for again in the next commission that the partners undertook. This was a monumental tomb for the anti-Pope John XXIII, who had died at Florence in 1419, and whose supporters had been granted a site for a tomb in the Baptistry by 1421 [49]. Work seems not to have begun until 1424, perhaps because the partners were preoccupied with the St Louis, but must then have proceeded rapidly, as the ensemble was declared as three-quarters complete in the tax return of 1427.

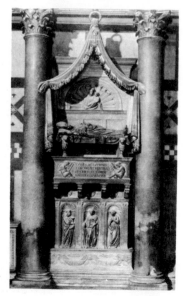

49. Monument to Pope John XXIII. Donatello and Michelozzo

Donatello had to design a monument that would fit between two existing columns of colossal size: with characteristic ingenuity he contrived to utilize these columns as vertical framing elements, linking them visually to the marble tomb between by means of pretended curtains that hang symmetrically from a ring above and are caught back against them at each side. Michelozzo was responsible for executing the marble parts of the tomb and may have had some hand in casting the bronze effigy of the Pope, if he was indeed employed as an expert founder, but the expressiveness of the portrait must reflect an original model by Donatello, worked up personally after casting. The shell-lunette with the Virgin and Child in relief, the effigy lying on a bier, the three plain panels behind and the sarcophagus with an inscription held up by *putti* were all to become standard motifs for later monuments. The complex has an austere majesty that recalls the spirit of Greek and Roman tombs, even though it does not resemble them in form.

In the tax return of 1427, Michelozzo mentioned two further tombs, one for Cardinal Brancacci, of which a quarter had been completed at Pisa, though ultimately destined for Naples, and one for the humanist Bartolommeo Aragazzi, destined for his native town of Montepulciano. The design of the Brancacci Monument [50] may have been conditioned by a desire on the

50. Mourning Youth.
Michelozzo

part of the patron to adhere to the tradition of fourteenth-century tombs at Naples. Once again, the figure sculpture is by Michelozzo, except for a panel depicting the Assumption of the Virgin on the front of the sarcophagus, which is a fine example of Donatello's shallow relief, relying on atmospheric perspective to achieve an effect of airy space. The three female allegories of the Cardinal Virtues which support the sarcophagus and the pair of mourning youths who hold back the curtains possess a solemn beauty that is thoroughly imbued with the melancholy of classical figures of mourners. The convincing stance of the figures, their expressive hands and faces, and the voluminous drapery, however, all demonstrate Michelozzo's concern with Donatello's means of suggesting deep emotion, even though his figures lack the reality and vivacity of the Campanile Prophets by which they are inspired.

The same is true of the figures which survive from the Aragazzi Monument. This tomb must have been nearly complete by 1430, when some of the elements were seen in transport to Montepulciano by Leonardo Bruni, the Chancellor of Florence.

51. St Bartholomew.
Michelozzo

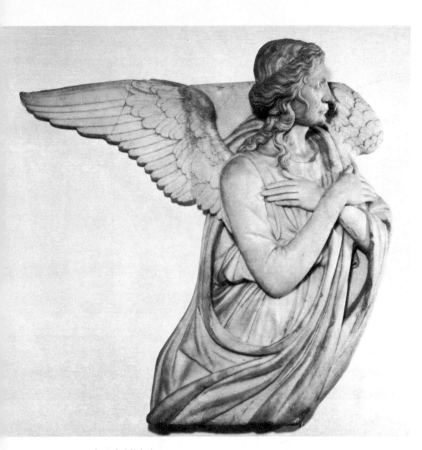

52. Angel. Michelozzo

The most impressive figure is a St Bartholomew [51], carved in deep relief, which formed the focus of attention. Two half-length Angels [52], which must have been situated near the top of the tomb, are almost as withdrawn and impassive as Neo-Classic sculptures, but the relief of Aragazzi taking leave of his Family [53] with its row of rather stocky adults is enlivened by the antics of three pestering babies dancing in the foreground. An interest in children constituted an endearing feature of the rival Singing Galleries of Luca della Robbia and Donatello, which date from the early 1430's (see pp. 76–9), and the Aragazzi monument may not have been finished until that period.

73

53. Aragazzi taking leave of his Family. Michelozzo

At this stage, Donatello and Michelozzo seem to have spent about three years in Rome (1430–3) with the general intention of studying classical sculpture, though no doubt in connection with some specific commissions too. Possibly the most influential was the tabernacle of the Holy Sacrament, St Peter's [54]. A panel with the Entombment has been mentioned in connection with Donatello's shallow reliefs, of which it is one of the most dramatically expressive. Twin groups of baby angels that flank the design below, crowding in front of the pilasters and gazing in awe at the door of the central tabernacle, constitute a charming and original motif which was later to become a standard element in such tabernacles at Florence.

54. Tabernacle of the Holy Sacrament. Donatello

55. Singing Gallery. Luca della Robbia

In 1427 a ban had been imposed on expenditure for sculpture in the Cathedral precincts, owing to a political crisis. The ban expired in 1431 and the sculptural decoration of the building was resumed with a campaign that concentrated on the interior of the crossing, in view of the fact that Brunelleschi's dome was nearing completion. Donatello and Michelozzo were still away at Rome, while Ghiberti was fully occupied with the Gates of Paradise, and the authorities had to turn to a less well-known sculptor, Luca della Robbia, for a marble singing gallery [55] which they proposed to install over the door of the North Sacristy. Luca's name had not appeared in connection with any previous artistic enterprise, but he must have been a competent sculptor to qualify for such an important commission. He was born in 1400 and it seems likely that he learned to carve under Nanni di Banco during the last phase of work on the Porta della Mandorla (1414–21). This would explain how he was known to the Cathedral authorities without being widely celebrated elsewhere. The style of the children on his Singing Gallery [56] is extremely close to that of the heavenly musicians who surround the Virgin in the relief of the Assumption by Nanni [42].

Luca's Gallery was a rectangular structure supported on five consoles and decorated with ten square panels of relief illustrating verses of Psalm 150 that are inscribed above and below. By 1434, four panels had been carved, including those destined

76

for the ends, which show singers engaged on an Alleluia chorus. After 1435, Luca started to cut his reliefs more deeply, probably for increased visibility in the murk of the crossing, a consideration which may have been brought to his notice by the style in which Donatello was carving a matching Gallery that had been commissioned in 1433.

56. Dancers. Luca della Robbia

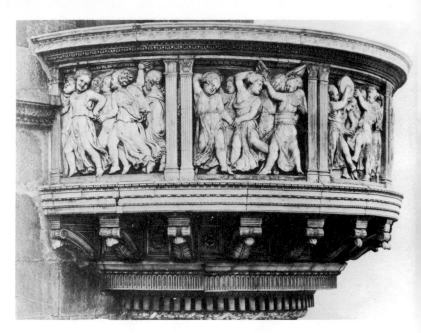

57. External pulpit, Prato. Donatello and Michelozzo

Donatello seems to have begun to think of his design in terms of panels, like Luca's, but then to have abandoned the models for this scheme to Michelozzo for use on an external pulpit at Prato Cathedral, which they had undertaken some five years before [57]. On this pulpit, the action of the running and dancing *putti* in the separate panels is implicitly continuous, unlike Luca's self-contained and static scenes. By a bold stroke of imagination, Donatello decided to develop the separate scenes into a frieze that was literally continuous, using two long blocks that run the whole length of his Singing Gallery [58]. He maintained a visual division of the surface into four main areas like Luca's by using pairs of free-standing columns in front of the frieze. His figures are deeply cut for clarity, while they are set off by mosaic patterns on the columns and on the background, rather as in Arnolfo's friezes of figures on tombs in the fourteenth century. Donatello's *putti* are not motivated by a logical scheme such as Luca had envisaged in illustrating Psalm 150, but represent an almost abstract idea in suggesting the flickering effect of rapid movement and the unconscious abandon of children at play. The sculptor seems to have con-

78

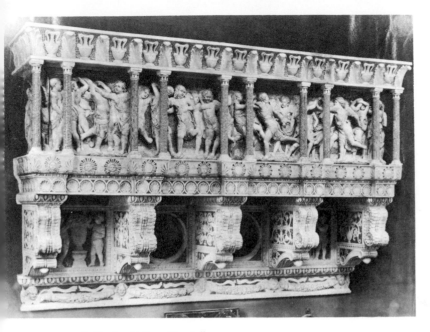

58. Singing Gallery. Donatello

ceived the idea as a humorous reference to classical scenes of
Bacchic frenzy and the mischievous baby *genii* which feature on
some Roman sarcophagi. The vivacious movement and humor-
ous characterization of his *putti* seem to have caught Luca's
attention and are echoed in a minor key, as it were, in the later
panels of his Gallery.

Luca's panels have always been extremely popular, and rightly
so, by reason of the slightly idealized vision of reality that they
present. The carefully observed distortions of the faces as the
children strain to sing or play their instruments are offset by the
charming innocence, gay or serious, of the youthful partici-
pants. The vision is as delicately poetic as Nanni's in the relief
of the Assumption, from which Luca probably derived his
inspiration, or as Ghiberti's in the exactly contemporary panels
of the Gates of Paradise.

Donatello's Singing Gallery was described in a document of
October 1438 as 'almost complete'. His activity from then until
his departure for Padua in 1443 is not accounted for by any
documents, but several important works seem on stylistic
grounds to date from that period.

79

Most of these were commissioned by an influential private patron, the banker Cosimo de' Medici, who hoped by lavish spending to expiate the sin of usury which was an occupational hazard of his profession. According to his biographer, Vespasiano da Bisticci the bookseller, he was especially attached to Donatello and even found work for him when unemployed in his old age. Unfortunately, Vespasiano's information is not very specific, but we learn that Cosimo commissioned the bronze doors of the Old Sacristy at San Lorenzo, which had been constructed at his behest by Brunelleschi some years before. Other early sources attribute to Donatello the plaster decorations of the Sacristy, and their style is unmistakable. The only problem is to decide when all these works were carried out: Donatello's absence at Rome (1430–3) and the short exile of the Medici (1433–4) point to a date in the second half of the 1430's.

Brunelleschi's plan for the sacristy provided for two sets of four roundels, two panels over the doorways and two bronze doors. The sculpture that was required consisted entirely of reliefs and could be modelled, either in plaster or in wax (as a preparatory stage of bronze casting). The ease with which these materials could be worked permitted the artist greater freedom than was possible in marble to experiment with the expressive effects that could be achieved by crudely modelled and naturalistic figures, shown in violent movement and under the stress of extreme emotion.

One set of roundels contains penetrating and realistic character studies of the four Evangelists, who, in contrast with Ghiberti's series on the North doors, are represented as ordinary human beings, their features haggard with meditation but ennobled by spiritual understanding. The other set, in the spandrels of the dome, depicts four scenes from the legend of St John the Evangelist, three of which are remarkable for a dramatic use of architectural perspective. In the Raising of Drusiana, a deep plunge into space is implied by converging lines of arches but the figures are deployed on a stage in the middle ground, dashing about with uninhibited vigour. The crude and summary modelling is equally suggestive of speed on the part of the artist and excitement on the part of the actors in the drama. In the Ascension of St John [59], a low viewpoint, approximating to the actual position of a spectator, is implied by the disappearance of the figures' feet below the edge of the stage-like structure on which they stand. The converging verticals of the architectural setting effectively reinforce the suggestion of ascent in the figure

59. Ascension of St John. Donatello

of the saint seen in mid-air. The architectural surrounds are treated like portholes, through which a larger space beyond can be glimpsed, as is shown by the truncation of some of the figures by the lower segment of the frame of the Ascension.

Donatello took as his theme for the doors of the Old Sacristy a series of Martyrs and a series of Apostles, two to a panel. The figures were not posed, however, in a traditional, hieratic way, but were depicted deep in thought, in animated discussion, or in violent movement [60]. As in the plaster reliefs, the figures are boldly modelled and have a vigorous sense of character. The effect is enhanced by bulky drapery hanging in monumental folds or whirling round the limbs that are in motion. Although no attempt is made to define their spatial environment, they seem to walk on the frame of their panels or lean against the sides, their toes or drapery sometimes overlapping the decorative border in an illusionary way that has a distinct spatial implication. The variety of pose, gesture and mood that Donatello managed to introduce into this series of uniform panels demonstrates the remarkable fertility of his imagination, where a lesser artist would have had recourse to a routine repetition of conventional formulae.

81

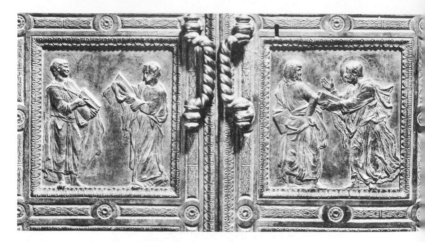

60. Bronze Doors (detail), San Lorenzo. Donatello

Cosimo de' Medici seems also to have been responsible for commissioning a work of a very different kind for exhibition in his palace, namely the bronze David [61]. Perhaps Donatello's most celebrated statue, this was the first free-standing, life-size nude of the Renaissance. It revived one of the commonest types of classical sculpture, the victorious athlete, and may have been inspired by Donatello's visit to Rome. The mood of dreamy contemplation on the face [62] seems to reflect a knowledge of the classical statue of Antinous, of which many versions exist, but the body is not as idealized as in a classical nude and its comparative naturalism gave rise to a story that the limbs had been cast from a living model. Unlikely though this is, it reflects an appreciation of the wonderfully sensuous surface texture, which effectively renders the softness of living flesh, by contrast with the sharply chiselled details of the hair framing the face, and the feathers of Goliath's helmet resting against David's leg. The mood of the figure is not best suited to a dramatic representation of the story of David and Goliath, and there may be some underlying humanistic meaning which has been forgotten. Verrocchio's later statue of David seems to constitute a sharp criticism of this shortcoming in the emotional temper of the figure (p. 132).

82

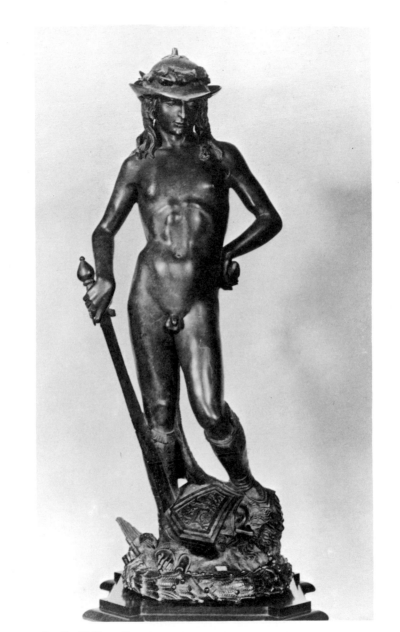

61. David. Donatello

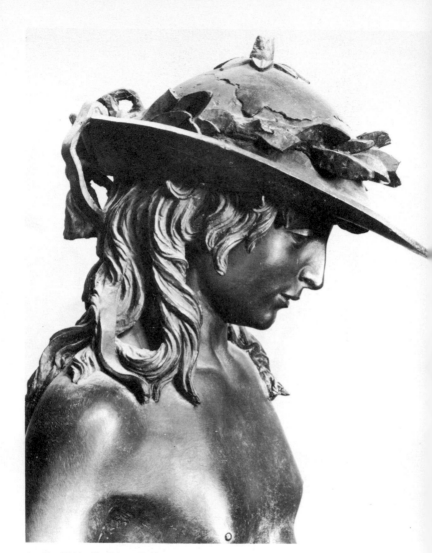

62. David (detail). Donatello

That Donatello was perfectly capable of expressing the
subtlest nuances of drama and emotion is, however, abundantly
clear from a composition of the Annunciation [63] which he
carved in grey, local stone for an altar of the Cavalcanti family
in Santa Croce at about the same date as the David. The Angel

84

63. Cavalcanti Annunciation. Donatello

Gabriel and Mary are life-size and carved in deep relief within
a shallow, stage-like space, such that they have the visual
impact and psychological immediacy of a *tableau vivant*. The
Virgin rises, startled and shy, but not alarmed, and withdraws
to the right side of the niche, gazing down at the kneeling angel,
who delivers his message with awe and humility. As always,
Donatello interprets the story with a sympathetic insight into
the human emotions that would be involved, subtly adjusting
the traditional formula of the Annunciation scene to suit his own
ends. The spiritual grandeur and serenity of the figures are en-
hanced by the use of ideal facial types inspired by antiquity, and
the highly decorative architecture of the niche is presumably
also supposed to convey an idea of Roman splendour, un-
orthodox though it in fact is.

The tenderness and delicacy of the mood in the Annunciation
and the idealized beauty of the David provide a salutary remind-
er of Donatello's extraordinarily wide imaginative range when
they are compared with the high-pitched drama of the reliefs at
San Lorenzo, that were executed within the same short span of

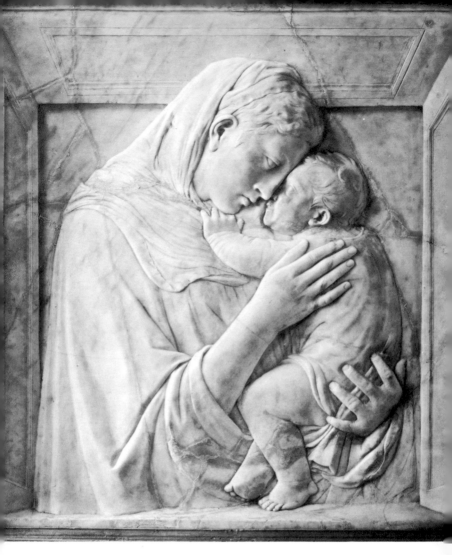

64. Pazzi Virgin and Child. Donatello

years (1435–43). It is important for the understanding of the sculpture of the mid-century at Florence to see how the 'sweet style' that became almost universal during Donatello's absence, was sanctioned by his example as much as by Ghiberti's or Luca della Robbia's. It is all too frequently forgotten that the reliefs of the Virgin and Child, which formed such an important aspect of Florentine sculpture at that period, followed prototypes that had been invented not only by Ghiberti and Luca but also by Donatello. Possibly as early as 1420 his Pazzi Madonna [64: Berlin] had exploited all the emotional power that could be derived from the imaginative use of motifs from classical sculpture in combination with the observation of nature, while there exist a number of other influential compositions which probably date from the period before his departure for Padua.

By 1443, Donatello's fame as a master of bronze statuary must have spread far afield, for in that year he was invited to the northern city of Padua to make an equestrian monument to Gattamelata [65], a famous mercenary leader who had died shortly before. This commission provided the greatest challenge of Donatello's career, as it involved a revival of one of the most ambitious types of ancient sculpture, which had long been known from the statue of Marcus Aurelius at Rome. The technical difficulty of casting so large a group in bronze was

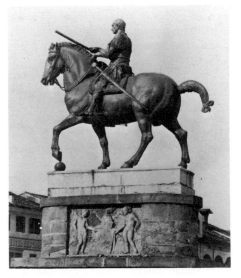

65. Gattamelata.
Donatello

enormous, as was the expense which it implied. For the horse, Donatello turned to a convenient precedent that existed near to hand, in the shape of four Greek bronze horses that had been brought from Constantinople and erected on the façade of St Mark's, Venice. For the figure of Gattamelata, however, he needed no prototype, probably basing the very realistic and impressive head on a death mask, but supplying the harsh features with a lifelike expression, the lips tightly compressed, the eyes focused shrewdly on some objective and the hair cropped close to the skull but unkempt. The statue stands on a high stone base that was originally intended to contain the warrior's remains, its distinct silhouette dominating the square beside the important pilgrimage church of Saint Anthony. It forms not so much a personal memorial as a civic monument in honour of the ideals of public life that had flourished in ancient Rome.

Although the commission for the Gattamelata Monument may have been the initial reason for Donatello's journey to Padua, its casting did not take place until 1447, several years after he had begun work for the authorities of the Basilica of St Anthony, who commissioned him to produce a bronze figure of Christ Crucified in 1444. The sanctity of the subject and possibly the wishes of his patrons seem to have inhibited him from making the figure as expressionistic as one might have expected, but the realism of the nude body, which was only slightly stylized, must have been an object of wonder in north Italy, where the Gothic style had hitherto reigned supreme.

Donatello's main group of bronzes for the Basilica was put in hand in 1446, after a substantial bequest had been received for the reconstruction of the high altar. The original scheme of the altar has been irreparably altered, but the most plausible reconstruction suggests that the seven main figures [66], which are about five feet high, were set on a stage above and behind the altar beneath an elaborate canopy, similar to that of the Cavalcanti Annunciation. Four oblong narrative reliefs, interspersed with panels showing music-making angels and symbols of the Evangelists, seem to have formed a frieze round the base of the altar, while a large, stone relief of the Entombment of Christ was set behind. The work of making wax models for casting seems to have gone forward with extraordinary speed, for by June 1448 all the main figures had been cast, together with most of the reliefs, and by about 1450 the complex appears to have been complete.

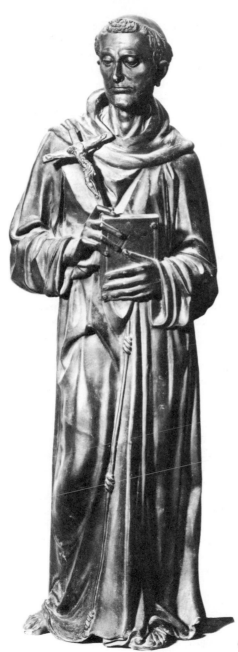

66. St Francis. Donatello

The highly original scheme of the altar seems to represent an extension of ideas on which Donatello had been working before he had left Florence, the tableau of life-size figures that he had invented for the Santa Croce Annunciation, and the free-standing figure in bronze that he had revived with his David. An increased confidence in casting large statues and the existence of a skilled team of foundry men who had been involved on the Gattamelata enabled Donatello to work with great freedom and speed, despite the quantity of sculpture that was required for the altar. Once a production line had been organized, Donatello could devote himself solely to producing models in wax, which would be cast by expert technicians and finished in the less important areas by studio assistants: the master needed to concern himself only with the passages which were vital to drama and expression. The modelling of the faces is almost 'impressionistic' in its lack of detail and concentrates boldly on defining the underlying bone-structure. This gives an unprecedented grandeur and pathos to the figures, although the emotional pitch of the group is restrained out of a respect for its destination on an altar in a major pilgrimage church. The play of flickering candlelight across the deeply shadowed faces of Donatello's emaciated saints standing in a majestic group behind the high altar must have conveyed an impression of physical and spiritual presence that would have captivated even the least imaginative of the devotees of the shrine.

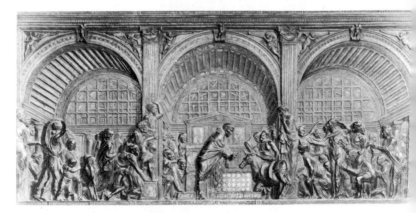

67. Miracle of the Mule. Donatello

The four narrative reliefs, which depict episodes from the life of Saint Anthony, are among the artist's most fascinating works. The intricacies of spatial treatment differ in each, and the details are picked out in gilding of varying intensity, which renders an effect of internal light. This is especially successful in the Miracle of the Mule [67], where the converging lines of coffering on the three huge barrel vaults are gilded to suggest the play of light on a concave surface, and the central episode is set off against a pattern of gold discs and rectangles. Although there is a remarkable amount of detailed observation and sensitive characterization, the strength of the compositions and clarity of the focal points prevent any feeling of overcrowding or pettiness. By comparison with the experimental stage represented by the reliefs of the Old Sacristy at San Lorenzo, there is a feeling of almost Roman grandeur and harmony even in the dramatic scenes, and in certain passages one begins to see the boldness of modelling and chiselling that was to be the hallmark of Donatello's later style, as manifested on the bronze pulpits of San Lorenzo, on which he was working at the time of his death.

The end of Donatello's stay at Padua was marred by disputes over payment and after working temporarily in various neighbouring cities, including Venice (where he executed a wooden figure of St John the Baptist for the Florentine colony in 1453), he returned to his native Tuscany. The almost horrific realism of the gaunt and emaciated St John at Venice strikes the keynote of the rest of Donatello's sculpture, in which there is an uncompromising concentration on the harsher aspects of the biblical figures and stories which he was called upon to portray.

Possibly the earliest of these was another St John the Baptist which he was casting in bronze for Siena Cathedral about 1457. This Baptist seems more authoritative and self-confident than the frailer one at Venice, perhaps because the proportions of the figure are less elongated and closer to the classical norm, as in the statues at Padua. The structure of his face is closely similar to that of the St Francis, although the unkempt hair and beard are like those of the wooden Baptist. The last of this series of ascetic saints, the St Mary Magdalene in the Baptistry at Florence [68] is by far the most effective. The terrifyingly repulsive features have an almost hypnotic fascination, which must be the reflection of a genuine depth of emotion. The tremendous pathos of the physical decay of the holy woman must have been striking beyond all measure to an audience who had been reared in the traditions of Ghibertesque sweetness and near-senti-

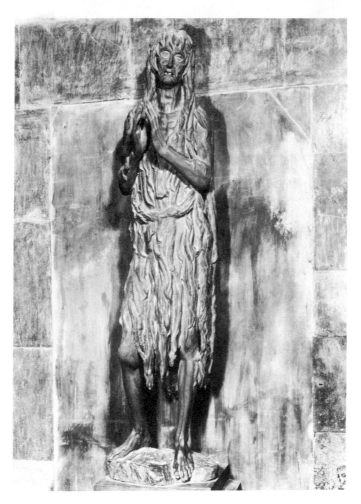

68. St Mary Magdalene. Donatello

mentality in their religious images, and were not inured to the horror-content of Northern Gothic religious art, which may have provided Donatello's inspiration. The Magdalene, though undated, presumably belongs to the last period of Donatello's career, as it represents the climax of all the experiments in expressionism that had occupied the artist throughout his life, and is only paralleled by the bronze reliefs which he modelled in his last years.

Standing slightly outside this series is the bronze group of Judith and Holofernes [69], which, though completely un-documented, appears to date from the same period and may have been commissioned by the Medici. The group was inten-ded as the centrepiece of a fountain, as the four corners of the large cushion on which it is set are pierced to form water-spouts. The very motif of the cushion recalls Donatello's early St Mark on Or San Michele [37], while the relationship of the figures is similar to that of a group of Abraham and Isaac which he had carved for the Campanile in 1421. Apart from suggesting the weight of the figures by its squashed shape, the cushion helps visually to relate them to the triangular base below. The front of Judith and the back of Holofernes are aligned with one face of the triangle, while his legs hang down almost symmetrically about the opposite apex. The carefully calculated composition gives the group a feeling of hieratic symbolism instead of realistic action, but this in part reflects the fact that the subject matter was regarded as symbolic of the victory of Humility over Pride and Vice, as we know from a record of a lost inscription on the original base.

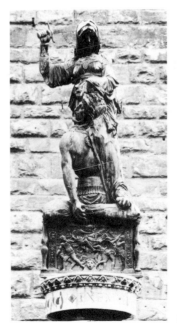

69. Judith and Holofernes. Donatello

The major commission that occupied Donatello's declining years was the preparation of a series of bronze reliefs for the Gospel and Epistle pulpits in the Medicean church of San Lorenzo. The evidence of Vespasiano da Bisticci that Cosimo gave Donatello this work at a time when he was idle, in order not to let so great a genius go to waste, means that the commission must have dated from before Cosimo's death (1464). The North pulpit bears the date June 1465, presumably recording its completion, and the South pulpit, which shows greater signs of the intervention of assistants in its finishing, must be later.

The North pulpit [70] depicts the events that occurred after the Passion. Its front is divided by protruding buttresses into three sections which contain Christ in Limbo, the Resurrection and Christ Appearing to the Apostles. The style of the figures is a still more violent variation on that of the reliefs at Padua: the smoothness of naked limbs is set off against crumpled drapery or shaggy hair, and the rear plane of the scenes presses forward, emphasizing the figure groups. The scene of the Resurrection is highly unorthodox, for the horrific figure of Christ rising from the tomb still partially enveloped, mummy-like, in His shroud contrasts strongly with the normal Renaissance type of the Resurrected Christ which was based on an interest in the idealized nude body and traditionally used as the axis of a symmetrical scene. The traces in the bronze of the original wax

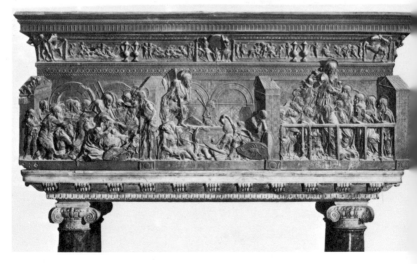

70. North pulpit. Donatello

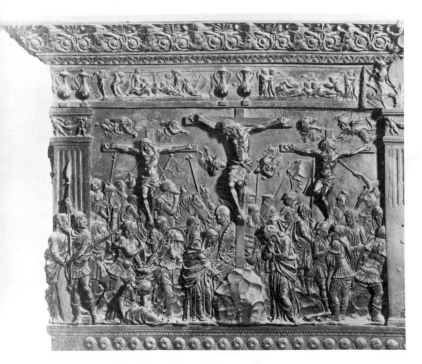

71. Crucifixion. Donatello and Bellano

surface, and the subsequent chiselling, still seem to reflect
Donatello's handiwork. On the back of the pulpit is a splendid
scene of the Martyrdom of St Lawrence, patron of the church:
set in a wide architectural stage, the gruesome scene of the
roasting of the saint on a grid is dominated by the long diagonal
of a pronged instrument with which he is being held down. A
remarkably original addition to the standard iconography of
the scene is the second corpse, face down among the flames in
the foreground, perhaps representing the saint in death rather
than a companion martyr.

On the South pulpit, scenes from the Passion are depicted.
The hand of Donatello's assistant, Bellano, seems most apparent
in the angular chiselling of the surfaces into sharply defined
facets on the Crucifixion [71] and the Agony in the Garden: the
landscape and drapery style are very close to his later independ-
ent reliefs at Padua. The Entombment has a flatter surface than
most of the other reliefs and the drapery is treated in a much

95

more linear fashion. This is usually taken as a sign of the other assistant who is known to have taken part in the finishing of the reliefs, Bertoldo. He was an important figure in that he remained at Florence, producing reliefs and bronze statuettes, and he was ultimately put in charge of the Medici sculpture collection about 1489. He thus influenced the young students whom the Medici supported there, including Michelangelo (see p. 170).

Even if some of the reliefs remained to be finished after Donatello's death (1466) and the surface working betrays the hands of assistants, the general lines of the compositions had probably been laid down by the master in wax models, though he may not have been strong enough at the end to undertake the arduous physical work of chasing the bronze after casting.

By the time that Donatello died, an old man of eighty, the 'sweet style' that had matured at Florence during his absence with sculptors of the next generation had a universal hold on the imagination of artists and patrons alike. Donatello's late style, with its boldness of imagination and execution, probably overawed them and seemed incomprehensible and inaccessible. Indicative of this is the fact that the pulpits do not seem to have been erected in their intended position and were not properly displayed until the sixteenth century. In fact, the impact of his late style seems to have been greater in Padua and Siena, where he had left workshops of fully-trained founders and sculptors who continued the tradition, than in his native city. It is not until the work of Verrocchio and Pollaiuolo that we find an echo of Donatello's expressive powers in Florence.

5

The 'Sweet Style' at Florence:

Luca della Robbia; Bernardo and Antonio Rossellino; Desiderio da Settignano

When Donatello left for Padua in 1443, the most powerful avant-garde influence was removed from the sculptural scene at Florence, and the style that was to predominate for the next twenty-five years had its origins in the works of the early Renaissance masters of the twenties and thirties: the tombs by Michelozzo; Donatello's works in a sweeter vein, such as the Cavalcanti Annunciation and the reliefs of the Virgin and Child; the bronze shrines and panels of the Gates of Paradise by Ghiberti; and the Singing Gallery of Luca. By that date, Ghiberti was over sixty and no longer practising as a sculptor, and so Luca was the only active member of the older generation.

The Singing Gallery was installed in 1438 and soon after that Luca executed a beautiful tabernacle [72] for Santa Maria Nuova (now at Peretola). Its architectural features are not unlike those of the niche of St Louis at Or San Michele, and so can be classified in a general sense as Brunelleschian. The calm of the

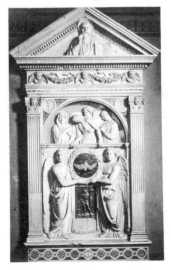

72. Tabernacle of the Sacrament. Luca della Robbia

angels, who form static vertical accents in the composition, is similar to that of the figures in some of the earlier panels of the Singing Gallery. The most important innovation lay not in style, however, but in technique, for colour was supplied not by painting parts of the marble, as was traditional, but by the insertion of an inlay of pieces of glazed terracotta. The Tabernacle was in fact the first dated instance (1441–3) of the use of the medium to which Luca was ultimately to owe his fame. A similar use of terracotta to supply colour in a marble ensemble recurred some fifteen years later in the tomb of Bishop Federighi of Fiesole [73] who died in 1450: there it was used to form a charming decorative border of flowers, not unrelated in feeling to the chiselled bronze frieze on the frame of the Gates of Paradise. A connection with Ghiberti was even more explicit in the pair of flying angels who support a wreath on the front of the sarcophagus and are borrowed from Ghiberti's bronze Shrine of the Three Martyrs (1424–5).

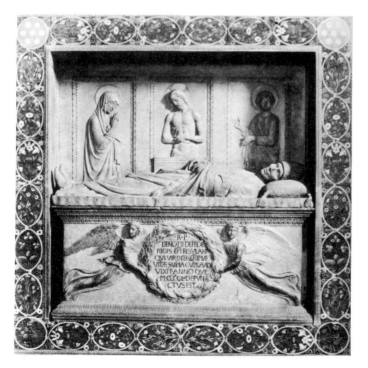

73. Monument of Bishop Federighi. Luca della Robbia

Almost simultaneously with the Peretola Tabernacle, Luca used the new medium of glazed terracotta for a narrative subject, the Resurrection [74]. It was commissioned in 1442 to fit in a lunette over the door of the North Sacristy in the Cathedral and under his own Singing Gallery. The introduction of colour made for greater visibility in the gloomy crossing and the success of the idea can be judged from the fact that a matching lunette of the Ascension was commissioned immediately after for the opposite Sacristy (1446–51). There is an interesting contrast in style between the earlier lunette, which is more static and recalls the style of Luca's predecessors in marble, Nanni and Michelozzo, and the later one, which is distinctly closer in feeling to the modelled work of Ghiberti, and in particular to the panel of the Resurrection on the North doors, from which the swaying Gothic pose of Christ seems to be derived.

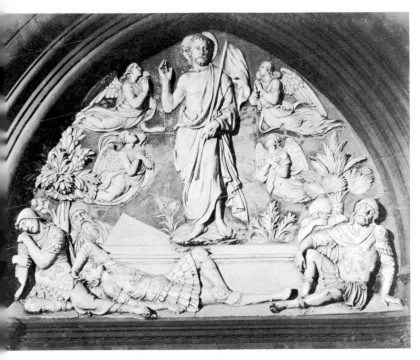

74. Resurrection. Luca della Robbia

Luca received two other commissions for sculpture at the Cathedral in the late 1440's. The more important was a pair of bronze doors for the North Sacristy, a commission which Donatello had left unfulfilled when he went to Padua. In collaboration with Michelozzo, who was presumably called in on the strength of his earlier association with Donatello and his expertise in bronze casting, Luca designed the two wings of the door with five panels, each containing three figures. The contrast in mood with Donatello's doors for the Old Sacristy at San Lorenzo, which had probably inspired the Cathedral authorities with the idea of the new set, could hardly be greater: the dynamic activity of the vigorous pairs of figures at San Lorenzo is the very opposite of the subdued calm of Luca's reliefs. His saintly figures are related in mood and style rather to the Evangelists of Ghiberti's North doors and, through them, to the even earlier panels of Virtues on Andrea Pisano's doors.

The same mood of religious serenity and meditation marked Luca's other commission for the Cathedral, a pair of Candlebearing Angels, modelled in white glazed terracotta. They constituted the first use of the medium for free-standing figures, and thus inaugurated a long series of sculptures that continued to be in demand well into the sixteenth century. Initially, the figures were individually modelled, such that each was an autograph work of art, but later the use of moulds was introduced. This permitted virtual mass-production, with a corresponding reduction in quality and aesthetic interest. The bright and permanent colours that the medium permitted were well suited to insertion in the severely monochromatic architectural schemes of Brunelleschi, replacing the less durable painted plaster that had been used, for instance, in the Old Sacristy by Donatello. The qualities of durability and cheapness favoured its use in exposed positions on the façades of buildings for coats of arms, lunettes over doors and wall-shrines, many of which are still in their original positions. The workshop flourished on commissions of this kind under Luca, and later under his nephew, Andrea, and numerous other relations until well into the sixteenth century.

A new generation of marble sculptors had meanwhile come to maturity and the first commission after Donatello's departure went to a newcomer, Bernardo Rossellino. Later he introduced to the Florentine milieu his younger brother Antonio and a friend from their native town of Settignano, Desiderio.

Between them, this trio dominated the field of marble sculpture for a quarter of a century, until about 1470.

The occasion of Bernardo's emergence at Florence was a commission for a monument to the well-loved, humanist Chancellor, Leonardo Bruni [75], who died in 1444. Donatello, the obvious choice for such a commission, had left for Padua the year before, while Luca was absorbed in work at the Cathedral. Bernardo seems to have been employed in the capacity of an architect at the Cathedral since 1441, and before that at Arezzo (1433), where he had successfully completed the fourteenth-century façade of the Misericordia with an upper storey of architecture and sculpture in a Renaissance idiom. The most important aspect of the design for his future style was a successful integration of sculptured figures and architecture in a harmonious composition where neither element outweighed the other. This earlier connection with Bruni's native town, whose citizens seem to have been largely responsible for the decision to give the chancellor a splendid tomb, despite his express wish to the contrary, probably influenced the choice of Bernardo for the commission.

75. Monument of Leonardo Bruni.
Bernardo Rossellino

The spirit of the undertaking was in tune with the accurately classical funeral of the Chancellor, described for us by Vespasiano da Bisticci: Bruni's corpse was dressed in a long silk robe and a copy of the *History of Florence* which he had written was placed in his hands. At the end of the pompous ceremony, after a eulogy had been declaimed in true Roman style, a wreath of laurel was placed on his brow. These details are faithfully represented on the tomb [76], where Bruni is shown lying on a draped funeral bier above an austere sarcophagus, which is decorated with Ghibertesque pairs of flying angels, who have taken on the aspect of classical Winged Victories at Bernardo's hands. The inscription on the tablet which they support was written by Marsuppini, Bruni's successor in the office of Chancellor, who commissioned a similar tomb by Desiderio in the next decade, for erection in the opposite aisle of Santa Croce [77].

Elements in the design, such as the triple division of the wall behind the effigy and the half-length Virgin and Child above, were derived from the tomb of John XXIII [49] by Donatello and Michelozzo, and the strong architectural frame of severe pilasters fulfilled the function of the original columns of the Baptistry, between which that tomb had been inserted to such

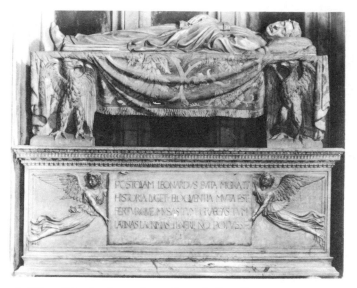

76. Effigy of Bruni and sarcophagus. Bernardo Rossellino

good effect. By re-arranging the elements of the earlier com-
position, Bernardo brought the effigy down almost to the eye-
level of the spectator, omitting the three Virtues below.
Untramelled by previous structures, he was free to express his
liking for a strong architectural frame, binding the sculptural
parts of the tomb into a harmonious whole, rather as he had
done on the façade of the Misericordia, Arezzo, ten years before.

Bernardo's intense interest in Luca della Robbia and Dona-
tello is attested by a commission of 1450 for a tabernacle in
Sant'Egidio [78]. It was not his first essay at this type of com-
position, but the two earlier examples are lost. In any case, the
dominant influence on the Sant'Egidio tabernacle as far as
shape and architecture are concerned was Luca's tabernacle
[72]. What he did within this framework, however, was entirely
novel, though inspired by an idea embodied in the tabernacle
[54] that Donatello had executed during his stay at Rome in the
1430's. There, groups of three little angels, who stand at the base
of the flanking pilasters, look and gesticulate towards the focal
point of the composition, the door behind which the Sacrament
is reserved. Bernardo's imaginative innovation was to bring
his angels inside the main arch of the tabernacle, and to con-
struct an illusionary vista of a barrel-vaulted hall in perspective,

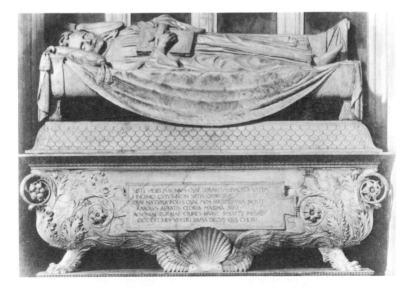

77. Effigy of Marsuppini and sarcophagus. Desiderio da Settignano

78. Tabernacle of the Sacrament.
Bernardo Rossellino

which they seem to enter from doors at each side. The door of
the cupboard, manufactured in bronze by Ghiberti and his
son, is thus supposed to be at the far end of this hall. The device
worked remarkably well and when Desiderio had perfected a
similar perspective scheme on his tabernacle at San Lorenzo
(1461), it became one of the standard motifs for sacramental
tabernacles.

Bernardo's concern with the architectural aspect of these
sculptural projects reflects his importance in the field of archi-
tecture, which must have provided his main source of income.
After building the Rucellai Palace to Alberti's designs (1446–51)
he went to Rome to act as architect to Pope Nicholas V, and later
directed the building of a new town called Pienza at the native
village of Pope Pius II. While he was away at Rome, his younger
brother Antonio and their associate Desiderio seem to have
been acknowledged as fully trained sculptors and must there-
after have played an increasingly large part in the sculpture that
was carved in the Rossellino workshop. The last project in
which Bernardo was personally involved as a sculptor was the
tomb of the Cardinal of Portugal, where Antonio played the
major role (see p. 111), and by the time of his death (1464) he
must have been regarded primarily as an architect rather than
a sculptor.

Antonio Rossellino (born 1427) was seventeen years junior to Bernardo and seems to have been trained by him in parallel with Desiderio, who was a close contemporary. Although the two young sculptors came of age at much the same time, acting as joint assessors of a pulpit in 1453, Desiderio seems to have been the more advanced, to judge from the fact that it was to him and not to Antonio that the commission for the next large tomb went, in the absence of Bernardo, who was at Rome. There is no documentary information about the tomb of Carlo Marsuppini [77], Chancellor of Florence, who died in 1453, but the sheer quantity of sculpture involved, as well as the presence of several distinct hands in the carving, suggests that Antonio and the Rossellino shop may well have played a large part, even if Desiderio was the nominal recipient of the contract. Another sculptor who is mentioned by two reliable early sources in connection with the tomb is Verrocchio, who had been forced to abandon his chosen trade of goldsmith for lack of work.

Desiderio's design for the Marsuppini tomb is clearly based on the precedent set by Bernardo with the Bruni tomb, though it is lower and wider in proportion, with an increased emphasis on sculpture as opposed to architecture. The sarcophagus is far less restrained than the rectangular chest used by Bernardo, and the exuberant acanthus scrolls at each end are carved with great virtuosity. Desiderio also added two free-standing boy angels who hold shields in front of the flanking pilasters [79]. These children, who are approximately life-size, are subtly

79. Putto with Shield. Desiderio da Settignano

80. Tabernacle of the Sacrament. Desiderio da Settignano

differentiated by an attention to individual portraiture. They form a charming link between the effigy and the spectator, softening as it were, the full impact of the meaning of death. A similar innocent gaiety characterizes the roundel above with its charming rendering of an intimate moment in the relationship of the Christ Child and His Mother.

The carving of the Marsuppini tomb must have occupied Desiderio several years, possibly until he began work on his second great commission, the tabernacle of the Sacrament for San Lorenzo [80], which was installed in 1461. The central part is a refinement upon Bernardo's idea of an illusionary setting, with an increased effect of recession being achieved by tilting the ground level more steeply and emphasizing the perspective by the converging divisions of pavement and barrel-vault. The angels who dart out at each side are smaller in proportion than Bernardo's and seem more distant in consequence. The tabernacle is flanked by a pair of candle-bearing angels, this time cast as young maidens, one quietly contemplative and the other with her lips slightly parted, as though about to exclaim [81]. The figure-sculpture is completed above by a nude Christ Child standing in benediction over a chalice, who seems to be a close cousin of the children on the Marsuppini tomb.

81. Angel (detail). Desiderio da Settignano 82. Pensive Girl. Desiderio da Settignano

83. Laughing Boy. Desiderio da Settignano

By comparison with these documented works, three charming busts of little boys [83], conventionally interpreted as the Infant Christ or St John the Baptist may be attributed to Desiderio. They show the sympathy and sensitivity with which he could portray children as individual personalities, despite a legitimate poetic idealization. He managed not only, however, to portray the features, as had been done in child portraits of Roman date, but also to catch fleeting facial expressions and hence to convey the emotional moods of his sitters to perfection: the Mellon boy at Washington is caught in a moment of solemn abstraction; the Vienna boy in the midst of a peal of infant laughter.

The same insight into the characteristic mood of a sitter enabled Desiderio to portray a young Florentine lady with as sure a touch as the children. Although the anonymous female busts of the fifteenth century present serious problems of attribution and identification, one justifies its ascription to Desiderio on grounds of style: the Pensive Girl in the Bargello [82]. The way in which the hair seems to grow organically out of the scalp, almost as though modelled in a medium as malleable as wax, is quite unmistakable, as is the fine surface texture of the skin. This is rendered with the virtuoso control of marble that characterizes all Desiderio's authentic works, for instance the angels of the tabernacle at San Lorenzo.

The large relief of the Dead Christ beneath the tabernacle and the roundel of the Virgin and Child from the Marsuppini tomb represent an aspect of Desiderio's art for which he was justly famed at the time: the shallow relief. Among his earliest efforts are some of a series of cherub-heads carved in grey stone on the external frieze of the Pazzi Chapel at Santa Croce. The attribution of certain heads to Donatello, despite the overall similarity of the series, stresses the proximity in style between the two sculptors during Desiderio's early years. He sometimes managed to rival Donatello's very personal technique of shallow relief, as in a St Jerome (National Gallery of Art, Washington), where a background figure of a running monk, his hands spread out and foreshortened in Donatellesque fashion, is barely scratched on the marble. Among Desiderio's best-loved reliefs are those of the Virgin and Child. The earliest seems to be one now at Turin [84], which is related in style to the children's heads on the Pazzi Chapel. Desiderio probably derived the motif of heads pressed possessively together and the Virgin protectively hugging the Child from the Pazzi

84. Virgin and Child. Desiderio da Settignano

Madonna [64] by Donatello. The Foulc Madonna at Philadelphia is close in feeling to the roundel on the Marsuppini tomb, though slightly less playful in mood; while the Panciatichi Madonna in the Bargello, with its more complex spatial relationships and more tightly integrated composition, appears to be the latest of the series.

Desiderio's effortless exploitation of the inherent qualities of marble, its crystalline crispness and subtle translucency, point to a control of his medium greater than that of any other artist of the fifteenth century, except for Donatello. His early death in 1464, at the age of about thirty-five, curtailed a career which promised great brilliance and left Antonio Rossellino supreme, while at the same time making way for the emergence of Verrocchio and a less enterprising sculptor, Mino da Fiesole.

As we have seen, Antonio developed more slowly than Desiderio. His first signed work is a portrait bust of Giovanni Chellini, which is dated 1456 and forms a key point in the history of the portrait during the fifteenth century (Chap. 6). He also seems to have contributed a portrait roundel to one of Bernardo's later commissions for tombs, that of Neri Capponi (post-1457). His artistic personality came to the fore with the next great tomb of the century, that of the young Cardinal James of Portugal [85], who died at Florence in 1459. This was by no

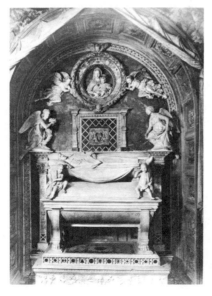

85. Monument of Cardinal James of Portugal. Antonio Rossellino

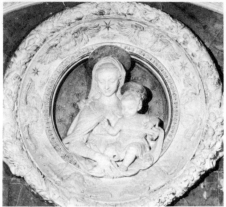

86. Virgin and Child.
Antonio Rossellino

means a purely sculptural project, for a whole new chapel was
built, opening from the north aisle of San Miniato al Monte
and offering three wall surfaces for decoration. Its first archi-
tect died in 1459, and the scheme passed to Giovanni, a brother
of the Rossellini; the ceiling of glazed terracotta was com-
missioned from Luca della Robbia, and the sculpture was
ordered soon after from the Rossellini. By his death in 1464,
Bernardo had received about one quarter of the total sum spent
on sculpture, and had probably carried out a proportionate
amount of the work. Antonio had completed the tomb and a
marble throne opposite by 1466, when the chapel was dedicated,
and the altarpiece was painted by the Pollaiuolo brothers in the
following year. Frescoes by Baldovinetti completed the scheme.

The chapel of the Cardinal of Portugal is a supreme example
of the harmony that could be achieved in the early Renaissance
when all three major arts were used in juxtaposition. The tomb,
which occupies the wall to the right of the altar, is an integral
part of the architectural scheme, and not an independent unit
like its prototypes at Santa Croce. The sarcophagus and effigy
are set back into one of the arms of a cruciform plan, and this
recess has pretended curtains of marble drawn back at each side.
Within, there is an atmosphere of greater activity than in the
earlier tombs, as though we were witnessing a number of
figures in motion: the Virgin looks down from the roundel
towards the face of the effigy and the Christ Child directs His
benediction towards him too [86]: they are carved in greater
depths than had been customary, and lean forward through an
opening similar in shape to the actual round window in the
opposite wall of the chapel. The Cardinal lies on a bier

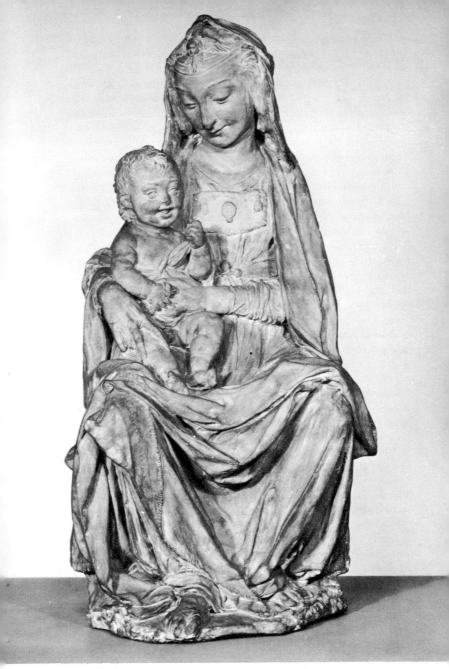

87. Virgin with the Laughing Child. Antonio Rossellino

113

above a sarcophagus that is based on a known antique example. Two children seated on the lid of the sarcophagus play with the ends of the shroud, while on the cornice immediately above a pair of angels alight in poses suggestive of continuous movement. The semicircle of the arch is visually continued in the curved edge of the hangings of the bier and picked up in the poses of the angels, such that there is a strong impression of a complete circle. The face and hands of the effigy were made from moulds, according to Vespasiano da Bisticci, and Desiderio received a payment for the death mask in 1463, which suggests that the original intention may have been for him to carve the effigy, until he became too weak to do so during his last illness.

By comparison with the Virgin and Child of the monument, a terracotta group of the Virgin with the Laughing Child [87] has been attributed to Antonio and dated about 1465: the idea of the laughing Child is close in spirit to Desiderio and the tender intimacy of the relationship between Mother and Child is typical of the mid-century attitude to the subject, where the human element is stressed, instead of the divine. The terracotta was probably a model for a marble statue, the appearance of which can be judged from a marble Virgin and Child of roughly equivalent scale which was probably Antonio's last work, the *Madonna della Latte* of the Nori Monument at Santa Croce (1478). This is a deep relief set on a pillar of the nave against a backcloth simulated in marble and above a Holy Water stoup. Its comparative solemnity is no doubt due to the fact that it was intended for a tomb, but the emotional link between Mother and Child is similar to that in the terracotta.

There exists a large number of independent reliefs of the Virgin and Child in marble, terracotta and plaster, which are attributed to Antonio on grounds of style. They tend to be carved in greater depth than was favoured by Desiderio, but the delicate features of the Virgins, with pointed chins and aquiline noses, combined with the highly realistic child portraits that represent Christ, show how close Antonio's style could come to Desiderio's. The mood of human intimacy is refined into an idealized vision, without becoming distant or hieratic: the sculptor manages to set up an emotional link with the spectator and, to judge from the numbers of copies that have survived, these reliefs were in great demand for small family shrines.

One of Antonio's few excursions into the field of life-size

sculpture is a figure of St Sebastian, which fills the central niche of an altarpiece at Empoli. The saint is bound to a tall tree trunk, and the niche precludes full side views, so that he scarcely qualifies as free-standing. The anatomy, however, is well conceived in a pose of simple *contrapposto*, with the left leg and the right shoulder forward. The interest in the ideal nude had few precedents in the mid-century and possibly represents a renewed feeling for classical sculpture.

In the 1470's, Antonio's main commissions were for a pulpit at Prato and for a tomb-chapel for Mary of Aragon, which was destined for Naples. The three narrative reliefs which he carved on the pulpit show that he did not feel at home with scenes of violent drama, few of which he had ever been called upon to execute. The overall design of the tomb in Sant'Anna dei Lombardi, Naples, was closely based on that of the Cardinal of Portugal, perhaps because the patron wished it, but a large narrative relief depicting the Nativity was introduced as an altarpiece [88]. Only there can Antonio's own carving be discerned and the rest of the complex was executed by assistants. The spatial treatment is Ghibertesque in feeling, but in the realistic peasants who function as the shepherds there seems to be an interesting influence from Flemish painting, an important example of which, the Portinari Altarpiece by Hugo van der Goes, had been imported into Florence about 1475.

Antonio seems to have been dead by 1481, and the traditions of the Rossellino workshop were continued by his assistant Benedetto da Maiano.

88. Nativity. Antonio Rossellino

6

Sculptural Portraits:

Mino da Fiesole, Benedetto da Maiano and their careers

Portrait-like realism had played an important part in Donatello's images as early as the Prophets of the Campanile [45, 47, 48], but unless one accepts identifications of some of them as likenesses of his contemporaries, there were no actual portraits by him until the head of Gattamelata. The nearest equivalent was a reliquary bust of San Rossore, made for Pisa about 1427, where the traditional form of the bust was given a radically new, realistic treatment instead of the symbolic appearance which had sufficed in the Middle Ages. It cannot of course be a portrait of the saint, but the force of character suggests that Donatello took either an individual, or perhaps a Roman bust, as a model. Equally enigmatic is the bronze Bust of a Boy (Bargello), which possibly dates from the period of the David, about 1440.

Ghiberti's interest in his own appearance is attested by a self-portrait in his youth on the North doors and the later one on the Gates of Paradise [33]: the first gives a general idea of his features, but the second projects something of his character too. The slight turn of the head was retained by later sculptors to give an impression of potential movement and vivacity.

These bronze portraits, despite their differing scales and destinations, have one factor in common: they were all modelled. The ease of moulding a head in wax, the speed with which it can be done and the corresponding effect of spontaneity mean that these portraits are more lifelike than the earliest examples in marble. The sheer difficulty of cutting and the resistance of marble partially dictate the stiff appearance and planar structure of the face in the earliest dated portrait bust, that of Piero de' Medici by Mino da Fiesole [89].

Born in 1429, Mino was a contemporary of Desiderio and apparently trained under him, after an initial period as a stonemason. He did not enter the Florentine Guild until 1464, the year of Desiderio's and Bernardo's deaths, and some ten years after the bust of Piero, which can be dated 1453 from the

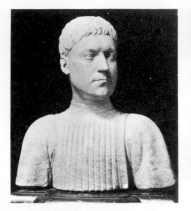

89. Piero de' Medici. Mino da Fiesole 90. Giovanni Chellini. Antonio Rossellino

inscribed age of the sitter. Piero the Gouty was the heir of
Cosimo de' Medici and a noted collector and patron of the arts.
Vasari states that the bust and a companion piece of his wife
were set over the doors of Piero's apartment in the Medici
Palace. Presumably, the patron had demanded a modern
equivalent to the ancient Roman ancestor-bust, in the humanist
spirit of living *all'antica*. The bust is Mino's earliest datable
work and he must have proven his capacity before this important
commission. The bust is stiff and tense, as we might expect of a
young sculptor who was asked to do something unfamiliar,
particularly something as daunting as portraying in marble the
features of one of the virtual rulers of Florence. That the
experiment was nevertheless counted a success can be judged
from a stream of orders for busts that ensued. Mino's first
journey to Rome and Naples is documented by two portrait
busts, one of Niccolo Strozzi which, we learn from an inscrip-
tion, was carved at Rome in 1454, and one of Astorgio Man-
fredi, the military commander, made at Naples in the following
year. Other busts followed: Luca Mini, the apothecary;
Giovanni de' Medici in full Roman armour; Rinaldo della Luna;
and his last dated bust, the Diotisalvi Neroni (1464) in the
Louvre [91]. There seems to have been some development in
Mino's facility in handling portraits, despite an underlying lack
of control in the anatomical structure of the face, which is ap-
parent in the universally hard and schematic planes of chins and
cheeks. In fact, by the stage of the Neroni bust he had grasped
the elements of characterization sufficiently to convey some-
thing of the sitter's personality and the reality of his presence.

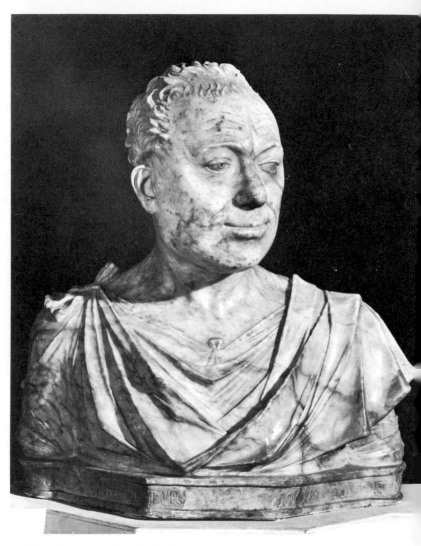

91. Diotisalvi Neroni. Mino da Fiesole

Within two years of Mino's bust of Piero, the mode was taken up by Antonio Rossellino for his first independent work, the bust of the physician Giovanni Chellini [90], which is signed and dated 1456. Despite their proximity in date, there is a world of difference between the two busts in lifelikeness and in the interpretation of character and mood: one can virtually feel the presence of Chellini in the marble bust. Antonio achieved verisimilitude by resorting to a technical device that gave an accurate, three-dimensional facsimile of the face, the life-mask. This was a process known from classical authors and recommended by Cennino Cennini, which amounted to the application of a face-pack to the sitter. This, when solidified, would provide a negative mould of the features from which a positive cast could be taken for use as a model in carving the actual marble. The use of death-masks to enhance the reality of effigies on tombs had been known for some time, but in this case, the features were generally distorted and unattractively sunken in death. Bernardo's effigy of Bruni no doubt relied on such a mask, taken, probably in wax, soon after death, while the use of moulds for the hands and face of the Cardinal of Portugal has been mentioned.

The use of a life-mask on Chellini is suggested not only by the truth to nature of minute particulars of the face and the conviction of the underlying bone structure, but also by the way in which the ears were flattened back against the skull, through the pressure of the face-pack as it was applied. That Antonio should translate this accidental effect into marble is perhaps a little surprising, but the compact volume of the head that resulted from the suppression of the ears would have been easier to carve and less vulnerable, while the patron may have wished to adhere strictly and, as it were, scientifically to the results of the mask.

The importance of the side views of the bust is quite apparent as one walks round it, the profile being the easiest contour of a human head to depict. By this date numerous medals had been minted in north Italy which served to show the impact of the profile, quite apart from the classical examples which featured in every humanist's collection. Although the fashion for medals reached Florence after that for the portrait bust, Alberti's Self-Portrait profile on a plaque, which was probably made at Florence in the 1430's, may have awakened interest. Antonio's second portrait was in fact a medallion showing the profile of Neri Capponi on his tomb [92], and the style is very

92. Neri Capponi. Antonio Rossellino 93. Bernardo Giugni.
 Mino da Fiesole

similar to that of Chellini, though executed in two and a half
dimensions, as it were, rather than three. Again something
strange seems to have happened to the ear, while the contour of
the back of the head with its close-cropped hair is suspiciously
close to that of the Chellini, which suggests that Antonio may
have been applying a formula in these areas. There is little ideal-
ization visible in the portrait, which sympathetically presents
an image of an ugly old man.

The great gulf of sensitivity that lay between Antonio and
Mino can be gauged by a comparison of the Capponi medallion
with a profile portrait of Bernardo Giugni that Mino executed
before 1466 for his tomb in the Badia [93: a version in the
Victoria and Albert Museum]. Where the Capponi was carved
in a relief of the greatest subtlety, the edges of the head melting
away in thickness as they meet the curve of the concave medal-
lion, Mino carved an image that has almost half the thickness
of a bust proper, with little compression of the planes away from
the third dimension. Such was the volume of his bust at
shoulder level, that on the tomb he had to carve a bracket
protruding from the frame to conceal its under-surface. The
cutting is bolder and far cruder, the lines of the face are incised
uniformly and without subtlety, and there is no attempt to con-
vey the surface quality of skin as it ripples over bone.

Antonio's second portrait bust is of Matteo Palmieri (1468):
the sitter was an associate of both Chellini and Capponi, all three
being prominent humanists with a cultured interest in the arts.
The bust has suffered severely from weathering because, in

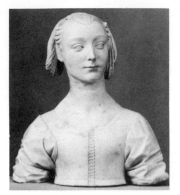

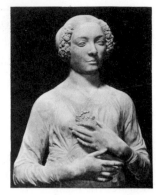

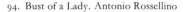
94. Bust of a Lady. Antonio Rossellino 95. Bust of 'Flora'. Verrocchio

imitation of Roman practice, it was set over the door of his house. Its surface must originally have been as delicate and smooth as that of the Chellini bust, but the removal of the 'epidermis' only emphasizes the confidence with which Antonio organized the sculptural masses of the head, especially in the crucial areas of neck and chin where poor Mino had to resort to a far more schematic rendering.

In the case of the female bust, there was little attempt to refer back to Roman busts of women, presumably because there was less pressure on the part of the sitters to appear *all'antica* and greater interest in looking *à la mode*. The high, plucked brows and elaborate, though constricted, hair styles tend to give a greater feeling of uniformity to these ladies than is the case with their male counterparts. The feminine magic of Desiderio's Pensive Girl [82] has been mentioned, and another of the anonymous female busts [94: now in Berlin] can be attributed to Antonio by comparison with the heads of the angels on the Portugal Tomb [85]. Far more self-confident than Desiderio's girl, she has a greater feeling of solidity and presence, as in Antonio's male busts.

Perhaps the most imposing of the female portraits is one generally attributed to Verrocchio, the Lady with a Bunch of Flowers (or 'Flora') [95], now in the Bargello. Once in the possession of the Medici, the bust is not mentioned in the list of works for which the artist was owed money by the family and it is difficult to determine the identification of the sitter. Of all

the busts of ladies it is the closest in solemnity of mood and severity of treatment to the Roman type, but Verrocchio extended the length of the portrait downwards to about waist level so as to include both the arms and the hands which are clasped round a posy. This startling innovation allowed the artist an additional opportunity of expressing character and mood through the action of the hands and its importance was not lost on Verrocchio's pupil, Leonardo, who utilized the device in painted portraits such as that of Mona Lisa.

The fact that a sculptor of the rather limited capacity of Mino was awarded two contracts for monumental tombs in the 1460's indicates the break in the sculptural tradition at Florence that was occasioned by the almost simultaneous deaths of Bernardo and Desiderio (1464): Antonio was occupied with the completion of the Portugal Chapel and other unfinished projects in the Rossellino shop and for a brief moment Mino, with a series of successful portrait commissions behind him, could enjoy the limelight, until he was ousted by the rising talents of Verrocchio and Benedetto in the early 1470's. Both of Mino's tombs consisted of variations on the scheme that was by now standard, with sarcophagus and inscription, bier and effigy, panelled background and a lunette and roundel above. The Giugni tomb differed in the substitution of the profile portrait [93] described above for the traditional relief of Virgin and Child. Mino also added a full-length standing figure of Justice in the central panel behind the effigy. The success of this tomb led to a commission for a second, a monument to Count Ugo of Tuscany (died 1001), which constituted his most important work in Florence [96]. This time, he not only placed a Charity in the centre of the monument but, in open imitation of Desiderio, added two shield-bearing boys at the sides. As Vasari remarked, the carving of the marble is dry and hard and although the figures have a certain sugary delicacy and trite appeal, there is not a spark of life in them. This is all too apparent by comparison with Desiderio's angels on the Marsuppini tomb [79]. With the emergence of first Verrocchio and then Benedetto, Mino must have realized that he was outclassed and took refuge at Rome (1474–80), where he collaborated with a number of other sculptors on a series of rather unimaginative and repetitive tombs, altars and tabernacles. Returning to Florence in 1480, he spent the last few years before his death in 1484 completing the monument to Count Ugo.

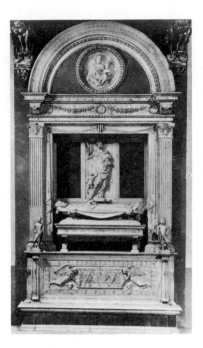

96. Monument of Count Ugo.
Mino da Fiesole

Benedetto da Maiano (born 1442) was trained as a worker in wood marquetry, but must have turned to marble carving fairly early, as he received commissions from 1468 onwards and matriculated in the Florentine Guild in 1473. Of his training nothing is known, but it is not unlikely that he worked for Antonio, perhaps helping with the Portugal Chapel in his early twenties. At a relatively early stage in his career he tried his hand at the difficult genre of the portrait bust, carving a likeness of Pietro Mellini in 1474 [97]. Where else than in the Rossellino shop could he have learned to carve such an effective portrait? Its reference to the Chellini bust is unmistakable, as is the impression that he was trying to outdo that portrait in sheer verisimilitude. The folds of skin and wrinkles on the wizened face of the old merchant are miraculously conveyed, detail for detail, while the basic structure of the head is firmly apprehended. There is one significant difference in detail from the Chellini bust: the ears are made to stick out sideways from the skull, claiming attention almost aggressively, as though to proclaim the advance in technique which permitted this passage of virtuoso carving.

123

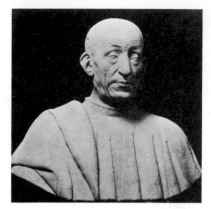

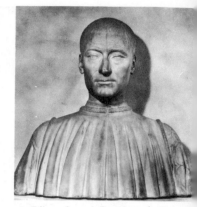

97. Pietro Mellini. Benedetto da Maiano 98. Filippo Strozzi. Benedetto da Maiano

Benedetto's other signed bust, which represents Filippo
Strozzi [98], the rival of the Medici, dates from the period late
in the 1480's when he was involved with the Strozzi Palace and
the tomb of Filippo, shortly before the latter's death in 1491.
A comparison with a terracotta model for the head in Berlin is
instructive: it shows that there is a degree of idealization in the
marble bust which one might not have suspected, as it appears
so realistic. The terracotta conveys a mood of greater intro-
spection and doubt, while its less erect head suggests an alto-
gether older man. That this was Strozzi's actual appearance is
confirmed by an independent portrait on the obverse of a medal
by Niccolo Fiorentino, which was cast to celebrate the
foundation of the palace in 1489. The marble, on the other hand,
through the frontal set of the head and the direct gaze, com-
bined with a more erect profile view and the fuller, tauter flesh
of the cheeks and neck, conveys a distinctly more youthful and
energetic impression. The treatment of the hair has reached the
greatest refinement possible in marble, forming a fine, linear,
rippling pattern over the shape of the skull.

Apart from portraiture, Benedetto's strong point was relief
sculpture, perhaps owing to his initial training as a wood
carver. His earliest work in marble, the Shrine of San Savino
at Faenza, included six narrative panels which were executed in
a dramatic style slightly reminiscent of Donatello's modelled
reliefs at San Lorenzo, though not of his marbles in shallow
relief. He understood the suggestion of space less well, and was
content with a Ghibertesque formula, consisting of a series of

figures in the foreground set against a background plane in low relief. Benedetto knew how to dispose the figures effectively in this limited depth, and was able to build up scenes of drama in a way that Antonio Rossellino had not comprehended, as we may judge from the ‾ :nels of the pulpit at Prato (1473).

His most important series of reliefs was designed for a highly decorative pulpit [99] which was commissioned by Mellini, presumably at much the same date as that of the bust, 1474. For four of the five panels that form the sides there exist terracotta sketch models [100] on a smaller scale. This method of preparation may serve to explain the affinities of Benedetto's relief style with Donatello's modelled work at San Lorenzo, rather than with the latter's marble panels. In order to suggest movement, Benedetto blocked out his forms boldly and suppressed irrelevant details. The Confirmation of the Franciscan Rule is notable for the well-managed, zig-zag spatial setting, which enlivens a scene that might have lent itself to a mundane symmetry. On the other hand, the Martyrdom of the Franciscans [100] shows how far Benedetto could fall short of Donatello's compositional genius: the foreground is cluttered and its relation with the background is insecure, while the imposing figure of the executioner, possibly derived from Pollaiuolo engravings, is not happily integrated with the other figures.

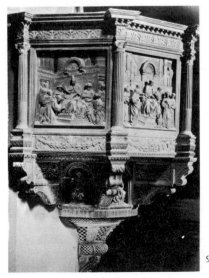

99. Pulpit, Santa Croce.
Benedetto da Maiano

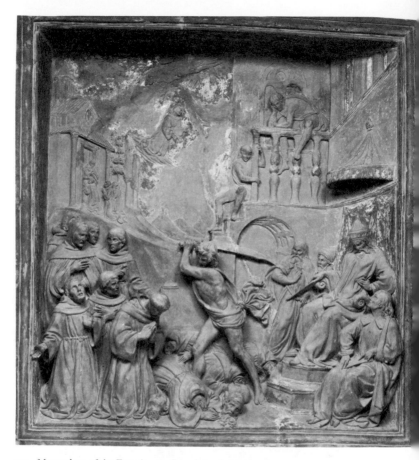

100. Martyrdom of the Franciscans. Benedetto da Maiano

In the late 1470's he carved a ciborium and a pair of candle-bearing angels of a highly decorative nature for San Domenico, Siena. At about the same moment, following the death of Antonio Rossellino (1479), he undertook the completion of the work for the Tomb of Mary of Aragon, for which Antonio had carved only the relief of the Nativity before his death. Possibly about 1480, he received an important commission for an elaborate door to the Sala dei Gigli in the Palazzo Vecchio, Florence, with above it a marble statue of St John the Baptist. Particularly when the figure is seen from beneath, as its position dictates, there is a serpentine movement about its axis which

seems to be a premonition of the sixteenth century. The facial type is not unlike Verrocchio's David, with the hair falling in long locks to the nape of the neck, but the mood of relaxation is quite different.

The most important late work by Benedetto is his altar of the Annunciation [101], which was commissioned for another chapel in Sant'Anna dei Lombardi at Naples where the tomb of Mary of Aragon had been erected only a few years before. The idea of an architectural perspective with figures entering a stage from the sides of an illusionistic hall is derived from the standard scheme for sacramental tabernacles, but the figures are enlarged in proportion to their importance. The Virgin is made into a solemn, massive figure by enveloping draperies, which give her a closed, oval outline and relate her to the saints in the flanking niches. The simplicity of Benedetto's composition gives a far more monumental effect than the crowded relief of the Nativity by Antonio Rossellino but there is little suggestion of a psychological link between the Virgin and the Annunciatory Angel, who rushes in precipitately from the left: a composition of the emotional grandeur of Donatello's Annunciation was evidently beyond him, even in his maturity.

101. Annunciation. Benedetto da Maiano

The general outlines of the composition of the altar were echoed soon after in the Corbinelli altar in Santo Spirito, Florence, by Andrea Sansovino [118]: there, the central arch, which had only been indicated by Benedetto, was extended to its full height, thus giving the architectural framework the look of a Roman triumphal arch. It may be that Sansovino learned marble carving with Benedetto, and as he matriculated in 1491, he could have had a hand in the carving of the altar of the Annunciation in the late 1480's. Benedetto, who died in 1497, thus bridged the gap between the great flowering of marble sculpture in the middle of the century and its revival with Andrea Sansovino and the young Michelangelo in the last decade, whose emergence formed a prelude to the sculpture of the High Renaissance at Florence and Rome.

7

The Maturing of the Renaissance:
Verrocchio and Pollaiuolo

Marble sculpture in the third quarter of the fifteenth century was dominated by the style of Antonio Rossellino (d. 1479) and a weaker variant produced by Mino da Fiesole. The other main sculptors active in Florence were the Della Robbia family, by this stage almost entirely devoted to the production of glazed terracotta; the Pollaiuoli, producing precious metalwork, small bronzes and paintings; and Verrocchio, who specialized in casting large bronze sculpture, but who could also carve marble and produce paintings, precious metalwork and all the decorative paraphernalia that were required by Renaissance festivals. Between the Pollaiuoli and Verrocchio there seems to have been a certain amount of professional rivalry, as their spheres of activity overlapped so extensively.

Verrocchio was selected by the successors of Cosimo de' Medici as their family sculptor, to take the place of Donatello and Desiderio, Cosimo's favourites, who had died at almost the same date as their patron (1464–6). Mino and the Pollaiuoli brothers, however, also received work from the Medici: Mino executed the series of portrait busts discussed above and the Pollaiuoli did a series of paintings of the Labours of Hercules and some bronze statuettes.

Verrocchio's early career is not documented beyond the facts that he was born in Florence in 1435 and was trained as a goldsmith but was forced to abandon that trade before 1457 for lack of employment. Our chief source of information about him consists of a list of works executed for the Medici on which payment was still owing after his death. They were demanding but niggardly patrons, as is evident from the extent of the list and from the financial straits which are revealed by Verrocchio's tax returns. Although he is reported by early sources to have worked under the elderly Donatello, his earliest identifiable marble carvings are closer in style to Desiderio da Settignano, with whom he may have collaborated on the Marsuppini monument [77] and the tabernacle of San Lorenzo [80]. A

marble Lavabo [102] in the Old Sacristy at San Lorenzo may constitute his first independent work after the death of Desiderio: it seems to have been commissioned by Piero de' Medici (who was in power 1464–9) as his personal device—an eagle holding a diamond ring—is prominently displayed in the lunette above. In the three-dimensional curves of the basin and the grotesque motifs of the central element it seems a goldsmith's design rather than an architect's. The style of the harpies at each end of the basin, with their delicate, flowing hair and slightly sinister expressions, is very close to that of similar creatures on the base of Desiderio's Marsuppini monument, and the carving is of a comparably high quality.

Verrocchio's next works show great expertise in bronze casting, and if he did not learn this from Donatello he may have picked it up from working with Vittorio Ghiberti, who was

102. Lavabo. Verrocchio

casting the bronze friezes for the Baptistry doors at that particular moment; or from Luca della Robbia, who was occupied throughout the period in question with his bronze doors for the Sacristy of the Cathedral (1445–69). Luca would certainly have been most proficient at making large figures in clay, such as Verrocchio must have prepared as a preliminary to casting his large bronzes. After executing a fine bronze Candlestick (1468, now in the Rijksmuseum, Amsterdam) for the Florentine government, he received an important commission from the Medici: this was a tomb [103] in the Old Sacristy, San Lorenzo, for Piero, who had died in 1469, and his brother Giovanni who had predeceased him. It was completed by 1472. Verrocchio conceived the original idea of setting the sarcophagus in an archway between the Sacristy and the Transept, so that both sides were visible, using a bronze grille in the form of a rope

103. Monument of Giovanni and Piero de' Medici. Verrocchio

network to separate the two spaces. The association of a sarcophagus with such a net was derived from the tomb of Neri Capponi (1457) by the Rossellini, but whereas the grille there obscured the sarcophagus, cutting it off from the spectator, Verrocchio confined it to the space above and round the edges. An element of colour was introduced by the use of red and green porphyry as well as bronze and marble. The decorative acanthus leaves and other bronze fittings on the sarcophagus are reminiscent of Ghiberti, but more florid, while the refined delicacy of the candelabra and flowers carved on the marble surrounds of the arch recalls Desiderio. The novelty of this tomb over its predecessors lies in the complete absence of Christian symbolism embodied in carved figures, and the fact that funereal grandeur and solemnity are intimated solely through the restrained splendour of the materials and the virtuosity of the workmanship.

Two of Verrocchio's most famous sculptures, the David and the Putto with a Dolphin, were executed for the Medici according to the posthumous list, but there is no indication of their dates. Stylistically, the David [104] is less advanced and may be earlier: it is an obvious critique of Donatello's bronze of the same subject [61], which was standing in the courtyard of the Medici Palace at the time of Lorenzo's wedding in 1469. The stance in the two figures, the angular projection of the left elbow and the lowered sword are closely similar. In style and mood, however, they could scarcely be more different: Donatello's slightly sensual nude boy, with long, rather feminine hair and a dreamily abstracted expression, is translated by Verrocchio into an image of a confident warrior-athlete, clad in Roman-style costume of leather breastplate, revealing the chest muscles, kilt and high boots, all with mock Kufic inscriptions to give an oriental flavour which would have satisfied a contemporary spectator as being historically correct. The arm and leg muscles seem still to be tensed from the recent struggle, while the hands, one gripping the hilt of the sword, the other resting firmly on the hip, are used to suggest the character of a man of action. As a free-standing sculpture, however, Verrocchio's David is less satisfactory than Donatello's, as it is posed frontally and its side views lack the well-defined profile and spatial interest of the earlier figure. This may have been conditioned by its intended site, if it was to be set against a wall or in a niche, where only the contours of the front view would have been important.

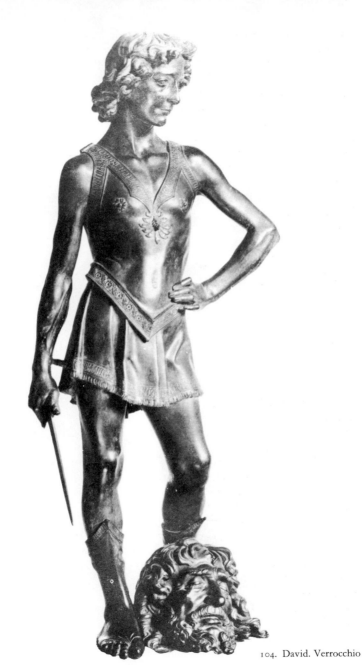

104. David. Verrocchio

105. Putto with a Dolphin. Verrocchio

That Verrocchio was capable of thinking of sculpture in the round is, in any case, proved by the Putto with a Dolphin [105] which was designed as the central decoration of a fountain in Lorenzo's country villa at Careggi. A relationship which is often remarked between this Putto and the children portrayed by Desiderio is not very convincing: Verrocchio's little boy is a more generalized version, without the individuality of portraiture. The large head and rather chubby limbs are more reminiscent of Luca della Robbia's terracotta groups of the Virgin and Child, where the Child usually shows these characteristics. Beyond this, the Putto may be inspired by Donatello's bronzes on the Siena Font and more specifically by his so-called Atys-Amorino in the Bargello, which provides a precedent both for the unusual scale, halfway between that of a statuette and a full-scale sculpture, and for the way in which the limbs project into the space round the figure. The Putto with a Dolphin is the first statue of the Renaissance to have multiple and merging viewpoints, which provoke the spectator either to rotate the figure or to walk round it in order fully to appreciate its composition. Not until the work of Michelangelo and later of Giovanni Bologna was the investigation of this problem carried further, except in the medium of the small bronze statuette, where Antonio Pollaiuolo took up the challenge in his Hercules and Antaeus [112]; but even here there was no improvement on the advanced solution of Verrocchio.

During the early 1460's, before Verrocchio had emerged as a sculptor, events were taking place at Or San Michele which were to give him an unexpected opportunity to rival Donatello beyond the confines of the Medici Palace and parish church. In 1460, the Parte Guelfa were forced to cede their niche to the Mercanzia, who erased their coat of arms and removed the statue of their patron, St Louis, notwithstanding its claim to fame as a masterpiece by Donatello. Possibly on the recommendation of Luca della Robbia, who had been their first choice, the committee approached Verrocchio in 1466 with a commission for a group in bronze of Christ and St Thomas [106]. He was paid a first advance in the following year and in 1468 began to receive a regular salary. In 1470 the amount of metal for casting the first figure, the Christ, was determined, which implies that a full-scale model had been made by that date. The Thomas seems to have been produced, after some delay, between 1476 and 1480 and the whole group was installed by 1483, when the sculptor left for Venice. The group at Or San

106. Christ and St Thomas. Verrocchio

Michele thus occupied Verrocchio throughout his career at Florence, simultaneously with all his other commitments.

Once the decision to have two figures had been reached, the artistic problem facing Verrocchio became clear: into the space of Donatello's niche, designed for a single statue, he had to fit a second large sculpture. He solved the problem by reducing the scale of the figures and having only Christ within the niche proper, making St Thomas stand below the raised podium and move in towards Christ from the left side, thrusting his right hand towards the open wound. The heavy draperies of both figures coalesce visually into a pattern of rising loops which emphasizes the feeling of movement upward and into the shadowy depths of the niche. The thick material of St Thomas's robe is so arranged as to accentuate the movement of the limbs beneath. The facial types, idealized but not specifically classical in appearance, the elaborately curled hair and the complicated, plastic drapery folds recall the tradition of Ghiberti and Luca, who were essentially modellers rather than carvers. One would indeed expect this of an artist who had been trained as a goldsmith. At this stage in Verrocchio's work one begins to feel the passionate interest in expression through physiognomy that was among the sculptor's most important legacies to his pupil, Leonardo.

This interest is exemplified in a silver narrative panel depicting the Execution of St John the Baptist [107], which he designed simultaneously with the last stages of the St Thomas (1477). This and another panel by Pollaiuolo were commissioned by the authorities of the Baptistry to complete a silver altar which had been begun about a century before. The Execution is not technically a relief, for the figures are made in the round and keyed into the sloping ground and backdrop of the scene. For this reason, there is no compression of their depth and no sense of relationship with Donatello's relief style. The figures have more in common with the small bronze statuette, which was just then coming into prominence with Pollaiuolo and Bertoldo. The figure of the executioner seen from behind, his nude musculature stressing the violent action of his upraised arm, is reminiscent of Pollaiuolo's bronzes and his famous engraving of a Battle of Nude Men [111], which had demonstrated how the correct delineation of anatomy in movement could enhance the suggestion of realism and drama (p. 143). The faces of Christ and St Thomas are echoed in the St John and the soldier on the left, while a further experiment in

107. Execution of St John the Baptist. Verrocchio

contorted facial expression, by way of contrast to these ideal features, appears in the pair of officers quarrelling at the right, apparently over their responsibility for the murder. Already, the juxtaposition of types, of the fierce emaciated older man, represented by the officers, with the fresh, almost feminine youth (on the left), plays its part in building up drama, and here can be seen the origin of Leonardo's later obsession with this motif.

Even more dramatic than the Execution of St John the Baptist is a terracotta lunette depicting the Resurrection [108] which seems to have been modelled for the Medici villa at Careggi. Within the framework of a design based on Luca's Resurrection (1442–5) in Florence Cathedral [74], Verrocchio applied a broad boldness of modelling in the faces and anatomy that is reminiscent of Donatello's plaster reliefs for the Old Sacristy at San Lorenzo, and is related to Pollaiuolo's more or less contemporary bronze statuette of Hercules and Antaeus [112]. Verrocchio breathed life into Luca's scheme by showing at least two of the

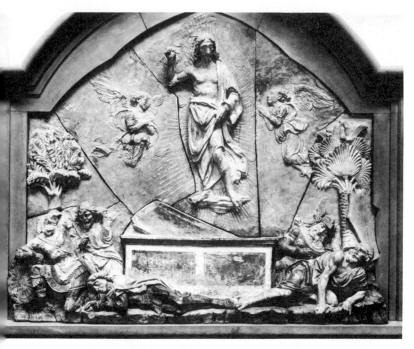

108. Resurrection. Verrocchio

soldiers in the midst of a traumatic awakening, one facing the spectator with his mouth wide open: he gives vent to a howl of terror as he turns from the Risen Christ ascending amidst rays of light between two angelic attendants. Paralysed with fear, an older man at the right clings to the rock on which he has been asleep. The faces are heavily modelled with lumps of clay squashed together to form prominent cheekbones and shadowy eye-sockets which lack eyeballs. The symbolic aspect of the scene is maintained in the decorative trees which close the composition to right and left, as in Luca's lunette. It was from work of this kind that Leonardo learned the dramatic effects of bold modelling in clay, which he was to hand on to Rustici at the turn of the century.

A project which occupied Verrocchio for the last few years at Florence was the monument to Cardinal Forteguerri. The Cardinal died in 1473 and was buried at Rome, but a committee was formed at his native Pistoia to arrange for a memorial in the

109. Sketch-model for the Monument of Cardinal Forteguerri. Verrocchio

Cathedral. After some kind of competition, a model by Verrocchio [109] was approved and a contract signed in 1476, even though a rival project by Piero Pollaiuolo was still being canvassed in the following year. Work must have begun immediately, for by the time of Verrocchio's departure for Venice (1483) the carving of the marble was well advanced. The pieces, however, were left at Florence until after 1514 and some figures were not carved until then. The monument also suffered from an adaptation to Baroque taste much later, when a portrait bust was substituted for a figure of the Cardinal kneeling in prayer and a grotesquely inappropriate frame was added. The small terracotta model in the Victoria and Albert Museum shows the projected appearance of the whole, though some details and poses were subsequently altered. Most important, it confirms that the kneeling Cardinal, ultimately carved by Rustici, was actively involved in the dramatic tableau and formed the key to the whole composition. Although it is not a tomb proper, the Forteguerri monument represents in some respects the final development of the idea outlined in the Portugal chapel: a monument animated by the participation of various allegorical figures in a common activity. Verrocchio's scheme was the most coherent of the marble tableaux of the fifteenth century, but represented an avenue of artistic thought that was not explored further until the tombs of the Baroque period. There is, however, a possibility that the representation of the deceased in an active posture may have inspired Pollaiuolo to include the figure of the Pope in the act of benediction on his monument to Innocent VIII in the 1490's. The multiple, highly plastic folds of the flowing draperies are plainly developed from the forms which Verrocchio had evolved in his modelled works. Much of the carving must have been delegated to assistants, as was normal in the workshop system of the Renaissance, but Verrocchio's personal intervention can be felt in the heads of Christ and the allegorical figures of Faith and Hope.

In 1479 the Venetian authorities decided to erect a monument to the mercenary soldier, Colleoni, who had died in 1475, leaving funds for an equestrian statue [110]. After the usual sort of competition to decide which of the available experts in bronze-casting should receive the commission, Verrocchio, who sent a life-size model of the horse in sections from Florence in 1481, won the contract. After seeing to the mounting of Christ and St Thomas, he moved to Venice in 1483. By the time of his

110. Colleoni. Verrocchio

death (1488), however, he had got no further than preparing the full scale model of horse and rider in clay, no doubt impeded by the immense technical problems of casting so large a bronze. The casting was carried out posthumously by Leopardi, to whom the surface working must be due. Presumably the overall composition of the group is Verrocchio's, and details such as the crude grimace on the face might well have looked very different had they been worked up by the master's chisel or under his supervision. By comparison with its obvious prototype, Donatello's Gattamelata in nearby Padua [65], the Colleoni is technically more advanced in the raised front hoof of the horse, which involved a difficult calculation of balance. Aesthetically it is more imposing because of the effect of *contrapposto* that is gained by swinging the head and shoulders in opposite directions about the axis of the body. The figure is larger and more erect, dominating the square below in an arresting fashion.

Verrocchio was able to blend the two disparate sculptural modes of the mid-century, the 'sweet-style' of Ghiberti and Luca and the brutal expressionism of Donatello, in a powerful artistic imagination and to produce works of an originality that owed nothing to the example of others. The sophisticated composition of the Putto with a Dolphin, the spiritual grandeur and pent-up emotion of Christ and St Thomas and the monumental and aggressive power of the Colleoni are aspects of his artistic personality which were fully utilized in the High Renaissance by Leonardo and Rustici, by Michelangelo in his early religious work, and even by Raphael in painting.

Of slightly less importance in the formation of the style of High Renaissance sculpture were the two Papal monuments at Rome by Verrocchio's rival, Antonio Pollaiuolo. His reputation at Florence was mainly achieved in media other than sculpture, ranging from the Labours of Hercules painted for the Medici and the engraved Battle of Nude Men [111], to reliefs and figurines on silver altar furniture, designs for embroidered scenes on a cope and a panel on the silver altar of the Florentine Baptistry. In the field of sculpture only the small bronze group of Hercules and Antaeus [112] and related statuettes survive to show his outstanding powers of anatomical description and his capacity for suggesting physical and emotional violence. The group was in the possession of the Medici and seems to have exerted considerable influence on subsequent depictions of violent action.

111. Battle of Nude Men (engraving). Antonio Pollaiuolo

112. Hercules and Antaeus. Antonio Pollaiuolo

The earlier of Pollaiuolo's monuments was that to Sixtus IV [113], commissioned after his death in 1484. Consisting of a glorified tomb slab, hitherto one of the less ostentatious forms of memorial even though examples had been produced by Ghiberti and Donatello, the monument comprises an effigy and a series of bronze reliefs showing allegorical figures of Virtues and Sciences with their characteristic attributes. The complex is set in a frame of acanthus scrolls reminiscent of Verrocchio's tomb of the Medici at San Lorenzo. The face of Sixtus is modelled in an uncompromisingly realistic way and the details are chiselled in bronze with a boldness that falls little short of Donatello's late work.

The later tomb is that of Pope Innocent VIII, who died in 1492. Pollaiuolo reverted to the idea of a wall monument, set in an arch, but used bronze instead of the more usual marble for the reliefs, the effigy and the seated figure of the Pope. Unlike the present arrangement, the effigy was originally set high up, immediately below the lunette, and the seated figure was near ground level. The panels of Virtues closely repeat their earlier counterparts, and the execution is generally of a more routine quality than that of the tomb of Sixtus IV. Although the original idea of the seated Pope was taken up by much later sculptors as a standard motif, the idea of a tomb decorated entirely with bronze reliefs did not find favour, as they proved to be detrimental to an effect of monumental grandeur.

113. Tomb of Sixtus IV. Antonio Pollaiuolo

8

The Sculptural High Renaissance at Florence and Rome

I. LEONARDO DA VINCI AND RUSTICI

Leonardo da Vinci had been a member of Verrocchio's shop since about 1470 and so he may have had a hand in almost all the major commissions. Several scholars have attempted to discover among the productions of the shop sculptures which might be by his hand, relying usually on facile criteria such as the presence of grotesque faces, Medusa-heads and ornamented armour or helmets. These are doomed to failure, for even a genius as great as Leonardo underwent the formal training of a workshop and hence owed many of his later themes to ideas picked up in that environment. The presence of these motifs is the hallmark of the master of the shop, Verrocchio, and not of the pupil, at least until a later stage.

Particularly important for Leonardo was his presence during the formation of the model for the Colleoni horse, for despatch to Venice in sections, between 1479 and 1481. This constituted his final collaboration with his master, and by 1482 he was in a position to write his famous letter of self-recommendation to Ludovico Sforza, Duke of Milan, in which he claimed a full knowledge of bronze-casting and offered to undertake an equestrian monument. Although his offer was accepted, the project for the monument did not materialize until 1489: then for four years he was involved in creating a full-scale terracotta model of the horse, which was destroyed during the French invasion of Milan in 1494.

Leonardo's ambitious original plan consisted of a horse and rider, the horse rearing over a vanquished foe who formed a support for its front legs. He seems to have been forced ultimately to return to the walking gait employed by Donatello and Verrocchio because of the problems of statics that the rearing pose would have involved. Leonardo's wealth of alternative ideas has survived in a series of drawings [114], which he re-used and developed when called upon at a later date to design a funerary monument to Trivulzio during his second Milanese period: the over-ambitious design once again came to

114. Drawing for the Sforza Monument. Leonardo da Vinci

nothing. The motif of rearing horses continued to fascinate him, however, and formed the mainstay of his composition for the fresco of the Battle of Anghiari, which was commissioned at Florence early in the sixteenth century but never completed. From a note on one of the preliminary drawings for this fresco we can reasonably deduce that it was his practice to make small wax models from which to study the complicated spiralling poses in which he visualized horses. Apart from some bronzes which are rather tenuously connected with his name on this evidence, there exists a series of terracotta groups of fighting horsemen of great complication and vivacity, some of which may be by his hand rather than by Rustici, to whom they are normally attributed [117].

Born in 1474, Rustici was another member of the workshop of Verrocchio, though one who was too young ever to have worked directly under the master. By 1504, he could be listed by Pomponius Gauricus in his *De Scultura* as one of the major sculptors of Tuscany, along with Benedetto da Maiano, Andrea Sansovino and Michelangelo. Of noble birth and ample means, Rustici was a dilettante sculptor who was able to remain relatively free of the ties of a workshop. One may assume from the heterogeneous products that have survived that he changed his style as the mood took him. He also painted, according to Vasari, though none of his works has been identified, and this possibly accounts for long periods of apparent inactivity, for instance from about 1515 until his departure to France in 1528.

Some of his earliest works are in terracotta, glazed in the Della Robbia workshops, and this has long delayed their identification. A marble roundel of the Virgin and Child [115], which tallies with one that he is recorded as having executed for the

115. Virgin and Child. Rustici

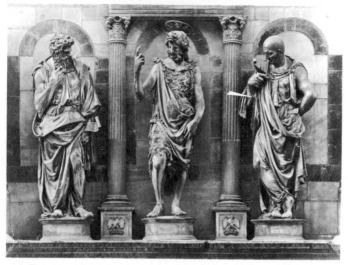

116. Preaching of St John the Baptist. Rustici

Guild of Silk Merchants, appears to be a 'comment' on two famous roundels carved by Michelangelo for private patrons in the early sixteenth century [133]. Its design is based partly on the Turin Madonna by Desiderio [84], but is concerned with relating the group to the circular field. It seems to have formed a starting point for one of Raphael's later paintings at Rome, the Alba Madonna.

Rustici's main claim to fame rests on the success of a group of three large bronze figures which depicts the Preaching of St John the Baptist over the North door of the Baptistry [116]. Commissioned in 1506, the group was cast in 1509 and unveiled on St John's Day, 1511. Rustici and Leonardo were living in the same house at this period, and their intimate association described by Vasari probably dates from this late stage in Rustici's career: Leonardesque influences are conspicuously lacking in his earlier sculpture. In his biography of Rustici, Vasari asserts that Leonardo's help with the group amounted to no more than technical assistance in casting, and he goes out of his way to deny rumours that Leonardo was the creator of the actual models; in his life of Leonardo, however, he suggests that the latter gave advice on the compositions too. Whatever the solution, the figures are so Leonardesque in character that if Rustici invented them, he must have been under very strong influence from the older artist.

The three participants are not treated as a coherent group in an illusionistic way as in Verrocchio's group of Christ and St Thomas [106], but each has his own little round pedestal, while St John is given prominence by the framing columns of the *aedicula* rather than by truly sculptural means. In fact, the figures function well in this quasi-independent way, the spiral poses and inward gaze of the Pharisee (left) and the Levite (right) emphasizing St John as the focus of attention. In the Pharisee, the bare, muscular arm and huge hand that in annoyance clutches at his flowing beard, and the heavy but handsome features under a tousled mop of hair combine with the bulky draperies to form a very powerful image, and one which seems not unconnected with Michelangelo's Moses [137]. Rustici's interest in the hideous, bald Levite, with rolls of flesh swelling his face to grotesque proportions, is well within the tradition of Verrocchio's shop and the older sculptor's fascination with physiognomy and its potential expressiveness. The Levite's position, with one leg crossed in front of the other and the opposite forearm behind the back, gives a feeling of spiral movement within a static pose, reflecting the inner turmoil of the man's spirit. The bald head and long sweep of drapery from shoulder to ankle would immediately have recalled to any Florentine the emaciated figure of Habakkuk, carved some eighty years before by Donatello and set in a niche on the nearby Campanile [48].

Rustici made a number of small groups in terracotta of fighting horsemen [117] for various private collectors in Florence and the few that have survived reflect the same close attention to Leonardo's style as the Baptistry group. Presumably Rustici had access to Leonardo's drawings for the Milanese monuments and for the fresco of the Battle of Anghiari, the basic units of which were composed of closely intertwined groups of cavalry in action. In plastic form, the theme had recently been popularized by a bronze relief by Bertoldo, cast for the Medici Palace, where a frieze-like composition derived from a Roman sarcophagus had been enlivened with considerable spiral movement in depth [131].

The last sculpture by Rustici that has so far been identified conclusively is a medium-sized bronze Mercury. It was commissioned by Cardinal Giulio de' Medici for a fountain in the palace, as a result of his admiration for Rustici's contribution to some temporary decorations that had been erected in Florence for the Entry of Pope Leo X (1515). It is fully

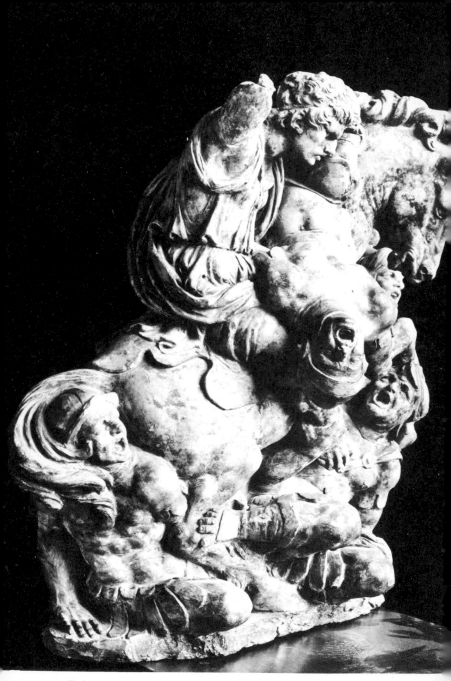

117. Fighting Horsemen. Rustici

described by Vasari because of its ingenuity as a mechanical toy: the statuette is pierced for water pipes and a jet from the mouth caused a whirligig once held in the right hand to revolve. Stylistically, the bronze is not as close to the Baptistry group or the style of Leonardo as might have been expected: the bold modelling and chiselling of the muscular anatomy recall rather the Hercules and Antaeus by Pollaiuolo, then in the possession of the Medici [112]. Evidently after Leonardo's departure Rustici turned to other examples for inspiration.

Between this date and his departure for France (1528), we know no sculpture certainly by his hand, although Vasari mentions a number which have not yet been identified.

The tradition begun by Verrocchio seems to have died in Florence with Rustici. The latter's chief pupil, Bandinelli, made little reference to Verrocchio, his attention being riveted to the work of Michelangelo and to antique sculpture. Michelangelo himself, on the other hand, showed in the early part of his career a greater appreciation of Verrocchio's late style in marble and bronze than any other sculptor.

II. ANDREA AND JACOPO SANSOVINO

Andrea Sansovino, a native of Monte San Savino in southern Tuscany, whence he derived his surname, seems to have been born between 1467 and 1471. The style of two early terracotta altarpieces in his native town, particularly one of the Virgin and Child with Saints, bears out Vasari's statement that Andrea was apprenticed initially to Pollaiuolo. He used the elongated female figures with small heads and bulky, swirling drapery that Pollaiuolo favoured, for instance in the silver figures of the Birth of the Baptist, made in 1477 for the altar of the Baptistry. Andrea's first significant work in marble, the altar of the Sacrament at Santo Spirito, Florence [118], was executed presumably not long after 1485, when his patrons, the Corbinelli family, were granted the ownership of the chapel. It must have been finished by 1491, when he was sent by Lorenzo de' Medici to Portugal as an artistic emissary. The triumphal arch motif on which the design of the altar was based (before its Baroque remodelling) is closely related to Benedetto da Maiano's altar of the Annunciation in Naples [101], but Andrea made a far more exciting and significant use of the opportunities that the scheme offered for sculpture, both in the round and in relief.

Four separate areas are decorated with reliefs: the lunette with a Coronation of the Virgin; two hollow roundels with the

118. Corbinelli Altar. Andrea Sansovino

119. Monument of Cardinal Basso della Rovere. Andrea Sansovino

Angel and Virgin of the Annunciation; the predella with narrative scenes, including the Last Supper, the many small figures of which are carved very freely in an 'impressionistic' technique that is derived from Benedetto's relief style; and the antependium with a Pietà in medium relief. Where Benedetto had been content with truncated figures of saints leaning out of their roundels as though from portholes, Andrea constructed intricate scenes giving an illusion of perspective, for which he took account of the low viewpoint of the spectator. The figures in the Pietà are much rounder and more classical in the firm modelling of flesh than their prototypes in Desiderio's Pietà on the San Lorenzo tabernacle of thirty years before [80], where the drama and pain of the subject had been treated in the style of Donatello. The St Matthew in the left niche has a new grandeur by comparison with Andrea's earlier terracotta saints, and his drapery hangs with a resonance of echoing curves which emphasizes the S-shape of the saint's pose. This pose was used again in most of his later statues and taken over by his pupil

Jacopo. The increased classicism of style that is manifested on the Corbinelli altar may be the result of an involvement with the activities of the Medici Sculpture Garden at about this date. Andrea matriculated in the Guild of Sculptors in 1491 and was one of the judges in a competition for the design of a new façade for the Cathedral, which gives some indication of his prominence.

Vasari's account of Andrea's activities in Portugal, where he was sent in 1491 by Lorenzo de' Medici, is very vague and no sculptures by his hand have as yet been convincingly identified there: in any case, judging by his next certain works, carved after his return in 1501, his style does not seem to have changed significantly. He was interested initially in the large spoilt block of marble which was ultimately given to Michelangelo and used for his David, but early in 1502 he was commissioned by the Guild of Merchants to carve a group of the Baptism of Christ in marble for the Baptistry [120]. The figures of Christ and St John, left unfinished when he was summoned to Rome (1505), were completed and erected by Vincenzo Danti in 1569. The extent of the latter's intervention is hard to judge, but both figures bear the stamp of Andrea's style as manifested in other works of the same date, such as a pair of marble figures for Genoa. Within a compositional formula that owes much to Ghiberti's interpretation of the subject [20], Andrea introduced a nearly nude Christ who is of outstanding grace and inner composure, His fine, muscular body adhering to the classical canons of proportion and pose. As in Rustici's bronze group of a few years later, a comparison with Verrocchio's Christ and St Thomas at Or San Michele is inevitable [106]. The shallowness of the ledge on the Baptistry where these later groups had to be disposed militated against a group with the coherence of Verrocchio's, and symbolism rather than realism was the keynote: this was where the example of Ghiberti proved useful.

In an almost contemporary Virgin and Child for Genoa, Andrea gave the Virgin a distinctly Roman face and style of hair, as if to proclaim his allegiance to the classical ideal at a time when Michelangelo was still content to perfect in his Bruges Madonna the facial type that had been invented by Verrocchio.

Important commissions for the Cathedral and Palazzo Vecchio which were awarded in 1504 had to be abandoned when Andrea was summoned to Rome in 1505 by Pope Julius II, to design and carve a monument to Cardinal Ascanio Sforza, who had died in May. This was to form part of the remodelling

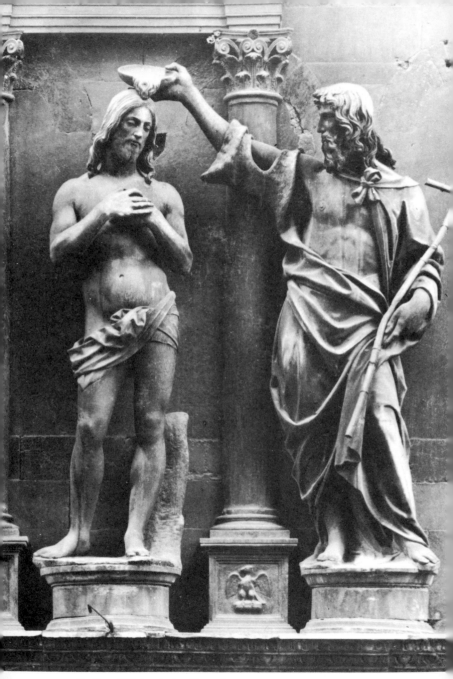

120. Baptism of Christ. Andrea Sansovino

of the choir of Santa Maria del Popolo, which was being supervised by Bramante, and he may have had a hand in the architectural design of the tomb. In 1507, a twin tomb was begun on the opposite side of the choir to house the remains of Cardinal Basso della Rovere [119], and both were finished with remarkable expedition, as they were mentioned in a guide book of 1509. Within the framework of a triumphal arch, female allegories of Virtue in niches flank a central effigy, which lies on the traditional sarcophagus, but supports itself in a novel pose on one elbow, facing the spectator. The allegorical figures are severely Roman in style, with centrally parted, waving hair, firm, well-proportioned bodies and heavy swathes of drapery, except for the Temperance, which was singled out by Vasari for praise because of its graceful *contrapposto* and diaphanous drapery. The seated figures of Faith and Hope on each tomb are related in style to figures painted by Raphael on the ceiling of the Stanza della Segnatura in the Vatican at the same period and are a typical product of the High Renaissance style that was current at Rome in the first decade of the sixteenth century.

The connection of Andrea with Raphael became explicit in a commission of 1512 for a Virgin and Child with St Anne [121], for the group was to be set at the foot of a pier on which Raphael was to paint a fresco of Isaiah, in the nave of Sant' Agostino. The subject of Andrea's group had, of course, been extensively treated by Leonardo, and his composition is related to the solution which Leonardo had sketched in his famous Cartoon (now in the National Gallery, London). When seen from in front, the two female figures are not entirely happily related but, with a calculation typical of Raphael, Andrea designed the group so that the most satisfactory view meets a spectator approaching from the west end of the nave (i.e. from the side of the group on which the Virgin is seated). From this angle, the heavy St Anne, raised on a plinth, is partly concealed by the Virgin and Child and her face and upper torso are swung to face the spectator, such that the composition appears more homogeneous as a sculptural mass. The very shape of the oval base which bears the sculptor's signature also serves to diminish the emphasis on a strictly frontal view. The classical abstraction of the Virgin's face, which perhaps reduces the emotional impact of the group on the modern spectator, was for Vasari and presumably for Andrea's contemporaries 'a divine beauty', which was especially pleasing by contrast with the realistic treatment of the face of the older St Anne.

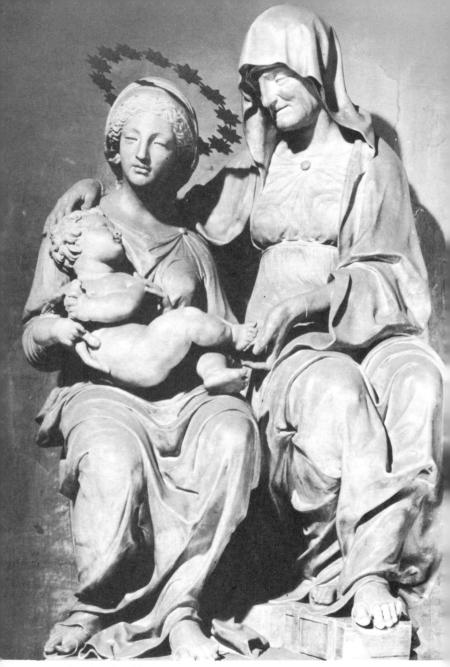

121. Virgin and Child with St Anne. Andrea Sansovino

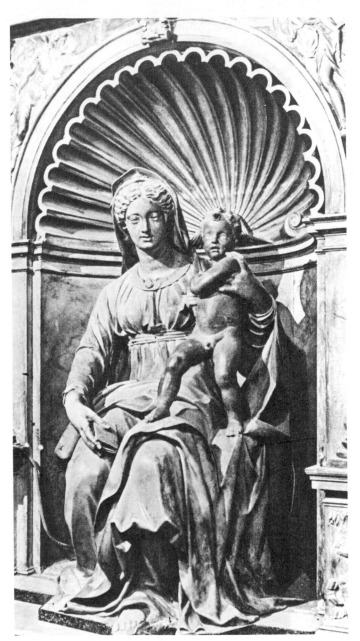

122. Madonna del Parto. Jacopo Sansovino

Shortly after this group, Andrea received a Papal commission which was to occupy him, sometimes against his will, for the rest of his career. This consisted of supervising the erection and sculptural decoration of the Holy House at Loreto, to designs submitted by Bramante in 1510. Weighed down by administrative responsibility, Andrea executed only two of the large panels of relief, an Annunciation [123] and an Adoration of the Shepherds, although he supervised the designs of the rest, which were carved in the main by sculptors of the younger generation, such as Bandinelli and Tribolo. The Annunciation is characterized by an interest in spatial illusion, the architecture receding into the composition in diagonals as in his early roundels of the same scene on the Corbinelli Altar. The Virgin is swathed in heavy drapery, the play of folds serving to emphasize her sudden rotary movement of alarm, but her Roman features are once again almost too impassive for the drama of the situation. Andrea died on one of his annual periods of leave from this commission, in 1529.

Jacopo Tatti, born at Florence in 1486, was apprenticed to Andrea Sansovino in 1502 and soon adopted his surname out of affection. He must have had a hand in blocking out the marble figures of the Baptism [120] and the statues for Genoa. He seems to have been involved in wood carving too. When Andrea went to Rome in 1505, Jacopo went too, possibly on

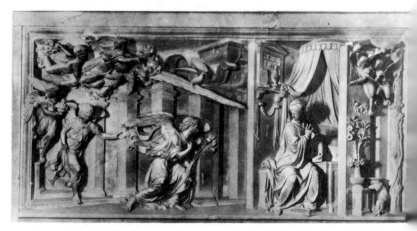

123. Annunciation. Andrea Sansovino

the invitation of Giuliano da Sangallo, who was one of Pope Julius' architects. Jacopo was taken up by Bramante when working at the Belvedere in the Vatican on restoring antique statuary, and was probably present at the excavation and identification of the Hellenistic group of Laocoön in 1506. At any rate, he made a wax model of it in competition and was named the winner by the judge, who was none other than Raphael himself.

When Sangallo fell ill and returned to Florence, Bramante found Jacopo a room in the Della Rovere palace, where the painter Perugino was also lodging at the time. This was the occasion of his making a wax model of the Deposition [124] in preparation for a painting by Perugino, probably in 1510. The original picture is lost but variants exist which testify to the accuracy of Vasari's information. The idea of making small scale models in wax for paintings recalls the practice of Leonardo in connection with the Battle of Anghiari. The model, which is Jacopo's earliest surviving work, is formed of wax, cloth and wood, unusual materials for a masterpiece. There is considerable realism and drama in the movements of the groups and the interest in depicting the human body in action from all angles may have been inspired by Michelangelo's cartoon for the Battle of Cascina, as well as Hellenistic sculptural groups such as the Laocoön. The pose of Christ's body, which is reminiscent of Raphael's Entombment, painted in 1507 for Perugia, may have been suggested by Perugino, who would have known his pupil's painting. The expressive boldness of modelling which gives the Deposition such a monumental quality recalls Verrocchio (the Resurrection [108]), Pollaiuolo and Donatello, who were by now regarded as canonical sources for this kind of subject.

That Jacopo used small models for his own compositions is proved by the existence of a Virgin and Child (Budapest) which was the winning design in a competition for a group on the façade of the Mercato Vecchio, held soon after his return to Florence in 1511. A lifelong friendship with the painter Andrea del Sarto found expression at this stage in their setting up a joint workshop, which was frequented by most of the younger generation of artists at Florence. Andrea del Sarto gave one of the bystanders in his fresco of the Adoration of the Magi in Santissima Annunziata the features of Jacopo, while the sculptor provided a model for a Saint John in Andrea's painting of the Madonna of the Harpies.

161

124. Deposition. Jacopo Sansovino

The authorities of Florence Cathedral had commissioned a series of twelve Apostles from Michelangelo some years before, but as he had abandoned work on the first, a St Matthew [125], in 1506, they decided to allot the figures to separate sculptors, beginning with a St James by Jacopo Sansovino [126]. This figure is intimately related to Andrea Sansovino's St John the Baptist for Genoa, on which Jacopo may have helped, and it shows the same fascination with the grace and calm of Ghiberti. Nothing could be further from the physical and emotional tensions of Michelangelo's unfinished St Matthew, with its strongly projecting bare knee and violently turned head. Of the St James, Vasari rightly remarks upon the skilful under-cutting of the drapery and this tends to reflect the dominant impression made by the figure, which, without being a master-piece, is well-conceived and satisfactory.

125. St Matthew. Michelangelo 126. St James. Jacopo Sansovino

Whether the opposition of the St James to the St Matthew was entirely deliberate or not, there can be no doubt that Jacopo's immediate ambition, when commissioned by a private patron to carve a Bacchus [127] in the same year, was to challenge Michelangelo, whose version of the subject he must have seen in the garden of Jacopo Galli at Rome [128]. Michelangelo had retained the heavy, muscular, Polycleitan build of a typical Roman Bacchus for his figure, though he had turned the frontal composition of antiquity into a spiral group, arrested in movement. Jacopo adopted the spiral pose with a little satyr behind, as in the earlier group, to counterpoint the main figure and to support the weight of marble, but invented an altogether more lithe and graceful figure, almost Praxitelean in proportions. He did not try to emulate the suggestive stagger of Michelangelo's rather paunchy youth, who stares with exaggerated concentration at his cup as though suffering from an alcoholic haze. Instead he chose to put an entirely different interpretation upon the subject, making his Bacchus a sprightly and joyful figure, thus stressing the elevation of the spirit by the god of wine, rather than its debasement. Vasari made much of a story about Jacopo studying the nude from the life, and rightly pointed out how daring and successful was the virtuoso motif of the raised arm with its delicately carved fingers.

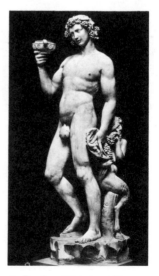

127. Bacchus. Jacopo Sansovino

128. Bacchus. Michelangelo

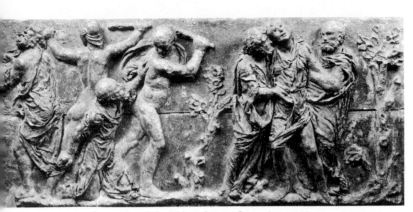

129. Susannah and the Elders. Jacopo Sansovino

For the triumphal Entry of Pope Leo X de' Medici into Florence in 1515, a large number of temporary decorations were made in perishable materials such as cardboard, canvas, stucco or clay, under the joint supervision of Andrea del Sarto and Jacopo. The survival of a panel which appears to have formed part of Jacopo's contribution to the temporary façade that was erected in front of the unfinished west end of the Cathedral is almost miraculous: executed on two boards, with the figures in clay and their draperies moulded in linen stiffened with size, the relief represents the Old Testament story of Susannah and the Elders [129]. The immediacy of the easily worked medium and the violent nature of the theme give this work a spontaneity and drama which fall little short in effectiveness of Donatello's plaster roundels in the Old Sacristy at San Lorenzo [59]. The eyes of the figures are gouged out in a technique reminiscent of Verrocchio's Resurrection [108], which may have been transmitted to Jacopo via Leonardo and Rustici. The stylistic connections of the panel with the Deposition [124] are extremely close too, in the vigorous poses and freely modelled forms: the bald soldier who swings his club at one of the offending Elders is depicted in an almost identical way to the man perched on top of the cross in the Deposition. The composition also has strong connections with contemporary painting: the naked soldiers of one group bespeak a knowledge of Raphael's composition of the Massacre of the Innocents, probably transmitted through the engraving by Marcantonio, while the group round Susannah is closely related to a fresco by Andrea del Sarto in the Scalzo cloister.

As a result of his contribution to the temporary façade of the Cathedral, Jacopo seems to have been promised some part in the project of Leo X for a permanent façade for the Medici church, San Lorenzo. Michelangelo managed, however, to exclude Jacopo from participating even in the proposed narrative panels, and the latter's dismay is recorded in a letter of 1517. As soon as he had completed his St James for the Cathedral, Jacopo returned to Rome and must have begun the Madonna del Parto [122] for Sant'Agostino immediately, as it was complete by 1519. This group of the Virgin and Child was commissioned by a Florentine and was to stand in the same church as Andrea Sansovino's earlier Virgin and Child with St Anne [121]. An element of competition no doubt inspired Jacopo's highly intelligent solution to the problem of the siting of his group, which conditioned its composition even more positively than had been the case with Andrea's sculpture. As one entered the church, the group was to one's right: accordingly, both figures were designed to turn their heads so as to meet the spectator's glance. From this preliminary vantage point, the head of the Child appears to be the focus of attention at the centre of a concave, shell-like niche, though when one has moved directly in front of the group, the Virgin's head occupies this position. The Child stands with one foot on the arm of the throne, which is enveloped in the Virgin's drapery, and with the other firmly planted on the broad folds over her knee. The little figure is supported by her left hand, which forms a visual counterpoint to the spiral movement that is set up by her right hand and arm. Christ is thus encircled protectively by the position of His mother, just as both figures are by the shape of the niche. The classicism of Andrea's Virgin is retained and even increased, but the well-defined eye-lids and pupils of Jacopo's give her face a positive expression of lively attention, in contrast with the veiled emotion that is suggested by the downcast and heavy-lidded eyes of Andrea's figure.

A statue of St James for the Spanish church dedicated to that saint at Rome must have been carved at much the same time as the Madonna del Parto, as the Cardinal who had commissioned it in his will died in 1517. By comparison with the St James [126] of Florence Cathedral, this statue is characterized by a greater attention to muscularity and strength, perhaps reflecting the impression made on Jacopo by the unveiling in 1521 of Michelangelo's Christ at Santa Maria sopra Minerva. The only other project that Jacopo undertook in the way of sculpture

consisted of a double monument to Cardinal Sant'Angelo and the Bishop of Agen in the church of San Marcello, where he held the position of architect after a fire of 1519. Apart from the inconvenient addition of a second bier and effigy, the design added little to the scheme that had been invented by Bramante and Andrea Sansovino for Santa Maria del Popolo earlier in the century. In fact the addition of extra sculptural elements tended to upset the precise balance of sculpture and architecture that they had achieved.

The comparatively small amount of sculpture that Jacopo executed between 1518 and his flight to Venice at the time of the Sack of Rome (1527) is a reflection of the increasing interest and employment that he was finding in architecture. Some measure of his attainment in this field can be gauged from the fact that he beat Raphael, Peruzzi and Antonio da Sangallo in a competition for the design of the Florentine church, San Giovanni, at Rome. With his departure from Rome, Jacopo moves out of the sculptural orbit of Florence altogether and the story of his success at Venice as an ever more classicizing, though highly imaginative sculptor, forms the backbone of the history of sixteenth-century sculpture in Northern Italy.

9
Michelangelo

The sculpture of Michelangelo has attracted more attention than that of any other Renaissance artist, and yet it still remains surprisingly enigmatic. The intense emotional involvement of the sculptor with each of his creations superficially appears to lay bare his soul to the spectator's gaze, and this has led to an impossibly wide range of subjective interpretations, which often tell us more about their authors than about Michelangelo. For there is a fatal tendency to read into sculptures as deeply moving and deceptively simple as his any philosophy or state of mind that one chooses and to explain their apparent activity or mood in any number of conflicting ways. These factors militate against a rational appraisal of his contribution to Italian sculpture and the style of the High Renaissance.

As with the late, 'expressionist' works of Donatello, so with a high proportion of Michelangelo's sculptures one has the feeling that they stand, partly at least, outside the normal patterns of artistic development, so exclusively personal do they seem. Although both artists were widely admired in their time, their contemporaries stood in great awe of them and, unable to comprehend their full range of expression, derived from their art only a limited number of motifs and ideas which they felt able to assimilate into their own repertories.

Thus, although the classic moment of equipoise in artistic style which we term the High Renaissance was completely overshadowed by Michelangelo's presence, only a handful of his sculptures properly fall within the terms of reference which we normally use to define the character of this moment. As in the case of Raphael, Michelangelo's train of artistic thought was in perpetual motion, ever advancing from problems solved to meet further self-imposed demands on his inventive powers. Both men were instrumental in creating the High Renaissance, and yet both were the driving forces behind the ensuing tendency towards stylistic extremes of various kinds that was to disturb its equilibrium and usher in the epoch which we call

Mannerism. The total production of either artist defies our vain attempt to draw neat dividing lines between the links of the unbroken chain of artistic development, and to characterize Mannerism as though it stood in unnatural opposition to the High Renaissance, when in fact it developed smoothly out of some of the highest artistic achievements of that period. The astounding fertility of Michelangelo's imagination is responsible for a paradoxical situation in sculpture, for the characteristics which we choose to regard as constituting High Renaissance style appear more persistently in the work of contemporaries like Andrea or Jacopo Sansovino than in that of Michelangelo himself. In the art of painting, however, the same is true: these characteristics have a longer currency in the productions of, for instance, Fra Bartolommeo or the young Andrea del Sarto than in the work of Raphael, or indeed of Michelangelo. One must, therefore, constantly bear in mind the ambivalence of the relationship between Michelangelo and the High Renaissance when examining his sculpture.

Within the scope of a single chapter in a survey such as this, a full account of Michelangelo's complicated career and detailed discussions of all his sculptures are out of the question. All that can reasonably be attempted is a summary of his career, concentrating particularly on the most famous of his works at Florence, with the barest outlines of his technical and stylistic development, and an assessment of his position with regard to his predecessors, contemporaries and followers.

Michelangelo's long and turbulent career was unusual from the very start. Perhaps because his father had been trying to make him study for one of the professions at a grammar school, he did not begin his apprenticeship with the painter Domenico Ghirlandaio until 1488, when he was thirteen. This meant that he was three years older than average. He must already have mastered the first principles of drawing by then, for his articles specified that he was to begin painting straight away, instead of starting with drawing, like a normal apprentice. The fact that he was to receive pay during his first year was also unusual and implies that he was sufficiently advanced to be of some real assistance to his master.

However, after serving only one year of his apprenticeship with Ghirlandaio, Michelangelo came to the notice of Lorenzo de' Medici, who was at the time virtually the arbiter of taste in Florence, as well as being her political and diplomatic leader. With a number of other promising young artists, Michelangelo

was selected by Lorenzo to further his studies under ideal conditions in the distinguished circle of the Medici. Apart from having the intellectual stimulus of coming into daily contact with the greatest minds in Florence, Michelangelo was privileged to work and study in the Medici sculpture garden, which had recently been installed in the Casino Mediceo under the supervision of Bertoldo (see p. 96). Among the works of art that had been assembled by the Medici family over three generations Michelangelo was free to devote himself to his chosen pursuit, the art of sculpture, stimulated no doubt by the classical statues which formed the nucleus of the collection. Bertoldo was himself a sculptor and had been an assistant of Donatello during the finishing stages of work on the bronze pulpits for San Lorenzo. He seems to have remained in the employment of the Medici from that time onward, specializing in bronze sculpture, usually on the small scale of statuettes, reliefs, medals and plaquettes. These did not appeal greatly to Michelangelo, who felt drawn to carving marble on a grand scale. Nevertheless, their interests overlapped in one area of sculpture, modelling. As has been explained in the Introduction, this is the basic, creative stage in the process of bronze casting, and Bertoldo was thus admirably qualified to demonstrate to his pupils the making of models in wax or clay. Michelangelo evidently profited by this, for ever afterwards small models played a vital role as preliminary sketches in the process of designing his monumental sculpture [138]: in fact some of his most ambitious projects are known only through the survival of such models [141]. Furthermore, the dramatic poses and violent movements of Bertoldo's figures, which were ultimately inspired by Donatello, exerted a strong appeal on Michelangelo and proved to be a powerful, formative influence on his style.

The fact that Bertoldo was not, as far as we know, a carver of marble may, somewhat paradoxically, have been beneficial. For it meant that Michelangelo was free to invent his own technique by trial and error and did not have to imitate the set ways of a particular master, as he would have been forced to do in a conventional Renaissance workshop. This freedom from a formal training also allowed him to think out his own solutions to every problem of composition and expression from first principles, without having stereotyped solutions thrust upon him. His genius was thus liberated from an allegiance to any particular style and he could survey the sculpture of the whole early Renaissance quite impartially. This freedom of choice

allowed him exceptional opportunities for self-expression, but made correspondingly heavy demands on his imagination and emotions, owing to the intense concentration which each and every sculpture required.

Michelangelo's freedom from stylistic conventions and the spontaneity of his approach to both form and meaning are amply demonstrated in his first surviving sculptures. These are two marble reliefs, carved probably while he was still working in the Medici sculpture garden, before the death of Lorenzo in 1492. They are highly original and surprisingly competent for a student of between fourteen and seventeen years of age, containing the germs of many later compositions and giving a foretastè of the two extremes of his artistic personality. One, the Battle of the Centaurs [130], has the violent movement and intense drama of the later Slaves, the Moses and the Victory group; the other, the Virgin of the Steps [132], foreshadows the contemplative stillness and deep melancholy of the Pietà in St Peter's, the Bruges Madonna and the sculptures in the Medici Chapel.

The Battle of the Centaurs is patently based on Bertoldo's masterpiece, the bronze relief of a Battle of Horsemen [131] which had a place of honour over a mantelpiece in the Medici Palace. Bertoldo's design in turn was based on a badly damaged Roman sarcophagus which still survives in the Camposanto at Pisa. The struggling multitude of figures in Bertoldo's relief are modelled almost in the round like bronze statuettes and stand out from the flat plane of bronze which serves as a background. They are conceived with unprecedented boldness in a series of vigorous poses suggesting physical exertion, rapid movement and emotional strain. Michelangelo's marble relief is remarkably different from Bertoldo's bronze, or the Roman prototype, because of the totally different way in which its figures seem to grow out of the background of marble and then to merge with it again, linked by their limbs in an inextricable conflict. A feeling of unity and intensity is imparted by one's consciousness of the original surface of the block, to which the foremost parts of most figures adhere, and one feels that Michelangelo was familiar with the relief panels on the pulpits by the Pisani, which provide the nearest precedent for this compositional method.

The Battle of the Centaurs is unfinished, and a comparison of its technique with that of his later sculptures left at a similar stage of completion, for instance the Taddei roundel [133:

171

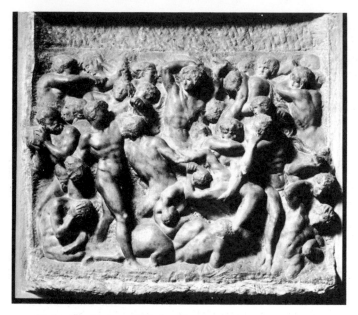

130. Battle of the Centaurs. Michelangelo

Royal Academy, London] shows how little he changed the unique and characteristic method of carving which he had developed at this early stage of his career. The directions of the parallel grooves left by the claw-chisel are used to differentiate the varying planes of the anatomy, as the skin ripples over muscle and bone. With each shape that he has to describe, Michelangelo alters the direction from which he attacks the block, leaving a mesh of criss-cross lines that subtly emphasize the rise and fall of the surface of the marble. This technique is remarkably similar to his early style of pen drawing, where hollows on a piece of drapery or anatomy were suggested not only by varying intensities of shading, but also by the actual direction in which the strokes were applied to the paper. By comparison with the standard method of shading by parallel hatchings, this technique gave a far more lively effect of relief or recession, and the same was true of his use of the claw-chisel in carving. Thus the drawing style that he perfected while with Ghirlandaio formed the basis of his self-taught sculptural technique.

The Virgin of the Steps is highly finished, unlike the Battle,

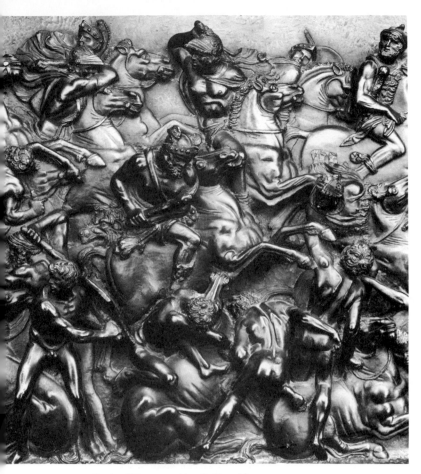

131. Battle of Horsemen (detail). Bertoldo

and has an almost waxy, smooth surface. It is carved in shallow relief, the technique invented by Donatello, and no doubt represents an experiment with the expressive effects that could be achieved by its use. Despite the existence of accepted formulae for the common subject of the Virgin and Child, Michelangelo invented an entirely new scheme, after a profound re-appraisal of its meaning. The Virgin, seated on a plain block, is shown in profile and has an expression of silent foreboding. Her pose and mood are derived from the mourning

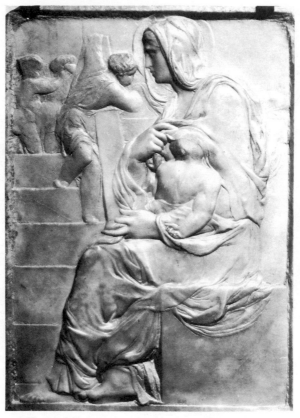

132. Virgin of the Steps. Michelangelo

women who are shown like this on Greek tombstones (*stelai*) and Michelangelo's use of this ancient, expressive motif implies that he thought of the subject in terms of a premonition of a Pietà group translated into a thoroughly classical idiom. This seems to be confirmed by an examination of the Child, whose face is hidden (which is extremely unusual) and whose back is relaxed in deep sleep, for He looks almost as though He were slumped in death. Only in occasional reliefs by Donatello can similar depths of foreboding be felt, and Michelangelo's use of shallow relief strongly suggests that he had drawn his inspiration from this source, while adding particular point to his image by the discerning use of a motif from classical art. A comparison of this version of the Virgin and Child with any of

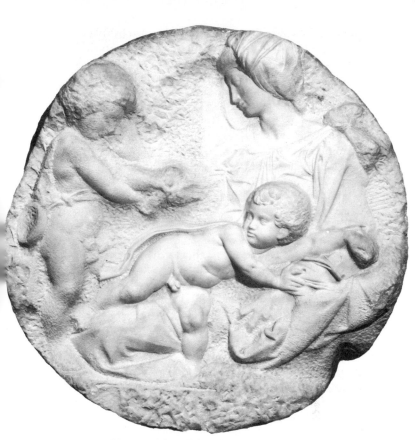

133. Taddei Roundel. Michelangelo

those produced in the middle of the fifteenth century by
sculptors such as Antonio Rossellino, Benedetto da Maiano or
Verrocchio, with their pretty, decorative details and charming
attention to the emotional rapport between a human mother
and child, serves to show how completely Michelangelo was
prepared to break with tradition, even at this early stage of his
career, in order to achieve a new depth of expression.

The knowledge of the nude that made the Battle of the Cen-
taurs so effective was probably gained at second hand, by
copying other works of art, particularly classical sculpture.
However, this traditional method did not suffice for Michel-
angelo's purposes. Nothing short of a complete understanding
of the working of the human body would give him the power

to equal or excel ancient sculpture. This he obtained by dint of dissecting corpses in secret in the mortuary of Santo Spirito, with the connivance of the Prior. It is unfortunate that a Hercules which he carved about 1493 has been lost, for it would surely have demonstrated his new-found expertise. In any case, the control of anatomy that he gained at this time stood him in good stead throughout his career, for the nude was to be the vehicle for his finest achievements in conveying profound depths of emotion.

The fall of the Medici from power and the threat of a French invasion caused Michelangelo to flee north in 1494 and subsequently to settle for a time in Bologna. Here he received a commission to carve three figures which were needed to complete the shrine of St Dominic, left unfinished at the death of Niccolo dell'Arca. The style of his figures was to some extent conditioned by the previous statues on the shrine, but even so their poses betray his interest in anatomy. Furthermore, the features of the St Proclus also show his awakening interest in the suggestion of emotion through facial expression: in fact, its grimace suggests a specific source, the head of Verrocchio's Colleoni. It is significant to find him borrowing directly from the greatest exponent of this aspect of artistic expression since Donatello himself.

Michelangelo returned to Florence late in 1495 and carved two statues which are now lost. One of these, a Sleeping Cupid, rendered the antique model on which it was based so convincingly that for a while it deceived its purchaser, Cardinal Riario. When the latter discovered that he owned not an antique but a work by a contemporary sculptor, he was deeply impressed and encouraged Michelangelo to move to Rome under his patronage (1496). There the young man was able to immerse himself in the study of ancient sculpture and thus to complete his education, according to the ideals of the Renaissance. He soon received an important commission from a certain Jacopo Galli for a statue of a thoroughly classical subject, a Bacchus [128]. In complete contrast to the attitude of reverence for classical prototypes which had prevailed for the previous century, Michelangelo ignored the standard Roman treatments of the subject. Instead, he used this opportunity to explore the suggestion of movement, showing the Bacchus in a staggering, reeling pose that is suggestive of drunkenness. The spiral axis of his body is counterpointed by the serpentine pose of the baby satyr which sits on a tree trunk behind nibbling grapes. The

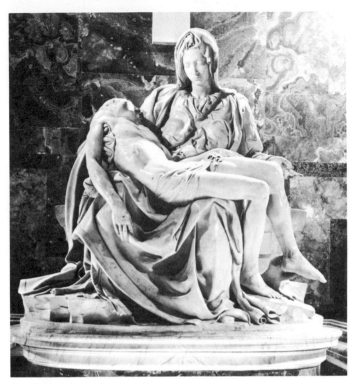

134. Pietà, Rome. Michelangelo

open mouth and dilated pupils of the eyes convey the clouding of the faculties of his mind as effectively as the firm jaw, compressed lips and purposefully focused eyes were to convey an impression of concentration and alertness in the David of a few years later [135].

It was also through Galli that Michelangelo received his first important religious commission, the Pietà in St Peter's [134]. As usual, the theme has been thought out afresh. The unprecedented composition may have been suggested by his patron, a French Cardinal, for the only examples of the dead Christ lying across Mary's lap in this way are to be found in northern Gothic sculpture and not in Italy. The perfect purity and melancholy of the Virgin's face, depicted young and beautiful to emphasize her spiritual innocence, according to Michelangelo's own explanation, reflects his attention to a less

remote source of inspiration, the late marble sculpture of Verrocchio. The same facial type was used again a few years later in the Bruges Madonna, but thereafter it gave way to a more personal type infused with the influence of classical sculpture, as in the roundels made for the Pitti and Taddei families [133]. The little, submissive gesture of the Virgin's left hand seems to include the spectator in the spiritual orbit of the group, in rather the same way as the motions of the hands do in a painting such as the Virgin of the Rocks by Leonardo. Both works are among the highest expressions of what has been called the 'sweet style' of the fifteenth century in Florence, and typify the peak of perfection in the visual arts that was reached about the year 1500 in the High Renaissance.

During his first visit to Rome, Michelangelo seems to have had little direct contact with the Papal court, but Galli negotiated for him a commission connected with the unfinished Piccolomini altar in Siena Cathedral, a project in which Pope Pius IV was particularly interested. As on the shrine of St Dominic, a number of statues were required for a predetermined setting, the sort of task which Michelangelo never found congenial, owing to the restrictions which were imposed on his freedom of expression.

Returning to Florence in 1501, he was soon distracted by a far more attractive proposition, a colossal statue of David [135], as a symbol of the Republican government. The carving took three years and the statue that resulted established Michelangelo's reputation not only in Florence but all over Italy and even further afield. To this day it has remained his most celebrated work. Unlike the earlier statues of David by Donatello [61] and Verrocchio [104], Michelangelo's marble giant was so conceived that it conveyed an eternal image of spiritual courage and physical energy without the need for a symbolic weapon such as the sword, and even the sling is nearly obscured from the front. A comparison with his earlier figure of St Proclus shows how rapidly he had perfected his means of expression: the nude body, its pose and gestures, and facial expression. The fierce glare of David has infinitely greater nobility than the caricatured anger of St Proclus, copied from Verrocchio's Colleoni; his hands have become far larger in proportion and correspondingly more expressive; and his measured stance is more secure than the uncertain half step of the saint. Though tense and alert, the David was conceived as momentarily standing still, and not as a moving figure like the earlier Bacchus.

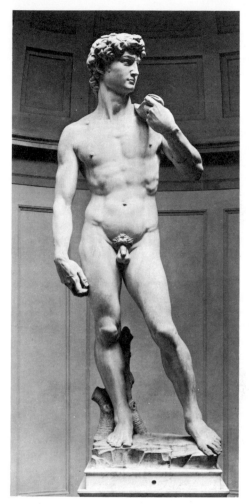

135. David. Michelangelo

This solution was forced on Michelangelo both by the comparative shallowness of the actual block of marble and by the vain efforts of several earlier sculptors who had made false starts on carving. The lack of depth demanded a frontal figure without much projection into space. Fortunately, his method of carving was ideally suited to overcoming the difficulties inherent in the shape of the block.

When faced with carving a statue in the round, Michelangelo would begin by cutting into the face of the block, gradually removing layer after layer of marble round the edge of his figure, as though it were simply a relief. He does not seem to have cut into the block from all sides, which was the normal method. This meant that he had scope for continual alterations and revisions of the contours, and even the positions, of all the parts of his projected figure that lay further back within the remainder of the untouched block. The forms nearest the surface would be worked up to the stage of claw-chiselling, while those lying behind were as yet only roughly blocked out. By this continuous process of blocking out the broad masses of marble and then refining the most prominent details, the creation of the figure was constantly in flux and needed the complete attention of the artist at every stage. The best example of the early stages of the process is the St Matthew [125], commissioned shortly before work on the David was complete, but never finished (see below).

As the figure was revealed from the front by cutting back into the depth of the block, so side views would automatically begin to emerge. Only at this stage would Michelangelo begin to work up the statue from these angles too, as can be seen in some of the unfinished Slaves for the Julius Tomb [139] (see below). The existence of so many statues that were left by sheer coincidence at different stages of completion enables us to plot every point in the process of creating an individual work; while sculptures that were finished, or nearly so, permit us to guess the intended appearance of those which were abandoned. The unfinished statues are always more colossal than the finished ones, as several extraneous layers of marble remain to be cut away to reveal the final forms. These layers of course alter the proportions of the figure, particularly of the limbs, where an additional thickness of marble appears greater than on the torso. This accounts for the massiveness of the unfinished Slaves for the Julius Tomb.

The St Matthew, mentioned above, was to have been the first of the series of twelve Apostles which were commissioned for Florence Cathedral just before the David reached completion. The work that Michelangelo actually carried out on the statue dated from 1506, and when it became apparent that he would never complete this single figure, let alone twelve, the authorities decided to commission other sculptors to carve one Apostle each, and began, as we have already seen, by awarding the St

James to Jacopo Sansovino (1511). The interruption of work on the St Matthew was not Michelangelo's fault, for in 1505 he was summoned peremptorily to Rome by Pope Julius II, who ordered him to design a monumental tomb which was to be housed in St Peter's. This project, calling initially for over forty statues of life size or above, was impossibly ambitious and caused the artist much distress throughout his career, owing to the importunity of his patrons. Things began badly when he found himself short of funds within a few months of starting work, owing to the Pope's decision to channel most of the available resources into Bramante's reconstruction of St Peter's itself. After futile protests, Michelangelo fled back to Florence in April 1506, out of sheer frustration, and began furiously to carve the St Matthew.

We are surely justified in reading into the fiercely angular and distorted shapes of the Apostle some of the deep disappointment and violent resentment that the sculptor felt. The composition with its bold muscular torsions reflects the impression made on him by the Hellenistic marble group of Laocoön, which had just been excavated in Rome, but Michelangelo made it the vehicle of his own strong emotions. His sculptures were such urgent and personal creations that his own states of mind were inevitably imparted to them, particularly in times of stress, even when they were not logically applicable to the particular subject he was treating. This aspect of his statues, even when unfinished, as extensions of his personality and tangible manifestations of his emotions gives them the profound appeal that they have exerted on all who have seen them, from the sixteenth century until the present day.

Michelangelo's main opportunity to explore the expressive possibilities of movement came not in sculpture, however, but in the more immediate and flexible medium of fresco painting. For between 1508 and 1512 he was totally occupied with the ceiling of the Sistine Chapel, imposed on him as a form of discipline by the Pope. Although he resented this distraction from his favourite art, Michelangelo was able to explore more freely in paint than would have been possible in marble the expressive effects that he could convey through ideal human bodies in movement. The experience provided a catalyst for the release of his full powers in his chosen medium.

It was not until after the completion of the ceiling and the subsequent death of the Pope (1513) that Michelangelo was free to start carving some of the many figures required for Julius'

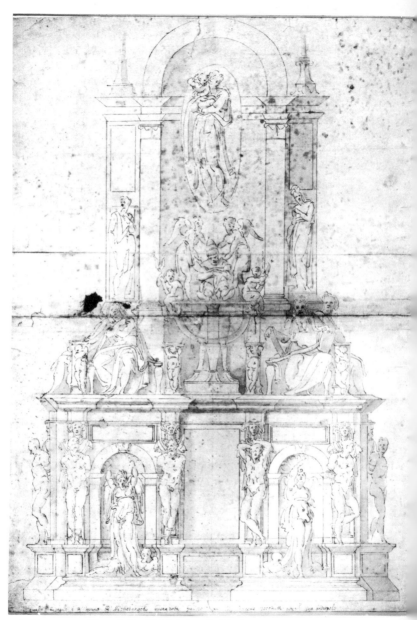

136. Monument of Pope Julius II. Michelangelo (after)

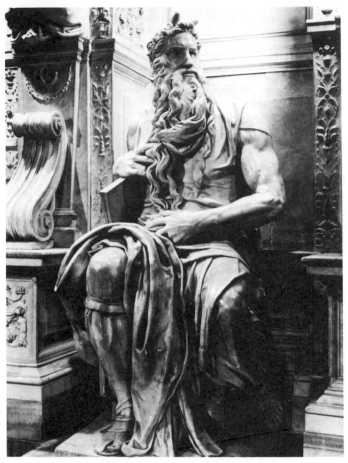

137. Moses. Michelangelo

Tomb. A revised contract was signed with Julius' heirs in May 1513, which stated that the tomb was to have one end abutting a wall. It was therefore no longer completely free-standing as in the initial project and the total number of sculptures was reduced [136]. At this stage Michelangelo carved the three most finished figures: the Moses [137], unhappily ensconced in the monument as it was ultimately erected, and the two Slaves, now in the Louvre. All three demonstrate his new-found range of expression. The Dying Slave has a spiral movement, reminiscent of the Bacchus, but infinitely more refined. His supremely

graceful, languid posture and sensuous expression suggest an entirely different mood. Our impression is that the mind of this ideal being must be suspended on the borders of consciousness either because of some deep emotional suffering or through the effort to awake from a deep slumber. These contradictory interpretations have both found support among Michelangelo's early biographers and later critics.

An unfinished ape behind the Slave seems to justify an interpretation of these ideal nudes as allegories of the visual arts (the ape symbolizing the imitative aspect of art), but whether they are meant to be dying, with the Pope, or to be freeing themselves from symbolic bonds in token of his enlightened patronage while alive seems to be an open question. Vasari regarded them simply as prisoners, which indeed reflects their probable origin in such figures on classical sarcophagi. But as part of a Christian funeral monument they must have borne an additional connotation based on the idea of the triumph of the soul over mortality, like the groups of Victory that were destined for the niches between them. The various levels of meaning possibly reflect the development of Michelangelo's own thinking during the lengthy process of executing the monument.

The other Slave (called Rebellious from his pose) and the Moses are less relief-like than the Dying Slave, because they were designed as corner figures and had to offer two satisfactory views, from the front and from the side. In the Rebellious Slave, this is achieved by a violent *contrapposto*, giving him a spiral movement, while in the Moses, the seated position is opened out to the side by the withdrawal of one leg and the turn of the head. His present setting in the central niche at ground level in the wall-monument at San Pietro in Vincoli fails to take account of this directional bias and drastically reduces the effectiveness of a figure originally designed as one of the climaxes of a mass of intimately related sculpture.

Work on the tomb was next interrupted by a project for a permanent façade for San Lorenzo, instigated by the Medici Pope Leo X, as a result of his ceremonial entry into Florence in 1515. The question of cooperating with Jacopo Sansovino arose, but Michelangelo refused to work with a man whom he felt belonged to the camp of his great rivals, Raphael and Bramante. The project was terminated in 1519 after some four years' work, owing to the Pope's decision to give precedence to a funereal chapel annexed to the transept of San Lorenzo to commemorate four members of his family, two of whom had

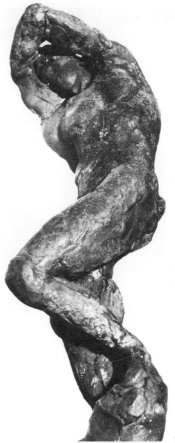

138. Slave (wax model). Michelangelo

died not long before. During this busy period, Michelangelo seems to have carved the four unfinished Slaves [138, 139], all still in Florence, for a third, still further reduced version of the Julius tomb. They are appreciably larger than the earlier pair, for which two appear to be replacements. All four now give the impression of supporting something above their heads, and the sculptor may have intended them for the role of caryatids, to be integrated into the architecture of the tomb. This alteration in their function is typical of his creative process and is reflected in carefully revised compositions. Their movements are given a common motivation which lends a greater unity to the series.

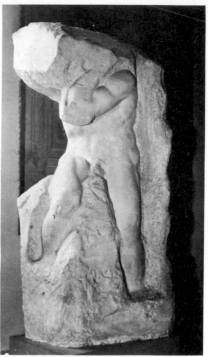

139. Atlas Slave. Michelangelo

Michelangelo's search for expression through violent move-
ment seems to have continued in the only statue that was carved
for the tomb during the 1520's, the Victory [140]. Such groups
involving two figures, one standing and one crushed beneath,
had been envisaged since the beginning of the project to fill
niches between the pilasters against which the Slaves were
bound. Only the one group was executed by the master, but his
abundant ideas for further groups seem to have inspired
important works by a younger generation of sculptors,
Ammanati, Pierino da Vinci and Vincenzo Danti, while
Giovanni Bologna took the Victory itself as a starting point for
his notable series of major groups in marble (1565–82).
Michelangelo's Victory was thus one of the most influential
compositions in the history of sixteenth-century sculpture.
Within a pyramidal shape it has a spiral movement that was
intentionally flame- or serpent-like: this became known as the
figura serpentinata, and constituted one of the canons of com-

140. Victory. Michelangelo

position which were demanded in sculpture and painting throughout the Mannerist period. The spiral was admirably suited to a free-standing composition, but as the Victory was intended for a niche, which would restrict the number of points of view, Michelangelo adapted his design by setting the arm squarely across the body and almost parallel with the original front surface of the block from which it was carved. This deliberate frontality was increased by the bizarre face of the victim which peers out beneath, pointing directly forward.

There is in the Casa Buonarotti a clay model [141] which is entirely spiral in conception and lacks these references to a frontal point of view. Thus it is fundamentally unlikely to have been designed for one of the other niches on the Julius monument as a pendant to the Victory, as has been claimed. It was more probably made in connection with an important scheme for a free-standing group of Hercules and Cacus to match the David, an earlier project which was revived about 1525.

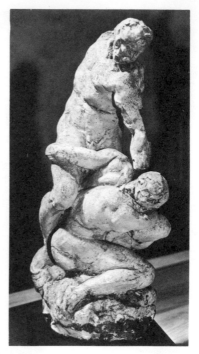

Initially, on the orders of Pope Clement VII, who did not wish
Michelangelo to be distracted from the sculpture of the Medici
Chapel, the block of marble was given to his inept rival,
Bandinelli. With a change of the regime in Florence, however,
the commission was transferred to Michelangelo and the clay
model may have been made at this stage. The arms and one leg
of the defeated Cacus curl round the legs of Hercules, leading
one's eye round the group, and there is a sense of struggle that is
very different from the stylized pose of the Victory and his
passive victim. A third figure was integrated into the group
when the subject of Hercules and Cacus was changed to
Samson and two Philistines (1528): Michelangelo's new design
seems to be recorded in a number of small bronze groups [142]
that may have been cast by pupils after an original model for the
monument. The position of the kneeling figure is changed to
give an effect of even greater spirality and he appears basically
behind the standing figure, instead of in front as before. The
third figure lies awkwardly beneath, spreading the base of the

188

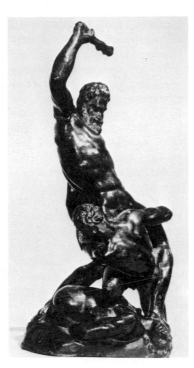

142. Samson and Two Philistines.
Michelangelo (after)

group even wider, while the raised arm of Samson constitutes, as it were, the tip of the flame, in terms of which the design was consciously organized. Unfortunately, the commission was yet again transferred to Bandinelli after the Siege of Florence, and he made of it the over-formal and uninspiring group of Hercules and Cacus that stands in front of the Palazzo Vecchio [144]. Michelangelo's most advanced piece of sculptural thinking was not realised, and it was left for Giovanni Bologna to take advantage of these experiments for his marble Samson and a Philistine as long afterwards as 1567 [179].

While work continued spasmodically on the Julius tomb (until the final erection in San Pietro in Vincoli in 1545 of that miserable fragment that we have of the original scheme, incorporating the Moses and only two other statues by Michelangelo's hand) the master was principally occupied with the Medici Chapel at San Lorenzo. Letters of Autumn 1520 between sculptor and patron suggest that initially a free-standing tomb structure was intended for the chapel, which was approximately

to match the Old Sacristy by Brunelleschi on the opposite side of the church. Owing to the confined space that the site permitted, wall tombs were soon admitted to be more practical, and the four sepulchres that were needed were first visualized as two pairs set against the opposite side walls. Subsequently the final scheme was adopted, with a single tomb on each side wall, and a double tomb (never executed) on the end wall opposite the altar. Michelangelo began the architecture immediately, and signed contracts for the supply of marble for sculpture too. Four statues had been begun by 1525 and two more by June 1526, when the architecture of the second wall tomb was begun. The Sack of Rome (1527) and the declaration of a Republic at Florence interrupted work, and Michelangelo was involved first with the projected Hercules and Cacus and later with the fortifications of the city at the time of its siege (1529). Between 1530 and 1534, work continued on the figures for the chapel and other sculptors were employed to help complete the scheme. Though most of the statues had been carved by the time of Michelangelo's departure for Rome (1534) they had not been put in place, and were later installed by Tribolo (1545).

One of the most celebrated complexes of sculpture in the world, Michelangelo's Medici Chapel has exerted a continual fascination on subsequent generations, not only for the sublime grandeur of its artistic effect but also for the problems of interpretation that it has been thought to present. In fact, the allegorical ideas that are embodied in the sculpture seem, from close attention to Michelangelo's own comments, to have been basically simple in conception. We can deduce most about the tomb of Giuliano [143], Duke of Nemours, from first hand evidence: on one of the preparatory drawings, the sculptor jotted down an imaginary dialogue between Night and Day, which implies that he regarded them (and by analogy the intermediate phases Dawn and Dusk on the other tomb) merely as symbols of the passing of time, to which Giuliano's death was due. Below these allegorical figures of the Times of Day on the sarcophagi, and recumbent like them but facing inwards, Michelangelo intended a pair of river gods, based on classical prototypes such as are found at the acute angles of many ancient pediments. These were never carved, but a full-scale terracotta model for the torso of one, with its extremities unfortunately missing, has survived in the Accademia, Florence. In the case of Giuliano's tomb, they were to have represented, reasonably enough, the rivers Tiber and Arno. The seated figures of the

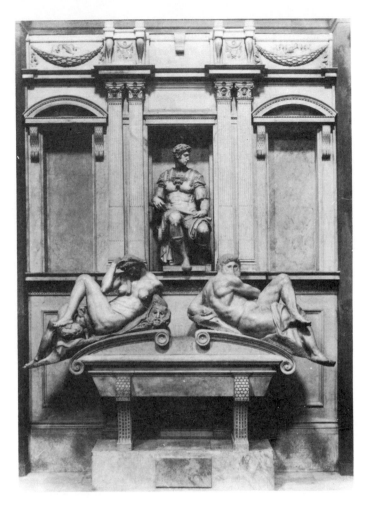

143. Tomb of Giuliano de' Medici. Michelangelo

deceased were not literal portraits, but idealized representations which rely for their effect on the subtle differentiation of character and mood. Giuliano was to have been flanked by further allegorical figures in the shallow niches at each side representing Heaven, rejoicing over his death, and Earth lamenting it. A model for one of these was made under Michelangelo's direction by Tribolo, who had been assigned

191

by Pope Clement to assist him, but who fell ill soon after beginning the marble. Above, figures crouching in mourning, of which the nude boy at Leningrad may be one, were to complete the sculptural decoration. Thus the apposite idea of mourning lay behind all the sculptures and Michelangelo adapted different motifs from ancient sculpture to supply the novel imagery. As with a single statue, the sculptor appears from the mass of drawings that have survived to have preferred to keep the design of the whole in flux while the details began to crystallize. This impeded progress until, in the early 1530's, he was forced by his patron to delegate some of the carving to assistants, among whom were Montorsoli and Tribolo. Exciting though the existing figures are, we cannot know what the total effect would have been, if the sculptor had pursued his ideas to a conclusion, with the usual radical changes along the way. In the event, Michelangelo had no further hand in the Medici Chapel after his final departure to Rome in 1534.

The unfortunate lack of completion that mars such a high proportion of Michelangelo's sculpture has given rise to a mistaken theory that he preferred to leave his work unfinished ('*non finito*'). This idea is fundamentally anachronistic, involving as it does, the transfer to Michelangelo of current modes of artistic thought, such as the virtues of 'truth to materials', 'natural forms' and so on. The fact that his sculptures can be appreciated in such terms is merely an indication that he, and most other good Renaissance sculptors, took these considerations into account at least subconsciously when designing their compositions: by the sixteenth century it was accepted as a matter of course to think in terms of '*disegno*' or abstract shape when composing a work of art. The expression of such abstractions was a fundamental means to the artist's end (which was probably as simple as 'beautiful sculpture'), but not an end in itself.

There are several reasons why so much of Michelangelo's sculpture was never completed. By far the most important was the extreme personal involvement that his working method demanded: the arduous process of creating a sculpture chisel-stroke by chisel-stroke, continually revising and varying the first idea, precluded the employment of assistants to undertake the physical labour of blocking out the main shape of the figure, which was the standard procedure of Renaissance workshops. Michelangelo was temperamentally incapable of delegating

artistic responsibility in this way. Yet his patrons, accustomed as they were to dealing with artists who relied heavily on assistants to produce a respectable quantity and quality of work, demanded of him what they took to be a reasonable amount of sculpture, supremely unaware of the strain that they were imposing on a highly strung temperament. What they did not appreciate was that every feature of his work bore the mark of his genius, or, if they appreciated the resultant high quality, they failed to make allowance for the intense emotion and superhuman effort that produced it. To them, an individual statue was destined to be part of a grandiose complex, in which a large number of essentially similar statues would be required: witness the forty-seven sculptures that were initially envisaged for the tomb of Pope Julius. To Michelangelo, on the other hand, the individual sculpture had to embody a perfect expression of an idea that he had in mind. The tragic result of this contradiction in aims between artist and patrons was the incompletion of so many noble schemes. The sculptor's apparent slowness led to the substitution of one project for another, and the resultant distractions from the task in hand and the material setbacks involved caused the artist deep frustrations and bitter resentment, often culminating in the emotional crises that led to his abandoning statues at any stage of the work.

It is inconceivable that Michelangelo intended any of his figures to remain unfinished, or that he preferred them so. The aim expressed in his writings was to embody in marble the ideal forms that he visualized in his mind's eye and which he regarded as facets of a divine truth and perfection. Accordingly, he must have regarded the extraneous marble layers that disguise some of his figures as a severe impediment to the proper expression of his inner ideal.

In fact, during the sixteenth century, the four Unfinished Slaves were not treated with the possibly exaggerated reverence in which they are now held, but were used to decorate the grotto in the Boboli Gardens, where they were set among pretence stalactites and regarded as faintly humorous grotesques.

10

Sculpture at the Court of Cosimo I de' Medici

1. BANDINELLI AND CELLINI

In the history of sixteenth-century sculpture a break is apparent about the year 1530: most of the sculptors who had received their training in the fifteenth century and had subsequently contributed to the High Renaissance were removed from the scene by that year: Andrea Sansovino by his death in 1529; his pupil, Jacopo, by his flight to Venice at the time of the Sack of Rome (1527); and Rustici by his departure to France in 1528 as a result of political disturbances at Florence. In the career of Michelangelo there was a crisis in 1534, when he left Florence for Rome, never to return. His departure coincided with the unveiling of the important sculptural group of Hercules and Cacus [144] by his rival, Baccio Bandinelli, an event which was almost symbolic of the latter's assumption of power as principal sculptor in Florence, a position that he was to enjoy for some twenty years under the patronage of Cosimo I de' Medici, to whom he was virtually court sculptor. The Hercules and Cacus was at the same time a manifestation of Bandinelli's inherent weakness as a monumental sculptor. The volume of criticism that it justifiably provoked gave him a poor start, just when the field had been cleared of his greatest rival.

Of course, the shadow of Michelangelo loomed over Florentine sculpture until his death in 1564. His opinions and actual designs were frequently sought by patrons, while the legacy of half-finished material for the Medici Chapel was the object of constant attention, as successive members of the family attempted to bring the project to a satisfactory conclusion. The theme of the group with two figures, a standing victor and a crushed victim, such as Michelangelo had planned for the niches on the Julius tomb, continued to fascinate artists of the younger generation, most of whom tried their hands at it sooner or later.

To give Bandinelli his due, he had a number of successful marble sculptures to his credit before the fiasco of the Hercules and Cacus. Born in 1488, the son of a goldsmith and inlay

expert, he turned to sculpture after an initial training in these crafts and was apprenticed to Rustici, apparently receiving the approbation of Leonardo. Like most of his contemporaries, he studied the possibilities of the male nude from Michelangelo's preliminary cartoon for the fresco of the Battle of Cascina, and seems from an early age to have been jealously fascinated by the genius of that master, whom he spent much of his career trying vainly to emulate. As a result of an early wax model for a St Jerome, which he presented to the Medici on their return to power in 1512, he received his first important official commission, for a statue of St Peter in the series of Apostles that had been abortively begun by Michelangelo and continued by Jacopo Sansovino. He apparently laboured over the figure for some time, but failed to achieve more than a distant echo of Donatello's St Mark in the pose and drapery, while the head, a caricature of earlier prototypes, conspicuously lacked expressive power. The disappointing absence of movement and grace becomes more apparent on comparison with Sansovino's St James. Between 1517–19 he was sent by Pope Leo X to assist Andrea Sansovino with the reliefs of the Holy House at Loreto and it was there that he received his initial training in a field of sculpture which was to prove his one strong point. Immediately after, he carved a statue of Orpheus for the Medici Palace which turned out rather well, perhaps owing to its heavy reliance on an ancient prototype, the Apollo Belvedere. Late in 1520 a copy of the Laocoön was commissioned for the King of France; it was so successful that the Medici retained it for their palace, whence it reached its present site in the Uffizi. Bandinelli's dalliance with the antique seems to have been less frustrating than his emulation of Michelangelo, no doubt because the same depth of emotional expressiveness was not demanded when working from ancient models. At this stage he was very active as a draughtsman and several of his compositions were engraved as a permanent tribute to his powers of design: by comparison with the engravings after Raphael and Michelangelo which he was hoping to outdo, his figures seem academic and mannered, and are crowded together in over-ambitious combinations.

What appeared to be his great opportunity to rival Michelangelo occurred in 1525 when a marble block which had been quarried for a pendant to the David arrived in Florence and was handed over to him, in order not to distract Michelangelo from his work on the Medici Chapel. The subject of Hercules had

always intrigued Bandinelli and we know of two earlier attempts at the theme. A first wax model was not suited to the shape of the block and a variant composition which he modelled at full scale in plaster was generally admitted to be inferior in energy and drama. The commission was the subject of Michelangelo's attention for a short time in 1528, under the republican government which was hostile to Bandinelli, and he evolved the composition with three figures, known from bronze casts [142]. When Bandinelli regained control of the block with the victory of the Medici (1529) he did not avail himself of these new ideas, but carved the arid, formal group that still stands in front of the Palazzo Vecchio [144]. The faces are no more than caricatures of violence and the group is rigidly posed, without the least suggestion of potential movement. These deficiencies were remarked as soon as the sculpture was unveiled and formed the substance of many derisory sonnets that were pinned to it by the Florentine public: Cellini's later description of the anatomy as a 'sack of melons' was by no means inapposite. The artistic shortcomings of the group were probably aggravated by the sculptor's political alignment with the Medici Pope, Clement VII, who laid siege to Florence in 1529. Michelangelo, of course, had been on the side of the republican government that had attempted to defend the liberty of the city. Furthermore, the two main literary sources that refer to Bandinelli were written from hostile points of view, that by Cellini owing to personal enmity and that by Vasari because of the sculptor's rivalry with Michelangelo, Vasari's hero.

Bandinelli's talent for negotiating ambitious commissions, which he often failed to fulfil, began to emerge in the 1530's: first, he undertook a statue of the Genoese admiral, Andrea Doria, which after a series of delays he finally abandoned in 1538; and next he promised the Pope a series of bronze statues for the Castel Sant'Angelo, Rome, which got no further than the stage of preliminary models. All that resulted was a series of bronze statuettes, made as experiments in casting technique [145]. The mythological figures that he produced, based firmly on antique compositions, possess a liveliness and grace that are lacking in most of his marble figures. Shortly after the unveiling of Hercules and Cacus, Bandinelli secured a commission for the sculpture on a pair of monumental tombs for the Medici Popes, Leo X and Clement VII, which were erected ultimately in Santa Maria sopra Minerva, Rome. A number of

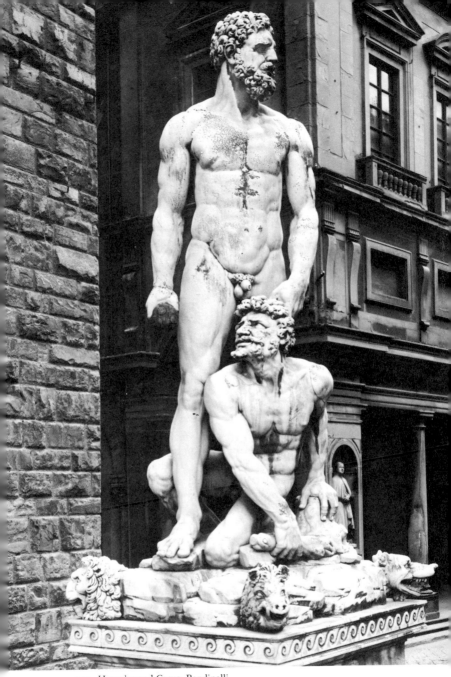

144. Hercules and Cacus. Bandinelli

197

145. Venus with a Dove. Bandinelli

narrative reliefs and standing saints were involved, but Bandinelli gave a very unsatisfactory performance, leaving much of the work, including statues of the Popes themselves, incomplete and in the hands of assistants, when he returned to Florence (1540).

With the Medici duke, Cosimo I, firmly established at Florence, and Michelangelo totally occupied at Rome with painting and later with architecture, Bandinelli's fortunes seemed to be rising. He succeeded in wheedling from Cosimo a commission that had previously been promised to Tribolo: a monumental tomb for Giovanni delle Bande Nere, Cosimo's father. Originally destined for a side chapel in San Lorenzo, for which its design was completely unsuited, the statue was ultimately relegated to the Piazza outside the church. The stolid, seated figure, although based on Roman precedents, was patently no match for the inspired and idealized statues of the Medici *Capitani* by Michelangelo in the New Sacristy. Only the large narrative relief on the pedestal [146] depicting the rendering of tribute to Giovanni has any artistic value. It shows the sculptor's interest in the relief style of Roman sarcophagi, combined with a vocabulary of pose and gesture closely allied to that of contemporary Mannerist painting.

When Cosimo moved his residence from the Medici Palace to the Palazzo Vecchio (May 1540), Bandinelli was quick to propose an ambitious scheme for decorating the dais of the large audience chamber with a set of statues of the Medici family, culminating, naturally enough, with one of Cosimo himself. The source which Bandinelli used for the poses of at least two of these statues was the work of Donatello, perhaps with the deliberate intention of alluding to the earlier period of Medicean fame, when Cosimo il Vecchio, to his great glory, had patronized that sculptor. Yet again his performance fell far short of his promises and resulted in much official criticism. Not least embarrassing was his failure to produce a complimentary statue of his patron, despite the existence of an earlier bust of the Duke, reported to be a good likeness. This was presumably due largely to lack of concentrated effort on the part of the sculptor, who allowed himself to be distracted by concurrent schemes that he was trying to foist upon the Duke for the decoration of the octagonal choir beneath the dome of Florence Cathedral.

It is surprising to what extent he succeeded in monopolizing the production of sculpture for Cosimo, despite his incapacity for bringing any project to a thoroughly satisfactory conclusion. It is, however, noticeable that the Duke accepted with alacrity Cellini's offer to produce monumental bronze sculpture

146. Monument to Giovanni delle Bande Nere. Bandinelli

on his return from France in 1545, perhaps in the optimistic expectation of inducing Bandinelli to finish some of his projects. The latter reacted with neurotic energy to the new challenge, but it had the unfortunate effect of increasing the megalomania of his sculptural ambitions instead of raising the quality of his finished work.

In 1547 the architectural elements of a new choir were begun, adhering to the octagonal ground plan of a temporary wooden structure that had been erected by Brunelleschi long before. Bandinelli's sculpture was planned in extraordinarily bad taste, with a Dead Christ actually on the altar, a colossal God the Father behind and above, and a nude pair, Adam and Eve [147], standing unashamed outside the enclosure. He evidently made a false beginning on every single figure for the complex, converting his first thoughts in each case into mythological statues by a simple change of symbolic attribute. The original Adam, for instance, became Bacchus and the first God the Father, Jupiter. This process of metamorphosis is most alarming when one considers how little, by implication, Bandinelli cared about his subject matter and how little, correspondingly, he projected any genuine emotional feeling into his figures. His mental and spiritual approach to sculpture seems to have been superficial by any standards, and pitifully so when compared with the agonizing meditation and self-examination to which Michelangelo submitted himself.

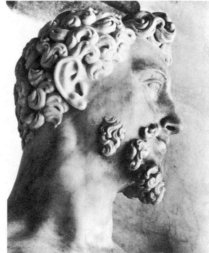

147. Adam (detail). Bandinelli

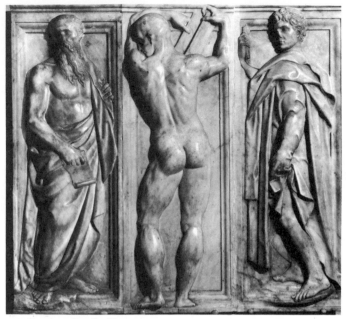

148. Prophets. Bandinelli

The only part of the scheme for the choir which was un-
deniably satisfactory was a series of rectangular reliefs, each
containing an anonymous figure of a prophet, which decorated
the low wall of the central enclosure [148]. Several are signed
and dated 1555. They show that the sculptor still retained an
interestingly varied repertory of poses and a surprisingly subtle
control of low relief. The closer his sculpture approached the
art of drawing, with its characteristic emphasis on contours, the
surer was Bandinelli's hand. It seems to have been the play of
forms in three dimensions and the suggestion of flowing, spiral
movement, essential features of sculpture after Michelangelo,
that defeated his imagination and capacities.

Bandinelli's most vociferous critic was his rival Cellini, who
ever after his return from France in 1545 harried him with
accusations of incompetence, which, though tainted with self-
interest, contained more than a germ of truth. Bandinelli was
not slow to realize the challenge implicit in Cellini's return and
immediately attempted to sabotage his rival by disparaging his
training as that of a mere craftsman and pouring scorn on his

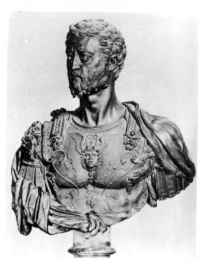

149. Bust of Cosimo I.
Benvenuto Cellini

capacity as a sculptor. Although this technique of ruthless slander had been successful some years before in disposing at least temporarily of a promising young rival, Ammanati (p. 221), Bandinelli had met his match in the arrogant and violent Cellini. He was rash enough to provoke the latter into entering the field of marble sculpture by offering him a faulty block, in the hope that he would disgrace himself, but his bluff was called when Cellini succeeded in carving a relatively satisfactory group of Apollo and Hyacinth despite the faults in the marble.

Bandinelli also pestered Cosimo into commissioning them both to make bronze portrait busts of him in competition, confident in the knowledge of his own earlier success with a marble bust. Cellini's bust [149], finished in 1547, is remarkable for the almost neurotic energy and intensity of expression which he suggested by the sharp turn of the head, the concentrated gaze and the windswept effect of the short, tousled locks of hair. The eyes were originally silvered or enamelled and the exquisite decorative detailing of the cuirass was picked out in gold. It may seem surprising that, despite this lively characterization and high degree of finish, Cellini's bust was not a success at the court and was replaced some ten years later (1557) by the one that Bandinelli had made meanwhile in a far more conventional, classicizing style. This Cosimo must have preferred for his public image, perhaps because of its more direct associations with ancient Rome.

Bandinelli was by now nearly seventy, and this was the last success that he enjoyed in the public arena: the unveiling of Cellini's Perseus (1554) and the return of Ammanati from Rome in the following year, with the support of Michelangelo, meant the end of the virtual monopoly which he had enjoyed since 1534. His last sculpture, a Pietà group in which he portrayed himself as Nicodemus, was designed for his own tomb, in open imitation of Michelangelo, who was engaged on a similar task at Rome. Though powerfully carved, the figures are not entirely happily disposed and the self-portrait of the artist occupies a disproportionately important place in the group. Although Bandinelli was involved with a project for a Fountain of Neptune in the Piazza della Signoria during the last two years of his life, and had got as far as making a full-scale model, he was prevented from executing the statue by his death in 1560.

Cellini had been trained as a goldsmith and specialized in the manufacture of seals, coins and medals under Pope Clement VII (Medici) and his successor, Paul III. An excitable temperament led to frequent disgrace with his patrons, and for much of his career he moved from city to city in an attempt to better his lot and to avoid the consequences of earlier misdeeds. He was, as he never failed to point out, a remarkably versatile artist, whose work as a goldsmith had the monumentality of sculpture and whose sculpture had the refinement of a goldsmith's work. Indeed, the first manifestation of his sculptural style occurred on the most famous and exquisite of his works in gold, the Salt-Cellar [150] which he made for King Francis I of France in the early 1540's. The style of the two main figures, Earth and Neptune, evinces an interest in the Mannerist sculpture in stucco which had been produced by Rosso and Primaticcio at Fontainebleau in the 1530's. They are characterized by the abstraction of the anatomical forms, the elongation of limbs and a feeling of poise rather than of suggested movement. Particularly on the female figure, the limbs are related to cylindrical or conical shapes, the face to a perfect oval, the neck to a cylinder and the breasts to hemispheres. This achieves a total effect of unnatural elegance and sophistication that is characteristic of Mannerist art. Nevertheless, there is still a strong element of Michelangelo in the compositions of the smaller figures, such as the female recumbent on the miniature temple that housed the pepper and the figurines in cartouches round the base. Yet

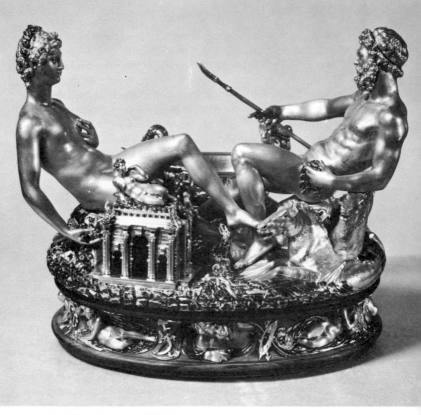

150. Salt-Cellar. Benvenuto Cellini

there is none of the emotional charge: the contortions of the
anatomy are merely to charm the eye and stimulate the senses.

Cellini's first surviving piece of sculpture on a large scale, a
bronze lunette known from its original location as the Nymph
of Fontainebleau, manifests the same characteristics. The
reclining pose of an antique river-god has here been adapted
to a female figure and the grand abstraction of the anatomy is
set off, as on the Salt-Cellar, against a foil of intricate detail. On
the larger scale, however, it must be admitted that Cellini's
lack of concern with articulating the body, which was later to
form the substance of Bandinelli's criticism of the Perseus, is so
disturbing as almost to mar the conception. The uneasy lie of
the legs and the inorganic way in which the hemispherical
breasts are attached to the torso are faults which demonstrate
the artist's inexperience in working on a grand scale.

On his return to Florence in 1545, under suspicion of having embezzled a large quantity of precious metal that had been supplied by the French king, Cellini was quick to make known to Cosimo his new-found skill at producing large sculptures in bronze. The Duke must have listened eagerly, for there was no one at Florence capable of casting monumental bronzes, yet the existence of statues such as Donatello's David and his Judith and Holofernes, commissioned by the Medici in the fifteenth century, must have excited his ambitions as a patron. He selected Perseus and Medusa as the subject of a group for Cellini to cast and within a few weeks gave his approval to a preliminary model in wax. The composition was probably based on a type of Etruscan statuette depicting Perseus holding aloft the head of Medusa, but Cellini chose to add the decapitated corpse below, possibly wishing to suggest an analogy with Donatello's group of Judith and Holofernes [69]. That group stood under the right arch of the Loggia dei Lanzi at the time, and the Duke may well have given orders that the new group should be designed as a pendant, to stand in its present position under the left arch of the Loggia. The corpse of Medusa lies on a cushion (scarcely visible in the wax model) which in turn rests on the capital of a column. Its limbs are so contrived that one hand can catch hold of an ankle and lock the corpse into position with the grip of death, while the other dangles down limply, in open imitation of Donatello's Holofernes. In a bronze model [151] which represents the next stage of development, the reference to Donatello's group becomes even more pointed with the evolution of the motif of the cushion as a visual support for the corpse of Medusa. This was essential for the viability of the composition as a monumental group. The cautious exploration in the wax model of the space around the Perseus gives way to a far more definite thrust forward with the left knee and a balancing counter-movement of the sword arm. At this stage, as related in his autobiography, Cellini resorted to a live model from whom to study the anatomical stresses of the Perseus, while the David by Donatello may also have played a part in teaching him how to render anatomy in bronze far more convincingly than in his earlier sculpture. Once this stage of comparative realism had been reached, he was able to turn his attention to the treatment of detail and the rendering of expressions.

A small bronze head in the Victoria and Albert Museum shows a tentative exploration of the emotional impact which

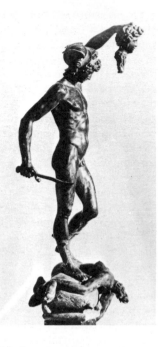

151. Perseus (bronze model).
Benvenuto Cellini

Cellini was seeking for the face of Medusa: in this model, a look of ghastly, deadened pain records the initial realism of the conception, but the artist is already beginning to work up the features to the perfection of sinister beauty that characterizes the final version. He drains away the suggestion of physical pain and substitutes a sensuous contrast between the silky smooth flesh of the cheeks and the scales of her snaky hair. This is so effective that it causes an almost physical revulsion in the beholder, as though apprehended through the sense of touch, rather as the fine sheen of the figures on the Salt-Cellar exerts a positive attraction to the caressing finger. This subtle differentiation of surface textures and this delicacy of detail, though more closely related to goldsmiths' work than to monumental sculpture, are crucial to the success of the Perseus group.

The final version [152] has the elegant, effortless poise that was the hallmark of Mannerist art: no suggestion of the recent struggle, no flicker of movement is allowed to disturb the serenity of the graceful pose. Crude reality, physical force and overwrought emotions did not appeal to Cellini, an artist who

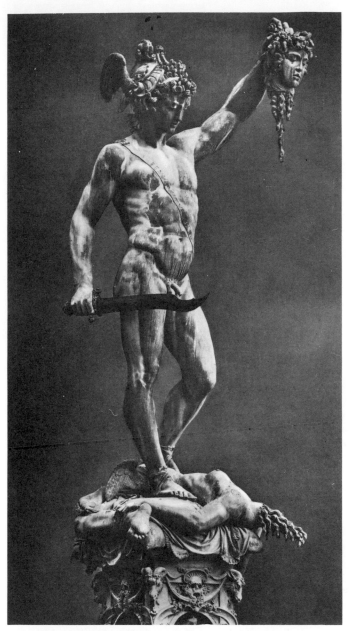

152. Perseus and Medusa. Benvenuto Cellini

153. Mercury. Benvenuto Cellini

knew very well the type of patrons for whom he was working, men who sought personal aggrandizement through the virtuosity of the artistic performances which they sponsored rather than through the grandeur or nobility of the ideas which the works incorporated. Mannerist art was not designed for earnest contemplation but for immediate effect, as an appurtenance of the courtly existence led by those who patronized it.

Beneath the cushion on which Medusa lies, the marble base of the group is all conceit and preciosity [153], the imaginative exuberance of the decorative motifs all but outdoing the stucco ornaments at Fontainebleau from which the Mannerist style in sculpture was derived. In niches on each side of the base stand four large bronze statuettes, while below there is a narrative relief of Perseus and Andromeda [154]. The statuettes are important for our knowledge of Cellini's vocabulary of form and demonstrate his proficiency at designing static figures in elegant poses, while the relief shows how little he cared for the traditional means of suggesting movement and drama. His artificial poses do not lend themselves to narrative expression, though individually they are fascinating.

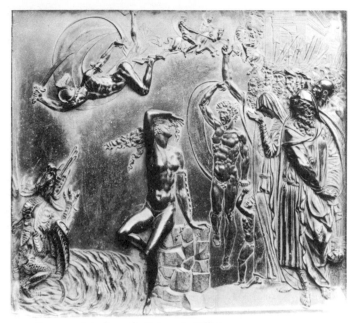

154. Perseus and Andromeda. Benvenuto Cellini

After the Apollo and Hyacinth, which he carved in reply to
Bandinelli's charges of incapacity as a sculptor, Cellini con-
tinued to work in marble, repairing for Cosimo an antique
torso as a Ganymede and later carving a figure of Narcissus in
a very forced pose that was necessitated by deep fissures in the
block. After completing the Perseus, he turned his attention to
a Crucifix in marble which he intended for his own tomb in
response to a vision of many years before. As a devotional
object the Crucifix is highly satisfactory and demonstrates the
finesse he had acquired in handling marble. The features of the
face are well defined by deep undercutting and an expression of
surprising pathos is achieved, considering his basic aversion
from emotional realism. Cellini valued the piece highly, but was
not above using it in an attempt to bribe Cosimo's wife,
Eleonora, not to support his rival, Ammanati, in the competi-
tion over the Fountain of Neptune. He was unsuccessful, how-
ever, and after completing the Crucifix in 1562 managed to sell
it to Cosimo for the Pitti Palace. It was ultimately given by
Francesco I to Philip II of Spain and installed in the Escorial.
His failure to secure the commission for the Fountain caused

him great disillusionment, and foreseeing no further opportunity in the face of increasing competition from the younger generation, he turned to writing his autobiography and technical treatises. These are invaluable for the first-hand evidence that they include on contemporary technique in different media, for the insight which they permit into the relations between artists of the sixteenth century and their patrons and for their general information about daily life at that time.

The talent of Cellini did much to enliven the artistic milieu of Florence in the middle of the century and helped to offset the empty rhetoric of Bandinelli's style which might otherwise have set the tone of an era. Cellini's powers of imagination, his sure sense of decoration and his brilliant technique combined to make him one of the greatest Mannerist sculptors, just as they fitted him ideally for the role of court artist that he was called upon to play in Florence under Cosimo de' Medici.

II. TRIBOLO AND PIERINO DA VINCI

Niccolo Tribolo, the sculptor from whom Bandinelli stole the commission for the monument to Giovanni delle Bande Nere (1540), had been apprenticed to Jacopo Sansovino during the period he was carving the St James (1511–18), and became his chief assistant through excelling at model-making and chiselling marble, the two prerequisites of Jacopo's success. Tribolo's earliest commissions seem to have involved the depiction of *putti*, the small children who were so popular in the role of shield bearers or decorative figures in Renaissance painting and sculpture, sometimes fulfilling the role of cherubs, sometimes of cupids. He was probably in Rome about 1524 and then moved to Bologna, where he carved three panels of relief for the portals of San Petronio, helping to complete the unfinished commission of Jacopo della Quercia. His figures were squat in proportions and rather unconvincingly articulated, but boldly posed. During the rest of the 1520's he moved about between Bologna, where he became involved in an abortive project for a tomb; Pisa, where he did some work at the Cathedral, probably meeting the young Ammanati; and Florence, where he executed for Della Palla, the artistic entrepreneur of King Francis I of France, a magnificent figure of Nature, based on the antique type of Diana of Ephesus, as a support for a genuine antique vase. This established his reputation as a sculptor of decorative garden figures, which were to be his speciality under Cosimo I.

He recommended himself to Pope Clement VII during the Siege of Florence (1529) by treasonously assisting his forces outside the city, and subsequently never lacked employment. Initially he was seconded to Loreto to help complete the series of narrative reliefs that had been abandoned after the death of Andrea Sansovino (1529); he also carved several *putti* and made models for the prophets in niches. In 1533 he was commanded to assist Michelangelo with the sculpture of the Medici Chapel and was set to work on the figures of Heaven and Earth that were to have flanked Giuliano. Tribolo got no further than a model for the Earth before falling ill, and progress was then interrupted by the death of Clement VII and Michelangelo's departure for Rome (1534). Under Alessandro de' Medici, he was completely employed in the production of ephemeral decorations for the Entry of Charles V and the Duke's marriage to Margherita. His experience in these decorations probably stood him in good stead for his later work in marble on fountains and other garden sculpture.

In 1537 he was recalled to Bologna, where he carved a very important relief depicting the Assumption of the Virgin (now in San Petronio) with figures on a comparatively large scale. The drama expressed in the gesticulating group of heavily-cloaked Apostles below contrasts strikingly with the lone figure of the Virgin above [155], a figure of extreme importance for the history of style because of its Mannerist exaggeration of the *contrapposto* that had long been normal for single figures. Its decorative formula of contrasting curves and angles playing in three dimensions in a *figura serpentinata* (see p. 186) was to form the foundation of a figure style that was later perfected by Giovanni Bologna. The initial impetus towards this compositional formula lay, it is true, in the work of Michelangelo and it does not seem unreasonable to suppose that Tribolo had some prior knowledge of the master's intentions for the figure of Rachel on the Julius Monument (although this actually seems not to have been carved until after the Assumption, about 1542). Or possibly the Virgin's pose may reflect one of the unexecuted designs for the Heaven and Earth of the Medici Chapel, on which Tribolo had been involved.

After the accession of Cosimo I in 1537, Tribolo was recalled to draw up plans for improving the Medici Villa at Castello with an elaborate system of artificial waterworks and an extensive remodelling of the gardens. His scheme provided many opportunities for decorative sculpture of all kinds, including a

155. Assumption of the Virgin (detail). 156. Fountain of the Labyrinth.
 Tribolo Tribolo and Pierino da Vinci

fashionable rustic grotto populated with realistic bronze
animals and two main fountains, the larger dedicated to
Hercules and the smaller to a female allegory of Florence (now
at Petraia [156]. In the execution of both these fountains
Tribolo was assisted by a brilliant young pupil, Pierino da
Vinci, the sculptor nephew of Leonardo. Even so, the bronze
terminal statues were not cast until well after Tribolo's death
(1550), the Hercules and Antaeus by Ammanati (to his own
design) and the allegory of Florence [157] by Giovanni
Bologna. In the latter case, a terracotta model by Tribolo,
which is known to us from a detailed description by Vasari,
may have formed the basis of the final composition. At any rate,
the motif of the girl wringing out her hair and apparently pro-
ducing the real steam of water which flows from her tresses was
certainly a feature of Tribolo's original design. Because the
final bronze is stylistically similar to Giovanni Bologna's later
works it is usually assumed that he was responsible not only for
its casting, but for its composition too. On the other hand, its
relationship with Tribolo's Virgin of the Assumption at
Bologna [155] is equally close, and it may be that Giovanni
Bologna was more or less faithful to Tribolo's original model
when he cast the bronze version. This would explain how he
apparently produced so sophisticated a composition at such an
early stage in his career at Florence. The *figura serpentinata* that
was to be so characteristic of Giovanni Bologna's later work
may thus have been learned indirectly from Tribolo (see p. 237).

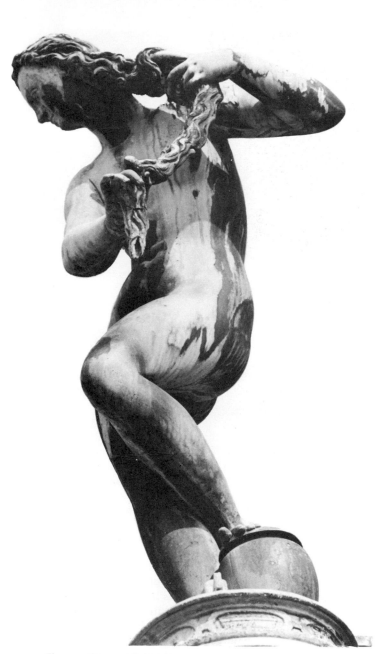

157. Florence. Giovanni Bologna

158. Boys. Tribolo and Pierino da Vinci

Tribolo himself carved a number of *putti* who romp round
the stem of the fountain of Hercules in contorted poses which
may have been meant as sophisticated parodies of Michel-
angelo's style [158]. For this fountain Pierino made the full-
scale models of four nude boys for casting in bronze. These
boys now lie playfully round the rim of the basin, half in and

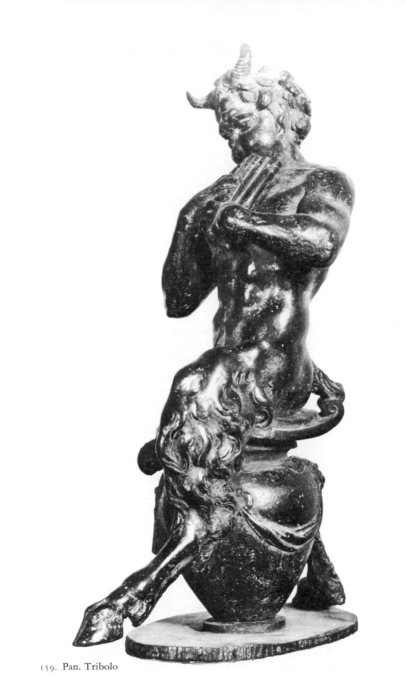

159. Pan. Tribolo

215

half out of the water, their bronze bodies glistening with real water in the sunshine. The two sculptors seem to have cooperated in carving the fountain of Florence. Its pedestal, basin and stem are made of a pink veined marble and are decorated with a multitude of tiny *putti*, grotesque masks and marine monsters. The fountains of the Medici Villa are among Tribolo's most successful works and constitute one of the peaks of perfection reached in the Mannerist style.

Tribolo's time must have been taken up chiefly with important official positions that he held in civil engineering and administration at Florence, apart from his attempts at installing the sculptures in the Medici Chapel. Only a year before his death he seems to have carved a full-scale figure of Aesculapius for Castello and to have made a momentous bronze statuette of Pan [159], both designed with asymmetrical, spiralling movements which give them a feeling of vivacity that far surpasses any work by Bandinelli or Cellini. In 1550, Tribolo fell ill as a result of a public disgrace caused by the failure of his waterworks in the city and died in the same year.

Pierino da Vinci unfortunately survived Tribolo by only three years, dying prematurely in 1553. Born in 1530, he had been apprenticed initially to Bandinelli, who had ignored him, and then to Tribolo, under whom he specialized in *putti*, as his master once had under Jacopo Sansovino, earlier in the century. His first recorded works, a *Putto Pissatore* at Arezzo and two *putti* supporting a coat of arms (Victoria and Albert Museum), demonstrate the precocious powers for which he soon received acclaim. After helping Tribolo on the fountains at Castello and producing independently a few small sculptures of his own, he seems to have found a generous and ambitious patron in Luca Martini, a prominent member of the Medicean court circle. For him, Pierino carved several of his most important sculptures.

The first was a youthful male figure holding an urn and representing a River God [160: the Louvre] which was presented by Martini to Eleonora di Toledo. The svelte body and slightly feminine pose have something in common with contemporary marbles by Cellini, while the facial type is derived from Michelangelo's Victory. The *putti* who playfully support the urn are close cousins of those by Tribolo on the Hercules Fountain. The statue is far from being merely derivative, however, and constitutes one of the finest examples of mid-century marble sculpture.

160. River God. Pierino da Vinci

161. Samson and a Philistine.
 Pierino da Vinci

162. Honour Triumphant over
 Falsehood. Vincenzo Danti

Pierino's other main sculpture for Martini was a group of
Samson and a Philistine [161]. The subject and treatment are
thoroughly Michelangelesque and Vasari believed it to be
based on sketches which Pierino had seen on a visit to Rome.
The composition is basically frontal and comes half way be-
tween the groups of Victory on the Julius Tomb and the
projects for the pendant to the David. The feeling of realistic,
muscular forces at play in the conflict also reflects an interest in
Michelangelo's earlier sculptures, St Matthew and the un-
finished Slaves, and Pierino is said to have adopted the master's
technique of carving from the front of the block.

Pierino's other achievement was the invention of a Mannerist
relief style. He combined the extreme contortions which he
learned from Tribolo and Bandinelli with a superior control of
anatomy showing a perceptive appreciation of Michelangelo's
Sistine Ceiling; this can be seen in the vivacious contours and
superb musculature of the nudes, their torsoes frequently
flattened out on the relief plane and the whole design carried
out in a finely controlled system of shallow relief, the better to
convey the painted source of inspiration. A comparatively early
relief of the Flagellation still shows some uncertainties in
handling the spatial setting, but these have disappeared by the

163. Cosimo I and Pisa. Pierino da Vinci

time of the Death of Count Ugolino and his Sons (Ashmolean
Museum, Oxford). His most celebrated relief is an allegory of
Cosimo I as Patron of Pisa, in which the Duke is seen raising
a female with the shield of Pisa from her knees and expelling a
host of allegories of vice [163]. The stylistic relationship of the
two youths with urns to the Louvre River God is obvious, while
the older, bearded figures are closely connected with the Ugo-
lino relief. The figure of Pisa, almost in a swastika pose, has a
parallel in a nude fountain figure of Fiesole by Tribolo, quite
apart from its obvious associations with the vocabulary of
poses that were popular with contemporary Mannerist painters
at the Medicean court, such as Bronzino. Pierino's relief style
was based on a firm understanding of the articulations of the
human body, whereas that of his master Tribolo had tended to
be far more empirical. There was no artist at Florence capable
of continuing this style and the reliefs that were produced later
in the century were based on different premises. Hence Pierino's
relief style is a unique and precious achievement in the history
of sixteenth-century sculpture occupying, like the bronze
Perseus and Medusa by Cellini, an isolated position on, as it
were, a pinnacle of virtuosity that was never attained by any
other artist.

219

The Sculptural Revival of the Mid-century:

Ammanati and Vincenzo Danti

Although the death of Bandinelli in 1560 and the defeat of Cellini in the ensuing competition for the Fountain of Neptune marked the end of an era, the real turning point had occurred a few years earlier with the return to Florence in 1555 of the brilliant sculptor Ammanati, who had the backing of Michelangelo at Rome and of Vasari at the Medicean Court. When Ammanati was awarded a commission for a Fountain of Juno in the audience chamber of the Palazzo Vecchio, directly opposite Bandinelli's uninspired series of statues round the dais, it became plain that the aged sculptor's virtual monopoly of official Medicean commissions, already weakened by the arrival of Cellini and the success of his Perseus (1545–54), was finally at its end. Bandinelli's last success was the bronze bust of Cosimo, which, as we have seen, was preferred to Cellini's. He also contrived to keep control of the project for the Fountain of Neptune and even began to work on the block for the central figure until death intervened.

While Ammanati was carving the figures for his marble Fountain of Juno, two younger sculptors with very different backgrounds arrived in Florence; Vincenzo Danti, a goldsmith from Perugia, who had a monumental bronze statue of Pope Julius III in his native town to his credit; and Giovanni Bologna, a Flemish sculptor who had been studying antique and Renaissance sculpture at Rome. Both these young sculptors produced good models as entries for the competition for the Fountain of Neptune, but neither had proved himself sufficiently to be entrusted with such an important commission, quite apart from the fact that after Bandinelli's death the outcome in favour of Ammanati was never seriously in doubt, in view of his influence at the Medici court.

Ammanati was a sculptor of very wide experience. He received his initial training under Bandinelli, then under Jacopo Sansovino at Venice. His first identifiable sculpture was a relief lunette for an altar in Pisa Cathedral (1536). In the same

164. Victory. Ammanati

year he was given three figures to carve on the tomb of Jacopo Sannazaro by Montorsoli, which was destined for Naples. Because of this contact, Ammanati was strongly influenced by Michelangelo, under whose direction Montorsoli had been carving the St Cosmas for the Medici Chapel as recently as 1533. He is known to have made copies of Michelangelo's cartoon of Leda and the Swan, and it was probably at this stage that he carved in marble his beautiful small version of the theme that is now in the Bargello. It is thoroughly imbued with the melancholy and poetic spirit of the recumbent figures of the Medici Chapel.

Ammanati first impinged on the sculptural scene at Florence in 1540 with a project for a monument to Mario Nari. This was deliberately sabotaged by Bandinelli in order to protect his own monopoly. The effigy of Nari once again points to Michelangelo's Medici Chapel as a source of inspiration, the recumbent pose of Dusk being married with the leather corselet revealing the muscles of the torso and the large relaxed hands of the Giuliano de' Medici. What is far more interesting, a group that would have stood above and behind the effigy, consisting of a female Victory suppressing a male Vice, seems to be a direct reflection of one of the groups projected for the niches of the Julius Tomb. The Nari Victory [164] is the earliest of a series of variations on this Michelangelesque theme which were produced by successive sculptors at Florence in the middle of the sixteenth century. The diaphanous drapery that clings to the

body of the Victory almost as though wet, in the manner of Hellenistic sculpture, combined with the extremely classical treatment of the face and hair, points to Ammanati's other indubitable source of inspiration, the work of Jacopo Sansovino and his master Andrea. The latter's figure of Temperance on the Basso monument [119] in Santa Maria del Popolo in fact provides a very close prototype for the Victory.

A brief visit that Jacopo Sansovino made to Florence in 1540 encouraged Ammanati to retire to Venice, after the erection of the monument had been frustrated by the machinations of the jealous Bandinelli. There, he seems to have collaborated on the sculptural decoration of the Library, which Jacopo was building, and for the corner of the crowning balustrade nearest to the Campanile he carved a figure of Neptune. Unfortunately the statue fell and was shattered in the eighteenth century.

Ammanati's main work in North Italy was not, however, in Venice, but in Padua where a wealthy humanist patron, Marco Mantova Benavides, commissioned him to design a full-scale triumphal arch, complete with reliefs and statues in niches, as well as a gigantic, muscle-bound Hercules in the Roman manner. The highly classicizing style which Ammanati adopted, combining a reminiscence of Michelangelo with well known antique compositions, was eminently suited to his patron's taste and he soon received an order for a tomb in the church of the Eremitani. The sculptor's latent skill as an architect found expression in this tomb, and he achieved a very fine balance between the four main statues and their architectural setting: some elements are traceable to Montorsoli's Sannazaro tomb and some, naturally, to Michelangelo, while the style of Jacopo Sansovino's Loggetta must also have had a considerable influence. Particularly striking among the sculpture is the advanced *contrapposto* of the seated allegorical females. The tomb was completed in 1546, and its success may have led to the award of an extremely important contract from Pope Julius III for a pair of tombs for members of the Del Monte family in San Pietro in Montorio, Rome. Vasari seems to have been responsible for the original designs, but Michelangelo had general supervision of the project and suggested a reduction in the quantity of decorative carving, as well as influencing the choice of sculptor in favour of Ammanati. The grand austerity of the classical frames in which the Virtues are set may thus be due to the old master but it must have met with Ammanati's

approval. The scheme may be compared to the Benavides Monument, where the relation of sculpture to architecture is so similar. The placing of standing allegories behind recumbent effigies recalls Ammanati's intentions for the Nari monument, while the pose of Antonio del Monte is almost identical with that of the effigy of Nari and the figure of Justice is developed from the earlier Victory. There is a new stylishness in the description of the light draperies of these figures, falling limply about the body of the Cardinal as he relaxes in meditation and fluttering prettily about the ankles of the Justice as she trips daintily forward from her niche. Pairs of *putti* act as caryatids supporting the balustrade across the entrance to the chapel, and betray an interest in the charming and informal styles of Tribolo and Pierino as shown on the fountains of Castello. The sculptures were complete by 1553 and Ammanati began work on the Pope's villa at the Vigna Giulia outside the city walls, where he helped to design and construct a delightful underground spring with decorative garden sculptures. This experience with artificial waterworks was to prove valuable when, on the death of the Pope (1555), he returned with Vasari to Florence.

As mentioned above, the influence of Vasari at the Medicean court secured for Ammanati the commission for the Fountain of Juno in the audience chamber of the Palazzo Vecchio. A later drawing [165] shows how the marble figures, which have long since been dispersed, were originally integrated into a fantastic oval design. Beginning from below with two recumbent figures representing Arno and Parnassus in the shape of river-gods, the oval was completed above by a marble rainbow with a seated Juno on top [166]. A nude Ceres stood in the centre, while allegories of Florence and Temperance flanked the composition below. The sheer boldness of the idea and the imagination and skill with which it was interpreted are a tribute to Ammanati's powers: the scheme recalls a luxurious table decoration made by some Mannerist goldsmith, or its equivalent on a large scale, one of the ingenious theatrical decorations that were such a feature of Renaissance festivals. The virtuosity which the translation of such an invention into a permanent structure implied was the artistic quality most admired during the Mannerist period. Although the elements were completed by 1563, the fountain was never erected as planned owing to the unforeseen acquisition by the Medici of the Victory from Michelangelo's Florentine studio, after his death. Ammanati's patron can almost be forgiven his

A PITHI

CONCERTO POETICO DI STATVE POSTO IN ASPETTO DEL
PALAZZO A PITHI FATTO PER INTENTIONE DI METERLO
A PRATOLINO

165. Fountain of Juno. Ammanati (after)

166. Juno. Ammanati

167. Marine Goddess. Ammanati (?)

fickleness in abandoning the Fountain of Juno when suddenly presented with such a fine work by the most revered artist of the time: but not quite, because his decision to install Michelangelo's Victory and a pendant by Giovanni Bologna in place of the fountain meant that the most original and fantastic sculptural complex of the mid-century never received a permanent home. Though all the sculptural elements have now been identified, it takes considerable imagination to visualize the total effect, enhanced as it would have been by an ingenious play of water and by the sparkle of candlelight on the glistening marble surfaces.

Disappointed though he must have felt, Ammanati can have had little time to brood, for by this time he was involved in carving the Neptune for the centre of the fountain in the Piazza from the block which Bandinelli had left partly damaged: it was ready for provisional display by 1565, at the marriage of Francesco de' Medici. The pose of the Neptune was conditioned by the proportions of the block, whatever further difficulties may have been imposed by Bandinelli's wanton damage, and this may partly account for its lack of success. It must be admitted however that Ammanati had rarely had to handle a monumental free-standing figure and was accustomed to the strong frontality implicit in the location of his previous statues, in niches above

226

168. Bearded River-God.
Ammanati

tombs and, in the case of the Fountain of Juno, in front of a wall.

The chief glory of the Neptune Fountain lies in the series of bronze figures that are disposed round the basin, their sleek limbs glistening with spray falling on their green patina. Two male and two female marine gods sit on the four corners [167], and subsidiary pairs of satyrs flank them, slightly lower. These were all executed a few years later (1571–5) by a team of assistants under the supervision of Ammanati, but only the Bearded River-God is generally accepted as autograph [168]. Even so, these large bronzes convey perfectly the flavour of the elegant, decorative style of sculpture that was in vogue under Francesco de' Medici. The design as a whole tends to be vitiated by the disproportion between the towering and rather static Neptune ('*Il Biancone*' or 'The Great White Man' to the Florentines) and the bronze figures, which are not much over life size. The fault lay not with Ammanati, but with his predecessor, Bandinelli, who had always misjudged matters of scale and harmony in his compositions, and had attempted to outdo the perfectly satisfactory fountains that had been designed for Messina in the 1550's by Montorsoli, simply by increasing the scale of the central figure without making corresponding adjustments to the subsidiary sculpture.

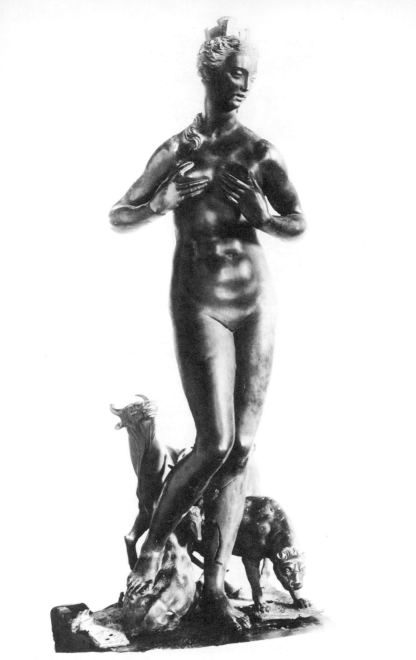

169. Ops (Earth). Ammanati

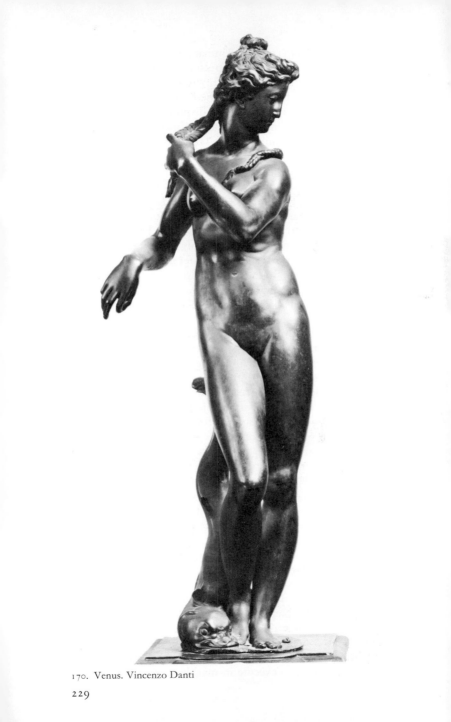

170. Venus. Vincenzo Danti

In the same period (1572–3) Ammanati contributed a large bronze statuette of a nude female representing Ops (Earth) [169] to the decoration of the newly constructed Studiolo (study and treasure-chamber) of Francesco in the Palazzo Vecchio. Eight similar mythological statuettes were disposed in niches round this little room, including a Venus by Vincenzo Danti [170] and an Apollo by Giovanni Bologna [182], and they provide an instructive opportunity for comparing these artist's respective styles. Ammanati's bronze is based on the composition of the Ceres on his Juno Fountain [165], but is more elongated, like the females of the Fountain of Neptune. Danti's Venus is similarly proportioned, whereas Giovanni Bologna's Apollo is well-built almost to the point of plumpness by comparison with these willowy goddesses: this plainly reflects his return to classical canons of proportion and a greater naturalism than had generally been favoured in the middle of the century. The other bronzes in the Studiolo are the work of less important sculptors, among them Bandinelli's followers, Giovanni Bandini and Vincenzo de' Rossi.

Soon after this commission, Ammanati began to have doubts about the morality of depicting nudes in public, in accordance with Counter-Reformation religious sentiment, and his sculptural activity ceased forthwith.

The young goldsmith, Vincenzo Danti, had executed jointly with his father a fine bronze statue of Pope Julius III outside the Cathedral at his native Perugia before coming to try his luck under the lavish patronage of the Medici (1557). The Pope is seated, with one arm outstretched in the act of benediction, and his stiff cope performs a series of movements that give a premonition of the Baroque, curving and swelling majestically round the arms and over the knees: the closed silhouette that it gives to the figure was to be characteristic of Danti's later sculpture, while the cartouches of feigned embroidery point towards his later excellence at designs in low relief. His first essay at major sculpture in Florence was in fact a failure: an ambitious cast of Hercules and Antaeus for the Fountain at Castello turned out badly and had to be remodelled later by Ammanati. He entered a full-scale model for the competition for the Fountain of Neptune and a correspondent informed Michelangelo that it was quite successful. Although lack of influence at the court ruled him out from the start, his attempt probably brought him a commission from a fellow-Perugian, resident at Florence, to execute in marble a group of Honour

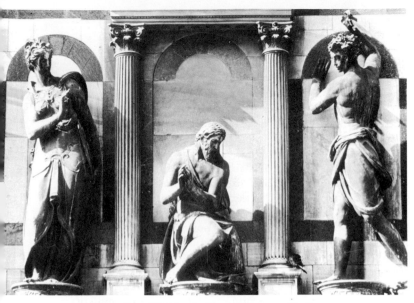

171. Beheading of St John the Baptist. Vincenzo Danti

Triumphant over Falsehood [162], yet another of the essays on the theme of Michelangelo's Victory. A reference to the Samson and a Philistine of a decade earlier by Pierino [161] is obvious but Danti's intention is quite different: where Pierino was copying Michelangelo's technique and earlier figure-style, Danti evolves a composition which is held together by taut contours and muscular tensions in a calculated equilibrium. The real force of conflict that motivated Pierino's group has evaporated and a supremely elegant, ballet-like pose, more akin to that of Cellini's Perseus [152], is the focus of attention.

After carving a group of marble statues for the outside of Vasari's newly constructed Uffizi, which included a highly idealized figure of Cosimo I in the guise of a Roman general and two recumbent allegories that were derived from those in the Medici Chapel, Danti was once again persuaded to try his hand at life-size bronzes: in 1569 he had refurbished the statues of St John the Baptist and Christ by Andrea Sansovino, added an angel (destroyed since) and set up the group on the Baptistry, as had always been intended [120]. Immediately afterwards he was ordered to cast three bronze figures enacting the Beheading of St John [171] for the remaining portal of the Baptistry: their unveiling in 1571 marked the climax of his career. A delightfully mannered Salome and an elegantly poised Executioner [172] flank a St John kneeling in prayer as he awaits martyrdom. An impression that we are witnessing a symbolic tableau rather than a realistic action is conveyed by the studied elegance of the poses, which recall the International Gothic style of Ghiberti's Doors below. The frigid expressions of disdain on the faces owe much to Cellini's Perseus and Medusa [152]. In the Salome, there is a greater emphasis on the elaborate and fantastic ornaments of her dress and coiffure than on the unconvincing gesture with which she pretends to ward off the horror of the execution. In view of his origins, it is hardly surprising to find Danti borrowing from the work of Ghiberti and Cellini, the two sculptors of the Renaissance who had most openly demonstrated in their monumental works their training as goldsmiths.

Closely related in style to the Salome is a figure of Venus plaiting her hair [170], which was Danti's contribution to the series of statuettes in the Studiolo: its pose is a pale reflection of the favourite motif of Giovanni Bologna, as one can see by comparing his Apollo [182]. Similarly, an intricate pattern of zig-zag lines and sinuous curves in three dimensions, enclosed within an unbroken contour, characterizes a delicately

172. Executioner (from Beheading group). Vincenzo Danti

173. Leda and the Swan. Vincenzo Danti

174. Moses and the Brazen Serpent (detail). Vincenzo Danti

carved Leda and the Swan in the Victoria and Albert Museum
[173]. Here, once again, Danti is giving a virtuoso performance
of variations on a theme of Giovanni Bologna. The implicit
homage to the latter reflects his increasing prominence in the
sculptural scene at Florence. Danti's virtual retirement to his
native Perugia soon after may be taken as an admission of
defeat, even though in the less sophisticated milieu of Perugia
he occupied a position of no little importance as city architect,
head of the Guild of Goldsmiths and founder-member of the
Academy.

One of the most interesting facets of Danti's activity was his
series of bronze reliefs. The best was a long panel depicting
Moses and the Brazen Serpent [174], now in the Bargello, which

235

seems to have been commissioned by the Medici for their private chapel in the Palazzo Vecchio. It may well have been among Danti's first works. The style of the figures appears to have been derived from a study of Francesco di Giorgio's bronze panels of the late fifteenth century at Perugia, combined with an attention to Michelangelesque anatomy rather in the manner of Pierino da Vinci: heads, shoulders and knees tend to project quite strongly from the plane of the relief, while the broad, muscular torsoes are flattened on to that plane. Danti favoured the same closed outline for individual figures as in his major sculpture, the central figure of Moses being a classic example, while groups in the middle distance were modelled very summarily in the wax and scarcely worked up at all after casting in bronze. As in Francesco di Giorgio's reliefs, the suggestion of movement and drama that was conveyed by the bold immediacy of these techniques was outstanding. A comparison with the Perseus and Andromeda [154] by Cellini of a few years before demonstrates Danti's superiority in this medium and reveals a lack of control on Cellini's part of gradations in the depths of relief, and a general failure to adhere to a consistent system. Danti's relief style had no sequel, for Giovanni Bologna adopted a totally different approach in the religious scenes which he had to depict [184], where clarity of narrative was all important.

Giovanni Bologna and the Climax of the Florentine Tradition

The other young sculptor who emerged like Vincenzo Danti at the time of the competition for the Fountain of Neptune (1560) was Giovanni Bologna. He came from an unusual background, in that he was Flemish and before leaving his homeland had learnt the technique of sculpture from Jacques Dubroeucq, a notable sculptor who was involved in carving a rood-loft for a church in Mons (c. 1544). Dubroeucq worked in an Italianate style that he had evolved after a visit to Rome, and we may assume that he encouraged his apprentice to undertake the journey to Rome to see for himself the wonders of antique and Renaissance sculpture. Be that as it may, the young sculptor spent two years there (1555–7), eagerly modelling in clay or wax everything he saw. An encounter with the aged Michelangelo served to encourage him in this method of work, and ever after he was an assiduous maker of models when preparing any sculptural composition.

On his homeward journey he naturally paused at Florence to study the masterpieces of the early Renaissance and of Michelangelo. Fortunately for the history of Italian sculpture, a rich and perspicacious patron of the arts, Bernardo Vecchietti, persuaded him to prolong his stay by an offer of financial support and accommodation. By introducing him to Francesco de' Medici during the expansive period of court patronage in the late 1550's, Vecchietti virtually ensured his permanent employment at Florence.

Despite the existence of reliable contemporary accounts such as Vasari's *Vite* (1568) and Borghini's *Il Riposo* (1584), Giovanni Bologna's early activity at Florence is surrounded by uncertainty. For instance, the identification of a marble Venus, which he made for Vecchietti, with a statue in the Grotticella in the Boboli Gardens is far from certain, for it seems rather advanced in style for an early work. If, however, he derived the fundamental idea of the *figura serpentinata* from Tribolo's model when casting the Florence for the fountain at Petraia (1560) [157],

there is less difficulty in accepting the Grotticella Venus as a work of that early date too (see p. 212).

The young sculptor's full-scale model for the Neptune competition was evidently something of a success and must have played no small part in influencing the authorities at Bologna to approach him when they were contemplating a public fountain three years later (1563). An impressive preliminary sketch model of Neptune for the central figure at Bologna has survived (Victoria and Albert Museum), and significant differences from the final version in pose and ponderation suggest that it may reflect the Florentine model of 1560. This commission, which took the artist well away from the competitive and claustrophobic atmosphere of Florence, acted as a catalyst in releasing his full powers. The fountain [175] is constructed as a secure pyramid round its architectural core, the

175. Fountain of Neptune.
Giovanni Bologna

sheer wealth and fantasy of its figurative and decorative bronze elements leading the eye effectively up to the magnificent crowning figure. The massive, muscular Neptune is like an antique Hercules come to life, the immense vitality and energy in his serpentine pose and the sharp turn of his head conveying an emotional presence that is worthy of his superhuman appearance. It is as though the pent up power of Michelangelo's Moses had been suddenly unleashed by an artist who seems almost instinctively to have understood the great master's aims and interests. The asymmetry of Neptune's pose is checked as the eye moves down to consider the *putti* with fishes, who are posed with an heraldic precision as exact mirror images of each other. Below, the sensuously curving forms of the marine goddesses at the corners blend subtly with the convoluted forms of the architecture round them, while the play of water over their bodies links the pedestal to the basin in which it stands. Giovanni Bologna's fountain implicitly embodied a severe critique of its counterpart at Florence, which was spoilt by the disproportionately large and constricted statue of Neptune that had been forced upon Ammanati. The use of bronze throughout and the adoption of a relatively uniform scale for all the figures lent the Bologna fountain the aesthetic unity which was so sadly lacking in Ammanati's design.

Possibly during his stay at Bologna, the sculptor also produced the earliest of several versions of a flying Mercury in bronze, which has since become his most celebrated statue. It was sent to the Emperor Maximilian II by Francesco de' Medici as part of the diplomatic preparations for the latter's marriage in 1565 to the Emperor's daughter Margaret. Though this figure has been lost, a later cast of similar size in the Bargello [176] probably reflects the original fairly closely, as it corresponds with a small bronze at Bologna that seems to have been cast from Giovanni Bologna's original wax model [177]. The derivation of the beautiful, balanced pose and the way in which the statue demands to be looked at from all angles may lie in earlier bronzes in the Medici collection, such as Verrocchio's Putto with a Dolphin [105] or Rustici's Mercury, while the more recent statuette of Mercury [153] on the base of Cellini's Perseus provides a precedent for the attempt at suggesting flight. However, Giovanni Bologna's greater interest in anatomy and superior control of suggesting movement enabled his figure to be all but flying in mid-air, unlike Cellini's earthbound acrobat.

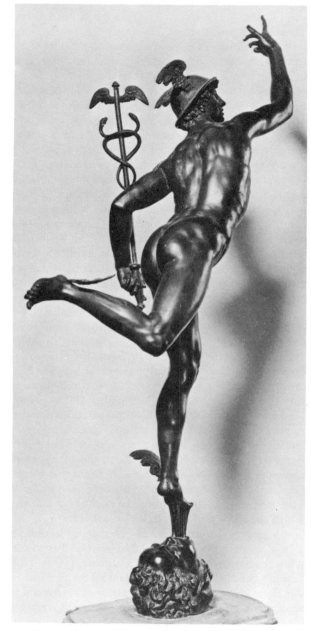

176. Mercury. Giovanni Bologna

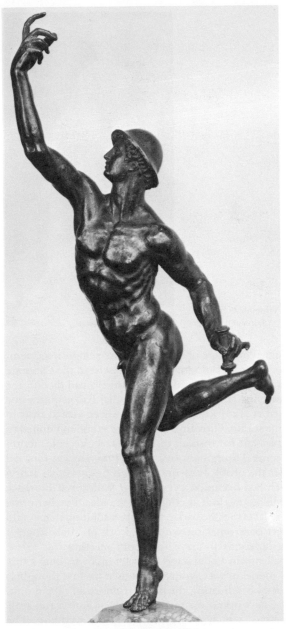

177. Mercury (bronze model). Giovanni Bologna

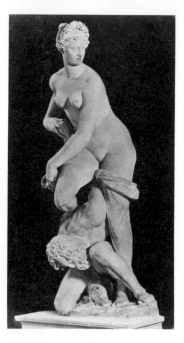

178. Florence Triumphant over Pisa.
Giovanni Bologna

For the actual marriage of Francesco, the sculptor was tem-
porarily recalled from Bologna (1565) to assist in the elaborate
decorations that were required. Michelangelo had died in the
previous year, and from his heir the Medici had acquired the
statue of Victory [140] which had hitherto been locked away in
his Florentine studio. Giovanni Bologna was commissioned to
produce a pendant for display in the Palazzo Vecchio, repre-
senting Florence Triumphant over Pisa [178]. He was thus led
to reconsider the problem of uniting two figures in an action
group, which had occupied every major sculptor at Florence
ever since Michelangelo had conceived the idea. Furthermore,
unlike his predecessors, he had to produce a solution that would
stand a direct confrontation with the work of Michelangelo.
Undaunted, he seems to have set about meeting this extra-
ordinary challenge in a characteristic fashion, by making a tiny
preliminary model in wax, which embodied his first thoughts;
then, considerably adjusting the proportions to suit the monu-
mental scale, he worked up this composition into a full-scale
model in plaster, which was exhibited at the wedding. The
marble version was not carved till much later, and then probably

by an assistant, Francavilla. The wax model (Victoria and Albert Museum) is wonderfully spontaneous, its elongated proportions corresponding with those of the Victory that it had to match. Its destination for a niche meant that it would be seen only from in front, but its axis was arranged spirally within a block of pyramidal shape, like the Victory, which had first embodied this influential canon of composition. The principal respect in which the final marble version differs from the Michelangelo group is the piercing of the block with daring interstices, such that light and space are allowed to play freely between the forms, in the manner of Hellenistic groups such as the Laocoön or the Farnese Bull, both of which Giovanni Bologna must have studied at Rome. This fundamental difference in sculptural conception continued to characterize his work, becoming even more marked in his next commission.

Francesco must have been delighted to discover a master capable of emulating Michelangelo and immediately ordered a free-standing marble group for the centre of a fountain, depicting Samson and a Philistine [179]. The choice of the theme is obviously a reference to the commission of the 1520's for a pendant to the David, which Michelangelo had never been allowed to carry out, while Giovanni Bologna's composition plainly reflects a knowledge of the model made at that time, which is now known only from bronze casts [142]. The progression in ideas from Giovanni Bologna's Florence Triumphant to his Samson thus echoed a similar advance made by Michelangelo half a century before but never actually fulfilled by him in full-scale sculpture. The placing of the Philistine basically in front of Samson also reflects the model made earlier by Michelangelo, when his theme was still Hercules and Cacus [141]. The feeling of imminent movement, as the jaw-bone of the ass is about to swing down on the victim, and the psychological link between the protagonists are enough to establish the group as a masterpiece [180]; but the feature which may well have appealed even more at the time is the almost incredible virtuosity with which the sculptor excavated the marble between the forms of the bodies while managing to contrive sufficient support for the sheer weight of marble that was still left. Technical expertise of this calibre was virtually unprecedented, even in the ancient world, and Jacopo Sansovino's feat in carving the upraised arm of his Bacchus [127], which so excited his contemporaries, pales into insignificance beside the achievement of the brilliant Fleming.

243

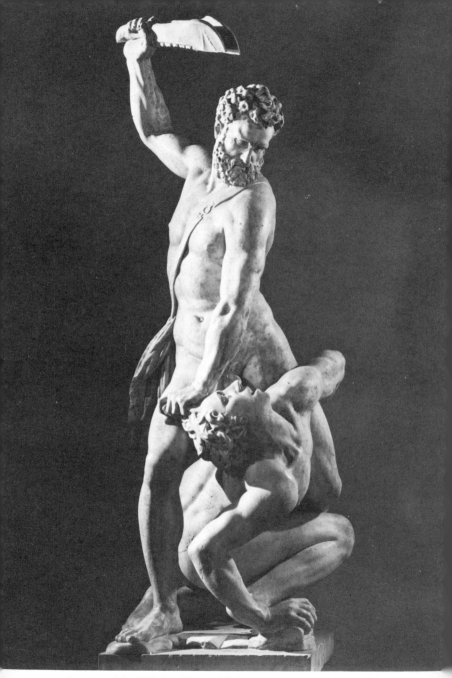

179. Samson and the Philistine. Giovanni Bologna

180. Face of the Philistine. Giovanni Bologna

A drawing shows that under the imaginatively curved basin of the fountain there were four bronze monkeys in niches round the base, and this may mark the climax of Giovanni's career as an animal artist. He evidently specialized in this side-line and produced besides the monkeys (Victoria and Albert Museum; Berlin-Dahlem) a series of endearing studies of birds, some of which are still *in situ* at Castello, while others are in the Bargello. Perhaps the most ambitious is a Turkey with spread tail [181], the pompous character of which is cleverly conveyed, while the surface texture of feathers is miraculously suggested by a broad, 'impressionistic' treatment that was cast straight from the original wax model.

181. Turkey. Giovanni Bologna

In the first half of the 1570's, Giovanni Bologna was engaged in carving three seated River-Gods and a crowning figure of Oceanus for a fountain outside the Pitti Palace (now in the Boboli Gardens). It is a fountain of the candelabrum type that had been employed by Tribolo at Castello to such effect, where a central shaft is crowned with a large terminal figure. An immense, circular basin, quarried long before, formed the starting point of the composition and forced the sculptor to place his figures high above it, in order not to conflict with its shape. Originally, an outer balustrade supporting a ring of figures facing inwards gave the composition a stability which now unfortunately it lacks. The Oceanus (now in the Bargello and replaced on the fountain by a copy) is a powerful, muscular figure, not unrelated to the Bologna Neptune, but latent energy instead of physical movement is suggested in his artfully balanced pose. The three River-Gods embody a series of experiments with seated or squatting figures, involving complicated poses and a visually stimulating play of curves and angles.

Concurrently with the fountain of Oceanus, Giovanni received a commission of a very different kind, also for Francesco, a bronze statuette of Apollo for the Studiolo [182]. Like all the other statuettes [169, 170], it was destined for a niche, and so the artist contrived to concentrate the visual interest on the frontal view, even though the composition was still based on the *figura serpentinata*. The most striking example by Giovanni Bologna of this type of composition is the supremely graceful gilt bronze of Astronomy [183], which is often dated near the Apollo. By turning this figure in the hands one experiences a subtle progression of highly pleasurable views through the merging of angular into curved forms (and *vice versa*), which present a perfect harmony from every point of view.

The virtually canonical composition of the Astronomy with its serpentine body typifies a number of Giovanni Bologna's bronze statuettes, while for figures in action more open poses, reminiscent of some of his major sculpture, were employed. Once the original wax models had been made, the actual production of statuettes was naturally delegated to his assistants, and this accounts for the variations in quality and finish. Many of the pupils specialized in this activity, besides helping to cast the major bronzes, and continued to turn out versions of the master's compositions long after his death, though often with distinctive personal variations. Especially prominent in this respect were Antonio Susini and Pietro Tacca, who prolonged his style well into the seventeenth century.

The virtual mass-production of these statuettes was one of the chief factors in the rapid spread of Giovanni Bologna's style throughout the courts of Europe: both durable and portable, they provided a tempting introduction to a style which embodied in its calculated virtuosity and easy elegance much that was admired by Northern rulers in the Italian courtly life. Once established, this taste gave rise to unrivalled opportunities for any artist who was adept enough at translating the style of Giovanni Bologna to meet the needs of these courts in the way of decorative or monumental sculpture. Consequently, the master soon enjoyed a position of prestige even greater than that held shortly before by Michelangelo, for his advice and personal recommendations were sought from all over Europe and he was able to press the claims of his pupils without opposition. The fashionable demand for works that conformed to his style was not superseded until the advent of the Roman

182. Apollo. Giovanni Bologna

183. Astronomy. Giovanni Bologna

Baroque of Bernini, at least a quarter of a century after the master's death. This in itself is a remarkable tribute to the lasting appeal of his compositions.

Giovanni Bologna's beginnings as a religious artist date from 1577, when he received a commission for the Altar of Liberty at Lucca. Hitherto he had been occupied exclusively with secular themes, and this new departure must surely be a reflection of the Counter-Reformation, the religious movement within the Roman Catholic church which was so affecting Ammanati at about this date (see p. 230). The spectacular marble figure of Christ is probably the only part that he carved personally, the rest of the altar being delegated to assistants, such as Francavilla, who had become his best pupil in marble carving. The Christ is an exercise in the open type of composition involving a single figure which he had explored in an early bronze Bacchus and in the Mercury: its graceful spring and feeling of uplift may be a tribute to the Resurrected Christ of some of Michelangelo's finest drawings, and in this respect the figure is in an entirely different class from its most immediate predecessors by Montorsoli and Ammanati.

A most significant extension to the sculptor's range was necessitated by his next religious commission, the decoration of a chapel of the Grimaldi family at Genoa: this was the invention of a viable relief style for narrative scenes. He had executed only one relief before, a silver panel with the Birth of Cybele, and, as we have remarked, there was no proper tradition of relief sculpture at Florence in the sixteenth century to guide him. The sketchy and impressionistic style of Danti did not lend itself to the clear exposition of narrative that was demanded by Counter-Reformation doctrine, and Giovanni Bologna seems to have turned to his native Flemish tradition, as used by Dubroeucq and rationalized by Cornelis Floris. In this system [184], which characteristically he developed to its logical conclusion, architectural settings were used to establish a sense of space, though the linear perspective was exaggerated to distinguish foreground from background more sharply than in an optically correct scheme. The figures were grouped in well-defined blocks, the edges of which usually coincide with breaks in the architectural surroundings. An effective dramatic device was evolved by arranging a hiatus in the grouping to correspond with a long vista between buildings or down colonnades. The compositions tend in short to be treated as a lucid pattern of forms on the surface area, with the emphasis laid on clarity of

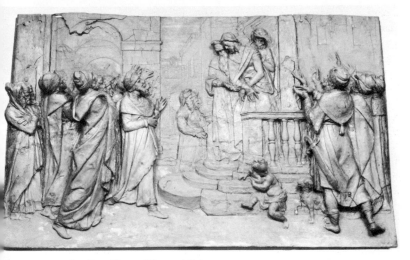

184. Ecce Homo. Giovanni Bologna

narrative rather than on illusionism. A wax model for one of the
Grimaldi reliefs, the Ecce Homo [184], serves to demonstrate
the height of drama which could be achieved in these strictly
disciplined compositions. A further series of bronze reliefs was
executed subsequently for the Chapel of Sant'Antonino at San
Marco, Florence, and a number of large bronze statues were
made in connection with both commissions. Several small
bronzes of the Crucifix or Christ at the Column emphasize the
popularity of the artist's religious works with patrons who
could still enjoy in them the phenomenal control of anatomy
and expression that had characterized his secular bronze statu-
ettes.

The climax of Giovanni Bologna's career as official sculptor
to the Medici court was reached with his most ambitious
secular group, the Rape of the Sabine [185]. His earliest thoughts
on this theme are embodied in a bronze group with only two
figures that was ready by June 1579 and must have been
designed concurrently with the Altar of Liberty. In a letter to
his patron, Ottavio Farnese, the artist explained that 'the sub-
ject was chosen to give scope to the knowledge and study of

185. Rape of the Sabine. Giovanni Bologna

art' and he proved himself equally indifferent to the precise subject of his marble group, which he regarded purely as a compositional exercise in integrating three figures into an action group, a challenge to his imaginative powers and technical virtuosity. The desire of his contemporaries to satisfy themselves as to the exact title found expression in the splendid bronze relief which they persuaded him to cast and set below the group. In it a number of variations on the theme, reflecting his wealth of ideas, left them with no doubt that the rape in question was that of a Sabine woman by a Roman.

The stages of transformation from a group of two to one of three figures are marked by surviving wax models (Victoria and Albert Museum). In effect, Giovanni was inserting between the legs of the standing youth a figure of an older man on his knees, in a position not unlike that of the Philistine in the earlier group: the wriggling body of the woman, which he tried in a variety of positions with regard to the standing man, formed another spiral, counterpointing that of the main composition. This was the first major sculptural group that had no preponderant views: the previous principle of designing a statue for four or eight striking views was evolved into an idea of a completely spiral composition. This demanded from the spectator continuous movement round the sculpture, if he was fully to appreciate the complexities of the design, and gave the same effect of endlessly merging contrasts of curve and angle, of solid and void, as one might obtain by revolving one of the bronze statuettes in the hands.

Though this was not his last sculpture, Giovanni Bologna never excelled the mastery of its design, but, having perhaps explored to his satisfaction the problems that it presented, he turned to other themes. Chief of these was the horse, which after the human form had most fascinated the ancients and had correspondingly interested sculptors throughout the Renaissance. Apart from the equestrian monuments by Donatello and Verrocchio that have survived [65, 110], there had been the projects of Leonardo da Vinci [114] and a number of full-scale compositions in temporary media for the festive decorations that had provided a testing ground for ambitious ideas throughout the sixteenth century. These had not infrequently been recorded in small bronzes, but for the most part had defied permanent expression on a monumental scale, owing to the technical difficulties and prohibitive expense that would have been involved.

253

At the height of his career, then, Giovanni Bologna undertook an equestrian statue of Cosimo I in bronze (1587–95) [186]. Immediately afterwards, he began a huge marble group of Hercules and the Centaur, the carving of which occupied him personally for five years, to the exclusion of other work except the making of small wax models for bronzes (1595–1600). The equestrian Cosimo is more closely related than its Renaissance prototypes to the classical Marcus Aurelius in the Capitoline Piazza at Rome. The anatomy of the horse was the subject of scientific study, as is apparent from a bronze statuette of a flayed horse showing the disposition of the muscles. In the final equestrian group, the horse's wind-swept mane and curly tail are contrasted effectively with the close-cropped hair and beard of the rider, the armour and the flattened folds of drapery, all of which emphasize the reserved grandeur and commanding presence of the Duke. Naturally much of the work on the bronze was executed by assistants, notably by Antonio Susini, who ever after was a specialist in animal subjects. The success of the statue was striking and there was an immediate flood of demands for similar portraits, which were actually produced largely by his pupils, owing to the master's death (1608).

Giovanni Bologna had occupied a position of importance in Florentine sculpture since his ascendancy with the model of Florence Triumphant over Pisa (1565), which marked him out as the natural successor of Michelangelo. The continuing rise of his powers with the Samson and a Philistine culminated in the Rape of the Sabine, which, by integrating three figures into a satisfactory group, formed the realization of an ambition which had been aroused by Michelangelo half a century before. Concurrently he had been fascinated by the problems of designing a single figure with an underlying spiral form that could satisfactorily be viewed from any angle, beginning from the premises of Michelangelo that had found expression in the work of Tribolo. Starting with the sure grounding in technique and initial enthusiasm for classical art that he owed to his Flemish master Giovanni Bologna rapidly assimilated the style of classical and especially Hellenistic sculpture and grafted this on to the body of style and ideas that constituted Michelangelo's legacy to Florentine sculpture. The result was a fresh flowering of a tradition which, though its initial stock was sound, had grown sterile through inbreeding.

After Giovanni Bologna's death in 1608, his workshop and its contents, together with his official position as court sculptor,

186. Cosimo I on Horseback. Giovanni Bologna

were inherited by his best pupil, Pietro Tacca. Tacca and his colleague Susini continued to operate the workshop on mass-production lines, turning out bronze statuettes from the master's models for the European market. Tacca supplied sculpture for Medicean undertakings such as the enormous dynastic mausoleum which was being built adjacent to San Lorenzo (the Cappella dei Principi), and the fountain at Livorno. Equestrian monuments continued to be much in demand from their highly expert foundry. Nevertheless, it cannot be pretended that their artistic inspiration was comparable with that of their master, and they prolonged the survival of his style, rather than developing it significantly. Papal patronage and the genius of Bernini were making Rome the centre of a radically new style, the Baroque, and the persistence of the late Mannerist style at Florence proved in the long run to be retardative. It seems desirable, therefore, to draw the curtains across the stage immediately after the climax of our story and the death of its last protagonist.

List of Illustrations

36. Nanni di Banco. St Luke. Museo dell'Opera del Duomo, Florence.
37. Donatello. St Mark. Or San Michele, Florence.
38. Niccolo di Pietro Lamberti. St Luke. Bargello, Florence.
39. Lorenzo Ghiberti. St John the Baptist. Or San Michele, Florence.
40. Nanni di Banco. Four Saints. Or San Michele, Florence.
41. Nanni di Banco. Assumption of the Virgin. Porta della Mandorla, Cathedral, Florence.
42. Nanni di Banco. Angel (detail from the Assumption). Porta della Mandorla, Cathedral, Florence.
43. Donatello. St George. Bargello, Florence.
44. Lorenzo Ghiberti. St Matthew. Or San Michele, Florence.
45. Donatello. Bearded Prophet. Museo dell'Opera del Duomo, Florence.
46. Donatello. St Louis. Museum, Santa Croce, Florence.
47. Donatello. Jeremiah. Museo dell'Opera del Duomo, Florence.
48. Donatello. Habakkuk. Museo dell'Opera del Duomo, Florence.
49. Donatello & Michelozzo. Monument to Pope John XXIII. Baptistry, Florence.
50. Michelozzo. Mourning Youth. Monument to Cardinal Brancacci, Sant' Angelo a Nilo, Naples.
51. Michelozzo. St Bartholomew. Monument of Bartolommeo Aragazzi, Cathedral, Montepulciano.
52. Michelozzo. Angel. Victoria and Albert Museum, London.
53. Michelozzo. Aragazzi taking leave of his Family. Monument of Bartolommeo Aragazzi, Cathedral, Montepulciano.
54. Donatello. Tabernacle of the Holy Sacrament. St Peter's, Rome.
55. Luca della Robbia. Singing Gallery. Museo dell'Opera del Duomo, Florence.
56. Luca della Robbia. Dancers. Singing Gallery, Museo dell'Opera del Duomo, Florence.
57. Donatello and Michelozzo. External Pulpit. Cathedral, Prato.
58. Donatello. Singing Gallery. Museo dell'Opera del Duomo, Florence.
59. Donatello. Ascension of St John. Old Sacristy, San Lorenzo, Florence.
60. Donatello. Bronze Doors (detail). Old Sacristy, San Lorenzo, Florence.
61. Donatello. David. Bargello, Florence.
62. Donatello. David (detail). Bargello, Florence.
63. Donatello. Cavalcanti Annunciation. Santa Croce, Florence.
64. Donatello. Pazzi Virgin and Child. Skulpturenabteilung, Berlin-Dahlem.
65. Donatello. Gattamelata. Piazza del Santo, Padua.
66. Donatello. St Francis. High Altar, Sant'Antonio, Padua.
67. Donatello. Miracle of the Mule. High Altar, Sant'Antonio, Padua.
68. Donatello. St Mary Magdalene. Baptistry, Florence.
69. Donatello. Judith and Holofernes. Piazza della Signoria, Florence.
70. Donatello. North Pulpit, San Lorenzo, Florence.
71. Donatello and Bellano. Crucifixion. South Pulpit, San Lorenzo, Florence.
72. Luca della Robbia. Tabernacle of the Sacrament. Parish Church, Peretola.
73. Luca della Robbia. Monument of Bishop Federighi. Santa Trinita, Florence.
74. Luca della Robbia. Resurrection. Cathedral, Florence.
75. Bernardo Rossellino. Monument of Leonardo Bruni. Santa Croce, Florence.
76. Bernardo Rossellino. Effigy and sarcophagus. Monument of Leonardo Bruni, Santa Croce, Florence.
77. Desiderio da Settignano. Effigy and sarcophagus. Monument of Carlo Marsuppini, Santa Croce, Florence.

116. Gianfrancesco Rustici. Preaching of St John the Baptist. Baptistry, Florence.
117. Gianfrancesco Rustici. Fighting Horsemen. Bargello, Florence.
118. Andrea Sansovino. Corbinelli Altar. Santo Spirito, Florence.
119. Andrea Sansovino. Monument of Cardinal Basso della Rovere. Santa Maria del Popolo, Rome.
120. Andrea Sansovino. Baptism of Christ. Baptistry, Florence.
121. Andrea Sansovino. Virgin and Child with St Anne. Sant'Agostino, Rome.
122. Jacopo Sansovino. Madonna del Parto. Sant'Agostino, Rome.
123. Andrea Sansovino. Annunciation. Santa Casa, Loreto.
124. Jacopo Sansovino. Deposition. Victoria and Albert Museum, London.
125. Michelangelo. St Matthew. Accademia, Florence.
126. Jacopo Sansovino. St James. Cathedral, Florence.
127. Jacopo Sansovino. Bacchus. Bargello, Florence.
128. Michelangelo. Bacchus. Bargello, Florence.
129. Jacopo Sansovino. Susannah and the Elders. Victoria and Albert Museum, London.
130. Michelangelo. Battle of the Centaurs. Casa Buonarotti, Florence.
131. Bertoldo. Battle of Horsemen (detail). Bargello, Florence.
132. Michelangelo. Virgin of the Steps. Casa Buonarotti, Florence.
133. Michelangelo. Taddei Roundel. Royal Academy, London.
134. Michelangelo. Pietà. St Peter's, Rome.
135. Michelangelo. David. Accademia, Florence.
136. Michelangelo (after). Monument of Pope Julius II (drawing). Kupferstichkabinett, East Berlin.
137. Michelangelo. Moses. San Pietro in Vincoli, Rome.
138. Michelangelo. Slave (wax model). Victoria and Albert Museum, London.
139. Michelangelo. Atlas Slave. Accademia, Florence.
140. Michelangelo. Victory. Palazzo Vecchio, Florence.
141. Michelangelo. Hercules and Cacus. Casa Buonarotti, Florence.
142. Michelangelo (after). Samson and Two Philistines. Museum Boymans van Beuningen, Rotterdam.
143. Michelangelo. Tomb of Giuliano de' Medici. Medici Chapel, San Lorenzo, Florence.
144. Baccio Bandinelli. Hercules and Cacus. Piazza della Signoria, Florence.
145. Baccio Bandinelli. Venus with a Dove. Bargello, Florence.
146. Baccio Bandinelli. Monument to Giovanni delle Bande Nere. Piazza San Lorenzo, Florence.
147. Baccio Bandinelli. Adam (detail). Bargello, Florence.
148. Baccio Bandinelli. Prophets, from choir enclosure. Cathedral, Florence.
149. Benvenuto Cellini. Bust of Cosimo I. Bargello, Florence.
150. Benvenuto Cellini. Salt-Cellar. Kunsthistorisches Museum, Vienna.
151. Benvenuto Cellini. Perseus, bronze model. Bargello, Florence.
152. Benvenuto Cellini. Perseus and Medusa. Loggia dei Lanzi, Florence.
153. Benvenuto Cellini. Mercury. On base of Perseus group, Loggia dei Lanzi, Florence.
154. Benvenuto Cellini. Perseus and Andromeda. On base of Perseus group, Loggia dei Lanzi, Florence.
155. Tribolo. Assumption of the Virgin (detail). San Petronio, Bologna.
156. Tribolo and Pierino da Vinci, Fountain of the Labyrinth, Petraia.
157. Giovanni Bologna. Florence. Fountain of the Labyrinth, Petraia.
158. Tribolo and Pierino da Vinci. Boys. Fountain of Hercules, Castello.

Acknowledgements to Illustrations

Reproduced by gracious permission of Her Majesty the Queen, 114.
Albertina, Vienna, 165; Tim Benton, 127, 155, 157–8, 167–8, 171–2, 175, 181, 185; Fratelli Fabbri Editori, 13, 15, 21, 27, 33, 40, 42, 69, 79, 82, 86, 105, 121, 130, 134, 137, 139, 140–1, 148, 161, 164; Kunsthistorisches Museum, Vienna, 83, 150, 183; The Louvre, Cliche des Musées Nationaux, 91, 98, 160; The Mansell Collection, 4, 9, 11, 12, 22–6, 28, 35, 45–6, 54, 59, 60, 62, 66, 68, 70, 72, 80, 81, 84, 92, 102, 103, 106, 108, 113, 117, 125, 128, 132, 135, 144, 148, 152, 162, 169, 170, 186; Staatliche Museum, East Berlin, 136; Staatliche Museum, West Berlin, 64, 94; The Victoria and Albert Museum, Crown Copyright, 7, 10, 29, 52, 87, 90, 93, 100, 109, 111, 112, 124, 131, 133, 142, 145, 163, 173–4, 177, 179, 180, 182, 184.

Locations of Principal Sculptures in Florence

Page references here relate to main discussion only
(pieces that appear in brackets [] are not mentioned in the text)

Benedetto da Maiano. Pulpit 125
Danti. [Virgin and Child]
Desiderio da Settignano. Marsuppini Monument 105–7
Donatello. Cavalcanti Annunciation 84–5
— [Wooden Crucifix]
Francavilla. [Statues in Niccolini Chapel]
Rossellino, Antonio. Madonna del Latte (Nori Monument) 114
Rossellino, Bernardo. Bruni Monument 101–3
Tino di Camaino. [Monument of Gastone della Torre]
Vasari. [Michelangelo Monument]

S. CROCE: PAZZI CHAPEL

Brunelleschi (?). [Evangelist roundels]
Desiderio da Settignano and Donatello (?). Frieze of Putto Heads 109
Robbia, Luca della. [Apostle roundels]

S. EGIDIO

Ghiberti. Tabernacle Door 104
Rossellino, Bernardo. Tabernacle 103–4

S. LORENZO

Desiderio da Settignano. Altar of the Sacrament 105–7
Donatello. Pulpits 94–6
— Scenes from the life of St John the Evangelist 80–1
— Two bronze doors 81
Michelangelo. Medici Chapel 189–92
Verrocchio. Lavabo 130
— Medici Monument 131–2

S. MARCO

Giovanni Bologna and Francavilla. [Chapel of S. Antonino (Salviati Chapel)]

S. MARIA NOVELLA

Benedetto da Maiano. [Monument of Filippo Strozzi]
Brunelleschi. [Pulpit]
— [Wooden Crucifix]
Ghiberti. [Tomb-Slab]
Rossellino, Bernardo. [Tomb of Beata Villana]

S. MINIATO AL MONTE

Michelozzo. [Cappella del Crocifisso]
Robbia, Luca della. Ceiling of the chapel of the Cardinal of Portugal 112
Rossellino, Antonio. Monument of the Cardinal of Portugal 111–15

S. SPIRITO

Rossellino, Bernardo. Monument of Neri Capponi 119–20
Sansovino, Andrea. Corbinelli Altar 153–5

Brief Bibliography

THIRTEENTH AND FOURTEENTH CENTURIES

G. H. and E. R. Crichton, *Nicola Pisano and the Revival of Sculpture in Italy*, Cambridge, 1938.

J. Pope-Hennessy, *Italian Gothic Sculpture*, London, 1955.

J. White, *Art and Architecture in Italy, 1250–1400*, Harmondsworth, 1966.

FIFTEENTH CENTURY

F. Hartt, etc., *The Chapel of the Cardinal of Portugal*, Philadelphia, 1964.

H. W. Janson, *The Sculpture of Donatello*, Princeton, 1957 (2nd ed. 1962).

R. Krautheimer, *Lorenzo Ghiberti*, Princeton, 1956.

A. Marquand, *Luca della Robbia*, Princeton, 1914.

G. Passavant, *Verrocchio*, London, 1969.

J. Pope-Hennessy, *Italian Renaissance Sculpture*, London, 1958.

C. Seymour Jr., *Sculpture in Italy, 1400–1500*, Harmondsworth, 1966.

SIXTEENTH CENTURY

J. Pope-Hennessy, *Italian High Renaissance and Baroque Sculpture*, London, 1963.

C. De Tolnay, *Michelangelo*, Princeton, 1947–60.

GENERAL

E. Borsook, *Companion Guide to Florence*, London, 1966.

J. Montagu, *Bronzes*, London, 1963.

J. Pope-Hennessy, *Essays on Italian Sculpture*, London, 1968.

A. Radcliffe, *European Bronze Statuettes*, London, 1966.

References for further reading will be found in the appropriate volumes cited above: the most complete accounts of many sculptors exist only in foreign languages or in art periodicals.

Index